PAINTERS of the AMERICAN SCENE

PAINTERS of the AMERICAN SCENE

NANCY HELLER
JULIA WILLIAMS

Galahad Books · New York

First published 1976 as *The Regionalists* in New York
by Watson-Guptill Publications,
a division of Billboard Publications, Inc.,
1515 Broadway, New York, NY 10036

Published in 1982 by
Galahad Books
95 Madison Avenue
New York, NY 10016

Published by arrangement with Watson-Guptill Publications

Manufactured in Hong Kong

10 9 8 7 6 5 4 3 2

Library of Congress Catalog Number 82-81901

ISBN 0-88365-659-0

To Jack and Howie

ACKNOWLEDGMENTS

We would like to thank Watson-Guptill Editorial Director Donald Holden and his associate Diane Casella Hines for their help with this project. We are especially grateful to Matthew Baigell, Art Department Chairperson at Rutgers College of Rutgers University, for his confidence and encouragement.

CONTENTS

LIST OF COLOR PLATES

PREFACE

This book is organized around four separate categories of paintings, grouped together by subject matter. Chapter I introduces the concept of Regionalism: the origin of the term itself, the stylistic roots of Regionalist art, and the painters who produced it. The second chapter deals with the most commonly considered type of Regionalism—namely, pictures of farms and other rural areas. Chapter III explores the visual images of small-town America. Regionalist paintings of urban centers are presented in Chapter IV, and Chapter V introduces the last category: paintings that illustrate American myths and legends, that refer to specific historical events, or that provide socio-political commentary. Finally, in the sixth chapter, the fate of Regionalist painting after the 1930s is discussed, along with a brief comment concerning the ultimate significance of the Regionalist movement in the context of American art history.

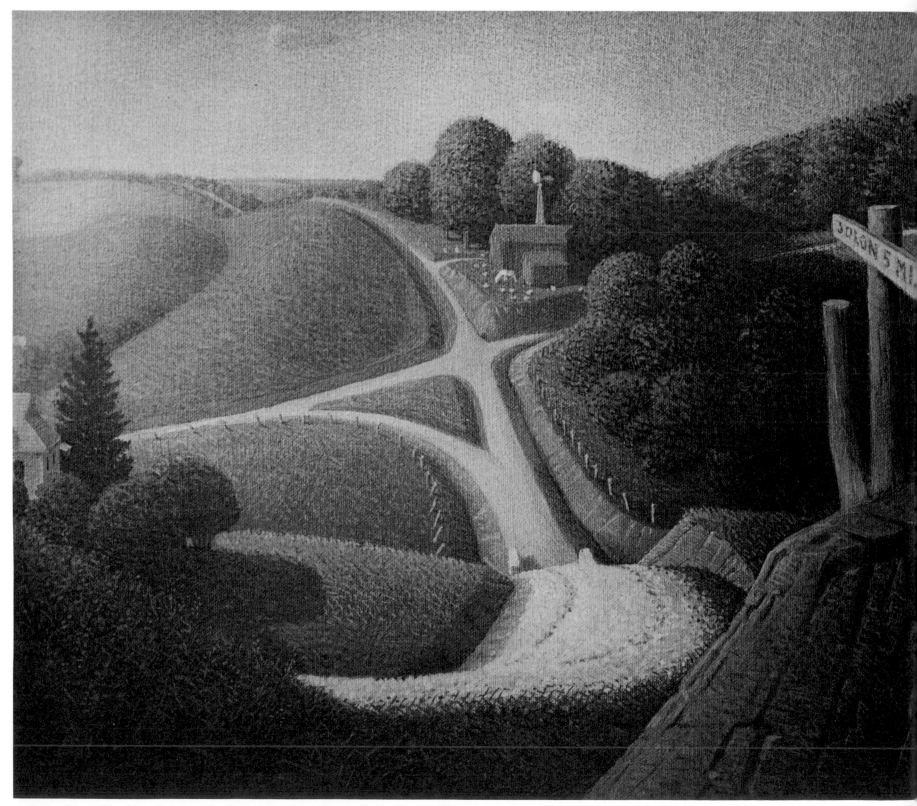

1. Grant Wood, The New Road, *1939, oil on composition board, 12″ x 14-1/4″. Private collection. Courtesy Associated American Artists.*

I

THE CONCEPT OF REGIONALISM

"America today is developing a school of painting which promises to be the most important movement in the world of art since the days of the Italian Renaissance." So said Peyton Boswell, Jr., a noted art critic of the 1930s, writing about Regionalism in his book, *Modern American Painting*. Regionalism was a popular school of American painting based on a realistic depiction of the American land and its people. Although history may have proven Boswell's statement to be somewhat exuberant, the loosely structured movement known as Regionalism did have a major impact on American art of the Great Depression era.

As used here, "Regionalism" is a broad term that includes paintings with various types of subject matter ranging from views of isolated farms and small towns (Plates 1, 2, 9) to big-city scenes of business offices and subway crowds (Plates 7, 57, Color Plate 30). There is no single Regionalist "style." For example, Grant Wood, who makes everything in his pictures look flat and smooth, and filled with painstakingly precise details (Color Plate 1, Plates 1, 2), is an archetypal Regionalist. But so is Thomas Hart Benton (Color Plate 2, Plates 4, 5), whose fantastically curving, elongated people always seem to be plugged into electrical outlets; and so is Reginald Marsh (Color Plate 4, Plate 7), whose sketchy technique and often garish colors emphasize the dynamism of his subjects.

Second, Regionalism does not refer to artwork produced in any particular part of the United States. Because the movement's acknowledged leaders (Grant Wood, Thomas Hart Benton, and John Steuart Curry) came from Iowa, Missouri, and Kansas, respectively, Regionalism is often considered a Midwestern phenomenon. However, Regionalism was extremely wide-

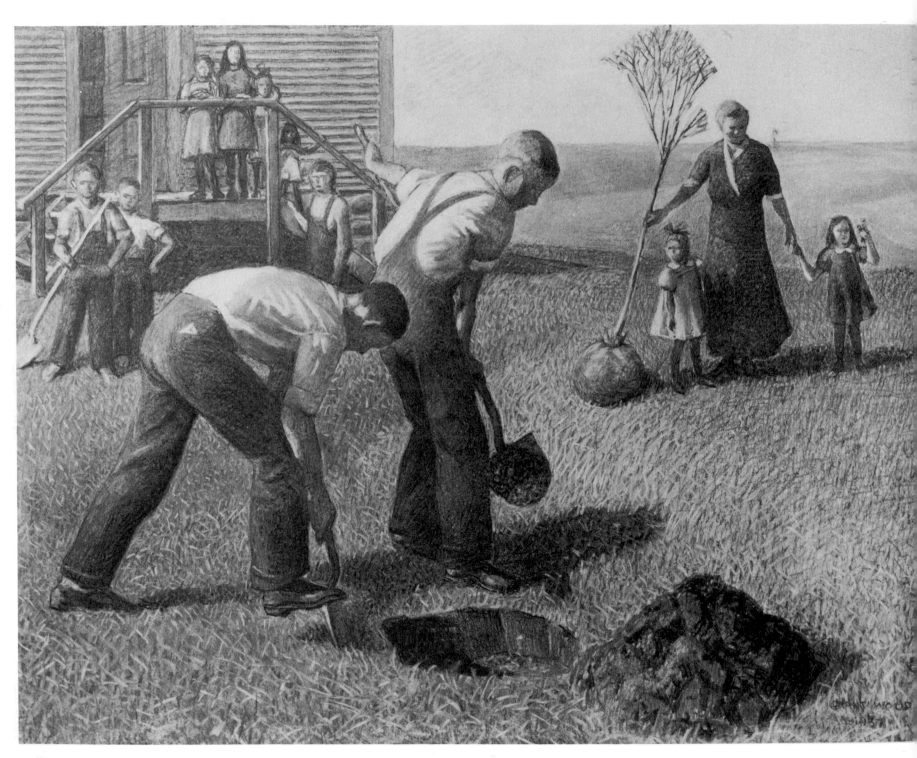

2. Grant Wood, Tree Planting, *1937, charcoal on paper, 24″ x 39″. Cedar Rapids Community Schools, Cedar Rapids, Iowa. Courtesy Associated American Artists.*

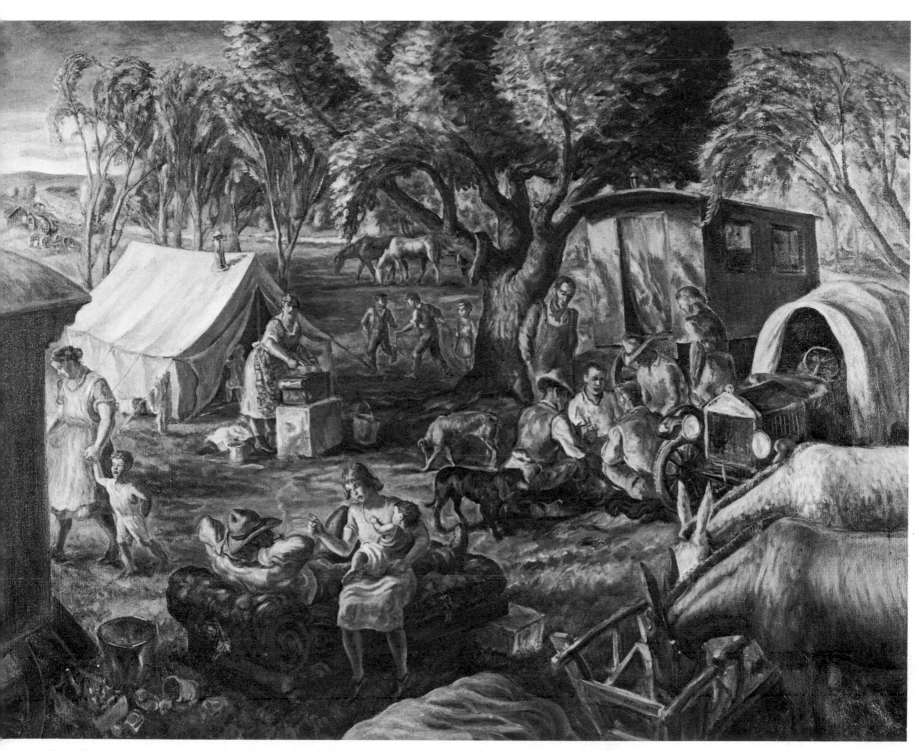

3. John Steuart Curry, Roadmender's Camp, *1929, oil on canvas, 40-1/8″ x 52″. The University of Nebraska Art Galleries, Lincoln, Nebraska; F. M. Hall Collection.*

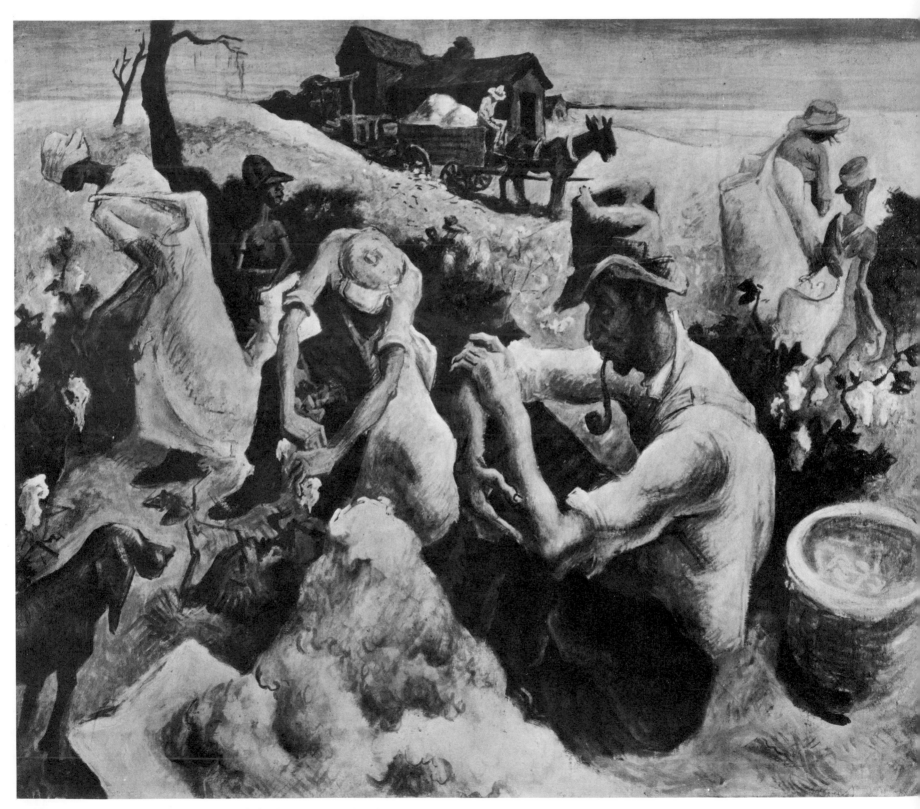

4. Thomas Hart Benton, Cotton Pickers, Georgia, *1928–29, oil and egg tempera on canvas, 30″ x 35-3/4″.*
The Metropolitan Museum of Art, New York, New York; George A. Hearn Fund, 1933.

spread. In terms of painting, it included work produced by artists all over the country; from Andrew Dasburg in the Southwest to Isabel Bishop in New York City.

The term "Regionalist" was originally applied to the works produced by a group of Southern writers, including John Crowe Ransom and Robert Penn Warren, who stressed in their writing the persons, places, and everyday activities common to the American South. Even though they wrote about a region they knew personally, these writers were not addressing a single section of the country. The Regionalists, in literature and later in the visual arts, emphasized the importance of an American art that came from, and could speak to, *all* Americans. For this reason, it is misleading to imply, as many sources do, that Regionalist painting was the exclusive province of Wood, Benton, and Curry—the three men who are considered the founders of this type of art. Indeed, one of the major purposes of this book is to demonstrate the true *breadth* of Regionalism, by reproducing and examining the work of some 36 painters whose names are too often left out of studies of American painting of the 1930s, artists such as Paul Cadmus, Waldo Peirce, and Luigi Lucioni.

Although most American artists during the thirties turned to the American scene for their subject matter, they did not all approach that subject matter in a Regionalist manner. (Of course, there were other American artists who continued to produce abstract paintings, based on European modernist styles, throughout this period.) The majority of representational pictures produced in the United States during the 1930s were part of what has been labeled the American Scene movement.

American Scene painting can be broken down into two primary categories: Regionalism and Social Realism. Regionalist artists, such as Thomas Hart Benton, Aaron Bohrod, and Peter Hurd, celebrate the diversity of the American landscape by painting essentially positive, people-oriented scenes of farms, small towns, and cities. When a Regionalist such as Reginald Marsh paints New York City, even Times Square becomes a magical place, since

Marsh stresses, not the vice and poverty of this area, but rather the vigor of its nightlife and the excitement and glamour of its colors, lights, and sounds.

The other type of American Scene painting of the thirties is known as Social Realism. Social Realist paintings are less concerned with positive visual evocations of the American land than with making specific types of social and political statements about the inadequacies and inequalities of American society. Ben Shahn is a good example of a Social Realist painter, and his series on the Sacco and Vanzetti trial is typical of the kind of art the Social Realists produced. Clear-cut examples of Social Realism discussed in this book are Fletcher Martin's *Trouble in Frisco* (Plate 71) and Joseph Hirsch's *Amalgamated Mural* (Plate 74).

However, these categories (of Regionalism and Social Realism) overlap occasionally. Confirmed Social Realists, such as Isaac and Raphael Soyer, sometimes painted works which were more descriptions than commentaries— paintings like *Employment Agency* (Color Plate 31) or *In the City Park* (Color Plate 30); and Regionalists like Paul Cadmus ventured into the realm of Social Realism with such works as *To the Lynching!* (Plate 72).

In this volume, we will also discuss certain artists whose work is sometimes considered under the aegis of Regionalism, but who are not themselves Regionalists. For example, Edward Hopper often paints scenes of sundrenched New England seacoast cottages. But his pictures have an eerie quality about them, which contrasts with the work of Benton and Curry. Hopper's paintings of America, even at their most hauntingly beautiful, seem somehow empty and ominously quiet. When he paints people (Color Plate 6), they are generally alone and brooding, alienated from their environments. It is true that even Hopper's most disturbing figure studies never achieve the level of anxiety and bitterness that are present in the work of contemporary European Expressionist painters, such as George Grosz and Otto Dix (Plate 13). Still, Hopper's people are a far cry from those painted by Benton, who almost always seem to be enjoying themselves and who appear to relate in a positive manner to the places where they live.

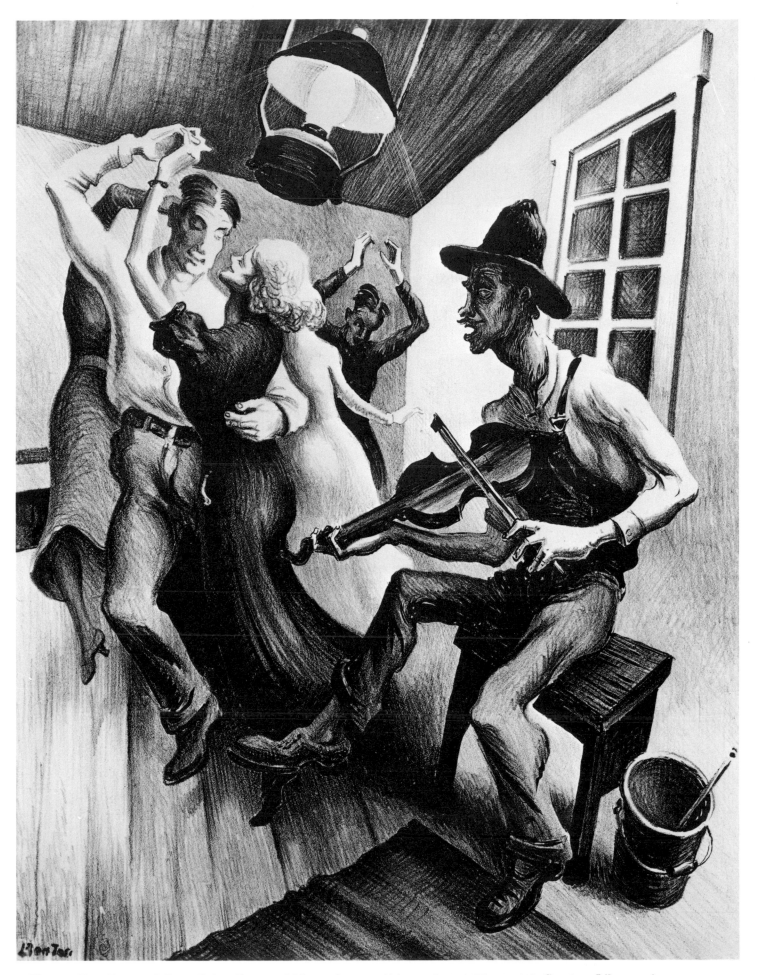

5. *Thomas Hart Benton,* I Got a Gal on Sourwood Mountain, *1938, lithograph, 12-1/2″ x 9-1/8″. Courtesy Library of Congress, Washington, D.C.*

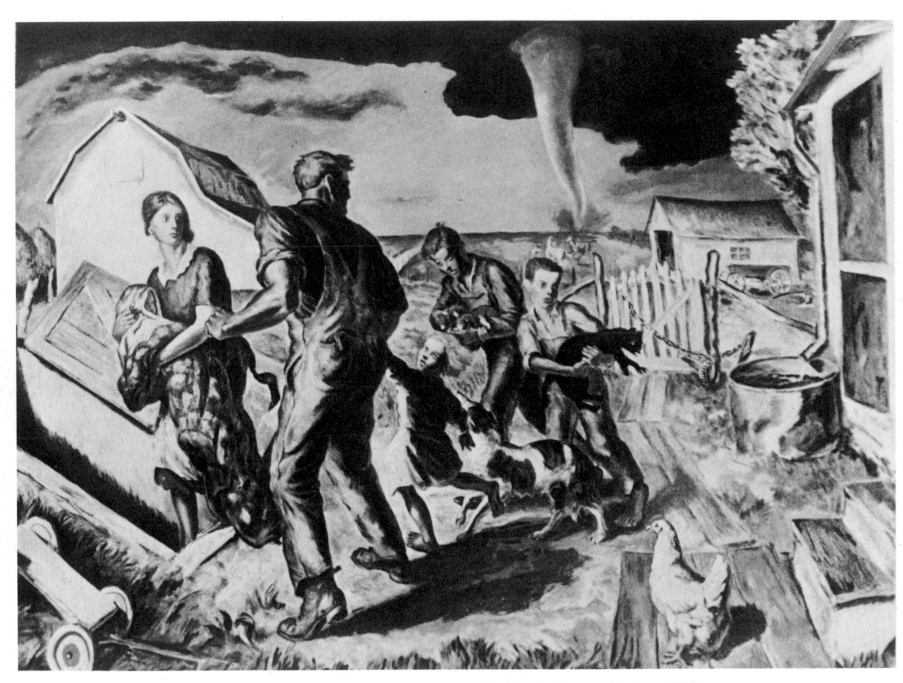

6. *John Steuart Curry,* Tornado over Kansas, *1929, oil on canvas, 46-1/2″ x 60-3/8″. Hackley Art Museum, Muskegon, Michigan.*

7. *Reginald Marsh,* Summer in New York, *1928, watercolor, 13-3/4" x 19-1/2". The Art Institute of Chicago, Chicago, Illinois; Watson F. Blair Purchase Prize.*

It is because of his largely negative approach to his subject matter that Hopper falls outside the category of Regionalism, despite his occasional Regionalist-type paintings. Although Hopper's work is impossible to classify, it is clear that his primary concern was with formal questions; he was always more interested in the colors and shapes within his paintings than he was with their content.

In a similar manner, Georgia O'Keeffe must be considered a formalist painter whose work is only related to Regionalist art. Although she is closely identified with a specific region (namely, the American Southwest), O'Keeffe's paintings of natural forms—primarily flowers, clouds, and sun-bleached bones—have nothing to do with the relation of people to their everyday environment. Therefore, she is not a Regionalist. Even one of O'Keeffe's most "Regionalistic" pictures, *Ranchos Church* (Color Plate 19), is less a painting about a specific building or type of building than a study of rectangular shapes and the shadings of colors that make up those shapes.

Charles Burchfield is also a difficult artist to classify. He was labeled a Regionalist by many critics in the thirties, and, indeed, a large segment of Burchfield's paintings of this period (Color Plate 5, Plate 9) are essentially Regionalist works. But the majority of Burchfield's other paintings are quite different in style. In these, Burchfield is more concerned with the use of eccentric patterns and shapes to convey an intensely personal mood than he is with making a Regionalist statement.

All three of these artists—Hopper, O'Keeffe, and Burchfield—are important American painters, active during the thirties, who occasionally produced works that can be classified as Regionalist. At the same time, they each had specific, non-Regionalist formal interests which determined the direction of the bulk of their paintings. Although they are not primarily Regionalist painters, these three highly individualistic artists are significant in the context of a book about Regionalism because they demonstrate the far-reaching effects of the turn toward American subject matter in the 1930s.

Of course, the content of Regionalist painting was nothing new. There is a

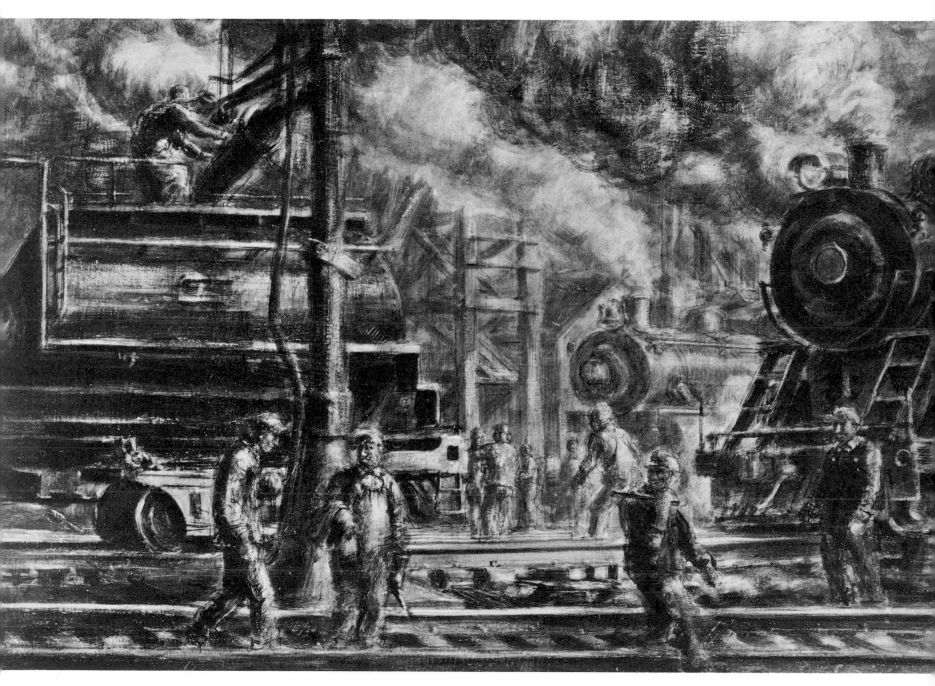

8. *Reginald Marsh*, Locomotives Watering, *1932, egg tempera on wood panel, 24″ x 36″. Mrs. Reginald Marsh, New York, New York.*

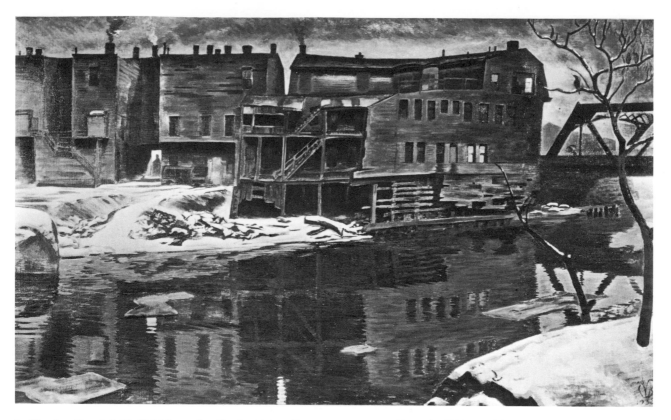

9. *Charles Burchfield,* Old House by Creek, *1938, oil on canvas, 34-1/2″ x 57″. Whitney Museum of American Art, New York, New York.*

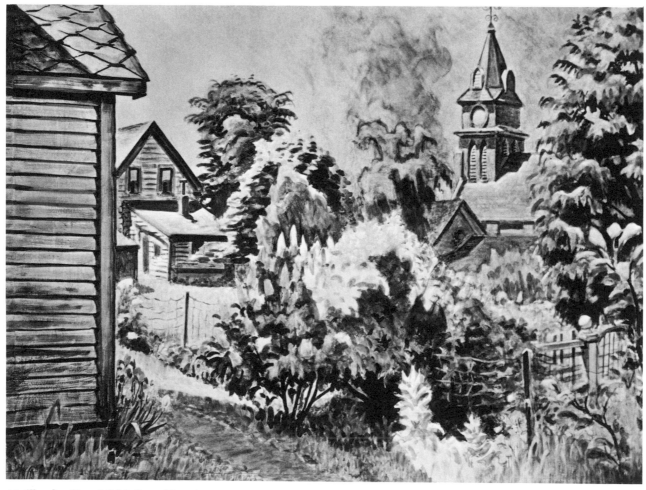

10. *Charles Burchfield,* June Morning, *1937-43, watercolor, 31″ x 40″. Courtesy Bernard Danenberg Galleries, New York, New York.*

long tradition of realism in American art, and American scenes, both townscapes and landscapes, as well as genre pictures (scenes of everyday activities, from work to prayer to outdoor recreation), had been painted throughout the nineteenth century by such noted artists as William Sidney Mount and Winslow Homer.

In the opening decade of the 1900s, the so-called Ash-Can School of artists, led by Robert Henri, painted realistic pictures of barrooms, crowded tenements, and picnics in city parks. John Sloan's work (Plates 11, 12) is typical of the kinds of subjects and approaches taken by these painters. The Ash-Can artists painted primarily Northeastern urban subjects, with which only a limited segment of the populace could identify. Henri and his cohorts held an influential exhibition in 1908. Five years later, they saw a good part of their potential audience turn away from realism as the American art community became entranced with European modernist paintings, presented to a large audience for the first time at the Armory Show of 1913.

The immediate roots of Regionalism can be seen in the 1920s, since certain important Regionalist pictures—such as Curry's *Baptism in Kansas* (Color Plate 3)—were actually painted before 1930. But it was in the thirties that United States painters regained a significant interest in realism and in depicting their country's land and people. Regionalist art also continued to be produced after 1939; however, the bulk of the artwork known as Regionalism was executed during the decade of the 1930s.

It is difficult, if not impossible, to pinpoint the reasons for the growth or popularity of an artistic movement. Because the Regionalist period corresponds almost precisely to the decade of the 1930s, the movement is often linked to the Great Depression. In this schema, the paintings of the Regionalists are described as fulfilling the need of a troubled country for positive, optimistic images to help it through the hard times.

This explanation is true to a certain extent. The thirties were difficult years for many Americans. For the millions unemployed, and underemployed, America had ceased to be a land of plenty. Even for many of those

who did not suffer physical privations, there was a loss of confidence and an anxiety about the future. Paintings such as *Stone City* (Color Plate 1) or *Threshing Wheat* (Color Plate 10) helped to bolster sagging morale by emphasizing what was good in America's past, and providing hopeful symbols for the nation.

However, it is important not to explain Regionalism simply as a response to the Great Depression. For years before the stockmarket crash, voices had been calling for an "American art," an art that was not based on imported European styles, that was not centered in one or two major cities, and that was accessible and understandable to *all* Americans. These calls came from two directions.

First, there were those who, in the wake of the First World War, wanted to retreat from America's involvement as a world power. This viewpoint was represented in the art world by critic Thomas Craven, who resented the hold of European modernism on American artists and worked to break it. Craven believed that modern European styles (such as Cubism and Futurism) were based on the artist's search for variations of style, not on a desire to communicate with his audience. Further, he claimed these "false" European styles had been transported to America where, because they were European, they had no relation to people's lives or interests. For Craven, the continual importation of European ideas had a debilitating effect on American art. The American artist who looked to Europe could never make great art because, for Craven, art must reflect life. Simply put, he believed that "art begins at home."

From the mid-twenties on, Craven exhorted American artists to look around them, to paint America. In Craven's opinion, an exploration of America by the artist would lead not only to new themes, but also to new styles. It would not do to use an "imported style on indigenous materials," making the Southwestern landscape look like "the Provençal landscape of Cézanne, and the Indian . . . [look like] the cubes and cones of Paris."

In Craven's view, once artists turned to America and left artificial Euro-

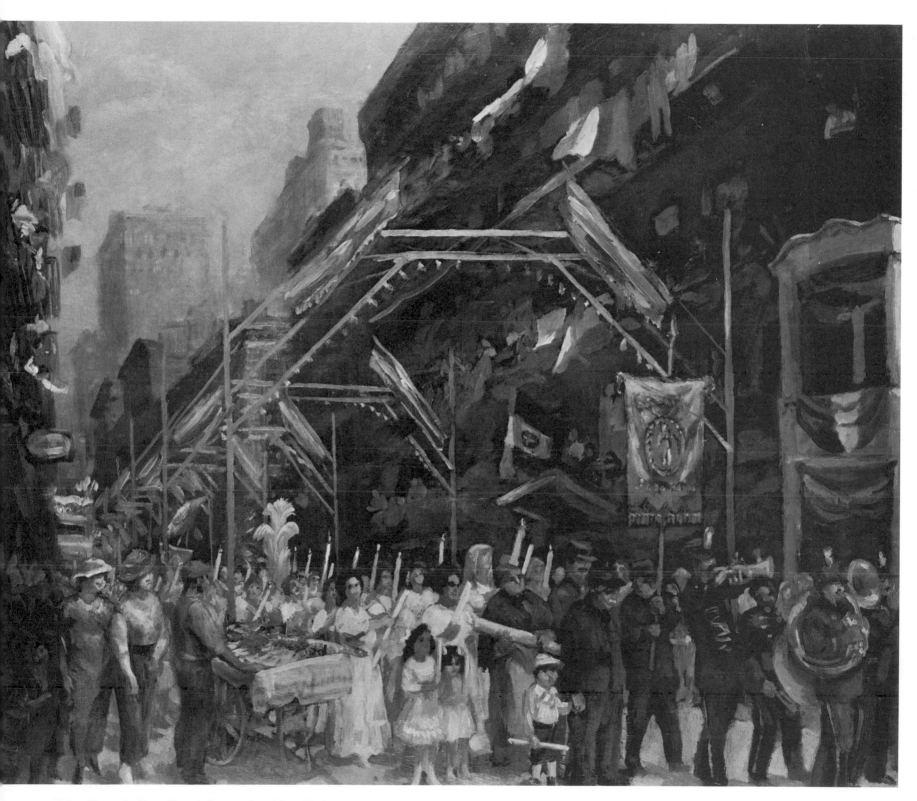

11. John Sloan, Italian Church Procession, New York, *1913-25, oil on canvas, 24″ x 28″. Fine Arts Gallery of San Diego, California; anonymous gift, 1926.*

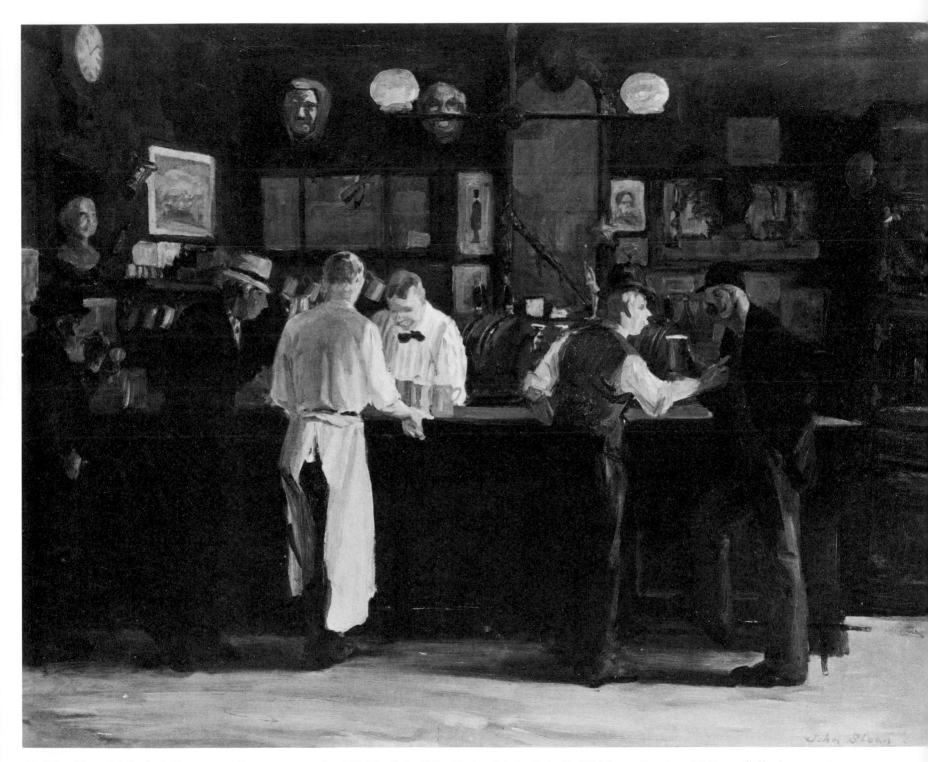

12. *John Sloan, McSorley's Bar, 1912, oil on canvas, 26″ x 32″. The Detroit Institute of Arts, Detroit, Michigan. Courtesy Midtown Galleries.*

pean styles behind, art in America would cease to be the "property of dilettantes," the elitist circles of intellectuals and the wealthy, centered primarily in New York. Rather, there would be an outpouring of art from all areas of the country. No longer would aspiring artists leave their homes and travel to Paris, or even to New York, to pursue their art. Instead they could remain in the South, the Midwest, New England, and the West, painting the people and the land around them. Furthermore, Craven envisioned a resurgence of public art, especially murals, and he urged artists to turn from abstraction to representational styles. In this way, art would speak to all Americans.

Craven pointed to the works of certain contemporary Mexican artists, especially José Clemente Orozco, Diego Rivera, and David Siqueiros, as fulfilling these ideals. In their murals, these painters were producing art which was both accessible and understandable to the Mexican public. American painters looked to these Mexican artists for inspiration, as is clear from a comparison of Mitchell Siporin's *Order Number Eleven* (Plate 15) with Orozco's *Zapatistas* (Plate 14).

There were others besides Craven who called for an American culture based on the idea of Regionalism. For these people, however, Regionalism was not merely the idea of American artists painting various areas of America. In their terms, Regionalism was a way of organizing all industrial societies. They saw art as only one aspect of a whole social and cultural system called Regionalism.

One of the clearest explanations of this Regionalist vision was presented in a 1927 article by Lewis Mumford. Mumford believed that city and country were too disparate in modern society; that a greater sense of interrelationship must be developed between the two. He called for planning in order to stop the haphazard growth of vast urban areas cut off from the country surrounding them. In place of these giant urban areas he proposed smaller cities scattered throughout America. These cities would not be cut off from the surrounding rural areas; rather, they would provide goods and services, and take other goods and services in return, thus forming a balanced relationship.

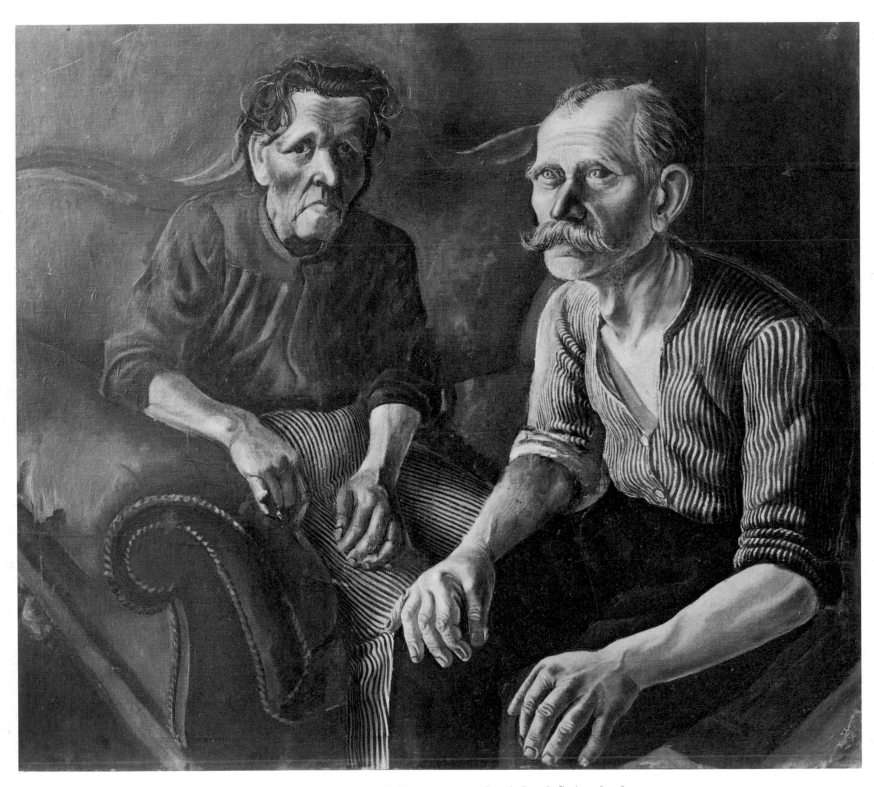

13. Otto Dix, The Artist's Parents, *1921, oil on canvas, 40″ x 41-1/2″. Kunstmuseum Basel, Basel, Switzerland.*

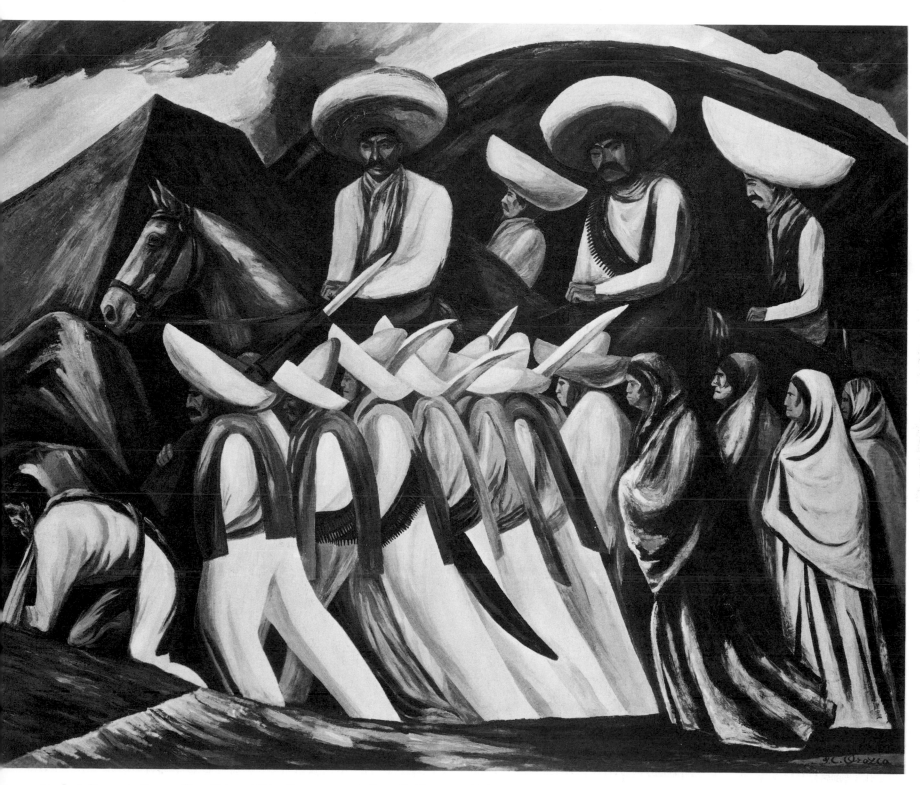

14. José Clemente Orozco, Zapatistas, *1931, oil on canvas, 45″ x 55″. Museum of Modern Art, New York, New York.*

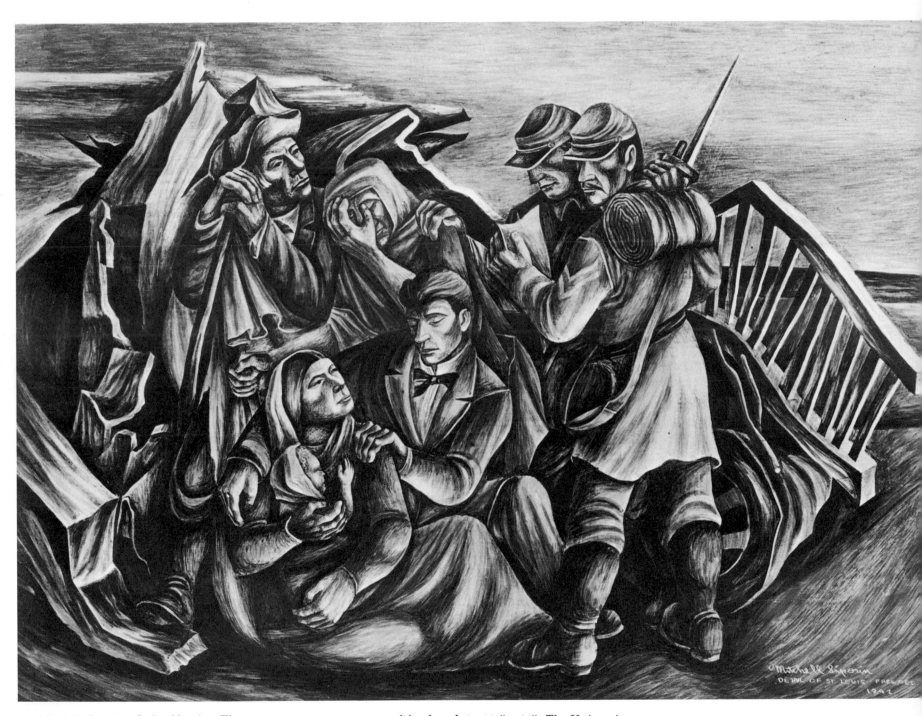

15. *Mitchell Siporin,* Order Number Eleven, *1942, tempera on composition board, 14-1/4" x 20". The University of Arizona Art Gallery, Tucson, Arizona; C. Leonard Pfeiffer Collection of American Art.*

More significant, in our terms, is Mumford's vision of how American art would change in the context of Regionalist planning. Like Craven, he believed that art should not be centered in one area of the country. Mumford saw the possibility of a rich and varied regional culture developing in the United States. He saw forerunners of this in writers of the Midwest, such as Carl Sandburg, Theodore Dreiser, Hamlin Garland, and Sinclair Lewis. Mumford hoped that other regions would produce comparable representatives, not only in literature, but also in architecture, music, and the visual arts. More important, he looked to the day when "we recognize that difference does not imply inferiority," and when "other regions of the country become sure enough of their existence to stop aping New York . . . and [when] Regional cultures . . . grow more vigorously."

Although founded on different premises, both these desires for an American art based on regional American cultures ultimately go back to the idea that America has a unique culture, distinct from that of any European country. *The Rise of an American Civilization*, an influential history of the United States written by Charles and Mary Beard and first published in 1927, is devoted to the concept of American culture as unique. However, this idea only became fully accepted in the United States in the 1930s.

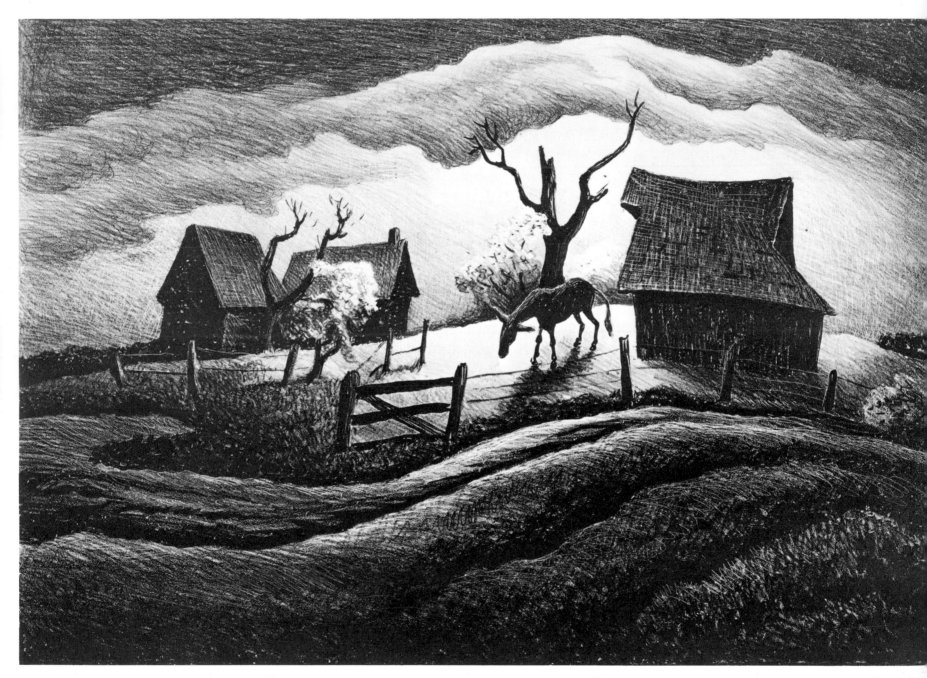

16. *Thomas Hart Benton,* Rainy Day, *1938, lithograph, 8-3/4" x 13-3/8". Courtesy Associated American Artists.*

II

THE AMERICAN LAND

The American landscape was not always a primary subject for American artists. In the seventeenth century, the earliest colonists, faced with basic problems of survival, had little interest in painting of any kind. As time passed, the harshness of conditions eased, and painting began to have some role in colonial life. This role, a very specialized one, was limited almost exclusively to portraiture. These early portraits contain the first glimpses of the American landscape. Occasionally an artist placed his sitter near a window, through which could be seen a harbor, a farm, or a house. These bits of landscape were subordinated to the main composition and generally were used to amplify the importance of the sitter by displaying his wealth and position in the form of the number of ships he owned, the richness of his farm, or the size of his home. Nonetheless, these window views are important as the earliest depictions of the American landscape.

It was really not until the nineteenth century that landscape painting became a major aspect of American art. At that time, two attitudes toward landscape painting developed. In a 1938 catalog to a show at the Whitney Museum, art historian Lloyd Goodrich identified the first of these attitudes as the "portraiture of specific places," painting that records the landscape in a straightforward way, just as a realistic portraitist might record a face. An early example of this type of landscape is John Trumbull's series of views of Niagara Falls, in which he simply recorded the scene's topography rather than exploiting its dramatic potential. The second attitude Goodrich notes is romantic. The artist who painted the land in this way was less interested in capturing the physical appearance of a place than in using the image of the landscape to evoke a mood or to reveal his inner feelings. Thomas Cole, the founder of the Hudson River School and the first major figure in the history of American landscape painting, approached the scenery of the Hudson

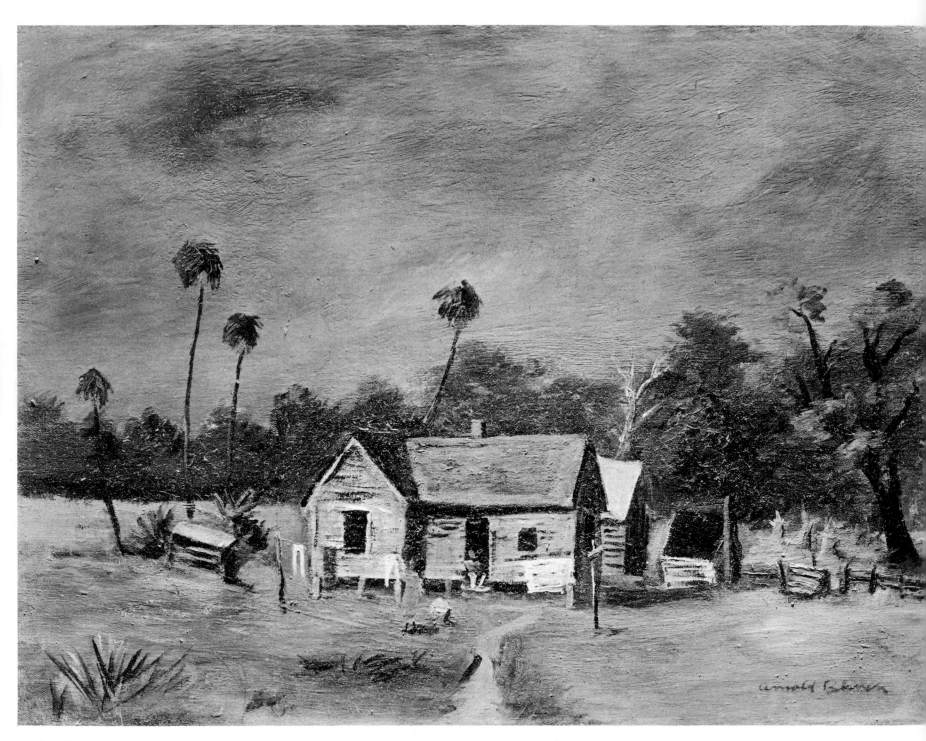

17. Arnold Blanch, Some Place in Georgia, *1940, oil on canvas, 12″ x 16″. The Metropolitan Museum of Art, New York, New York; George A. Hearn Fund, 1940.*

18. Luigi Lucioni, Vermont Pastoral, *1939, oil on canvas, 23″ x 39″. Museum of Art, Carnegie Institute, Pittsburgh, Pennsylvania.*

River from this point of view. Often, he infused his landscapes with allegorical meanings. For example, he contrasted the different stages in the development of a tree (i.e., sapling, mature tree, and blasted stump) to suggest the passage of time and the archetypal cycles of life and death.

These two broad attitudes toward landscape painting continued in American art throughout the nineteenth century. However, by the end of the century most major artists had abandoned the idea of recording the appearance of a specific place. The mysterious landscapes of Albert Blakelock, and to an even greater extent those of Albert Pinkham Ryder, dramatically illustrate this turn from recording a place to creating an intensely personal landscape.

In the twentieth century this trend was continued by Arthur Dove, John Marin, and (in his early period) Charles Burchfield (Plate 20). Even those artists who did not infuse their landscapes with intense emotions turned away from the description of a specific place in their paintings. For many artists at the turn of the century landscape was simply a vehicle for experimenting with avant-garde styles, ranging from Impressionism to Futurism, and gave little sense of specific place.

The Regionalists, however, reasserted the importance of "portrait of a place" landscape painting in American art. This is not surprising, given that Regionalism was based on the great geographic variety of the United States. Furthermore, because the Regionalists believed that art was shaped by its environment, their interest in capturing and defining the character of each of the country's regions is understandable. The American art critic, Peyton Boswell, Jr., said in 1940 that "America is a vast physical area with not one but a thousand aspects. It is a variegated, mosaiclike picture in which the parts add up to the sum of the whole." Regionalist artists accepted this point of view, and attempted to delineate the particular nature of their own regions. Therefore, many landscapes by Regionalist artists are straightforward visualizations of a specific place. Artists such as Arnold Blanch, Luigi Lucioni, Peter Hurd, and John Steuart Curry all painted their different regions, and have left images of four of the major regions of the country: the

19. Charles Burchfield, Evening, 1932, watercolor, 31-1/2'' x 43-1/2''. The Newark Museum, Newark, New Jersey.

20. *Charles Burchfield,* The First Hepaticas, *1917–18, watercolor, 21-1/2″ x 27-1/2″. Museum of Modern Art, New York, New York; gift of Abby Aldrich Rockefeller.*

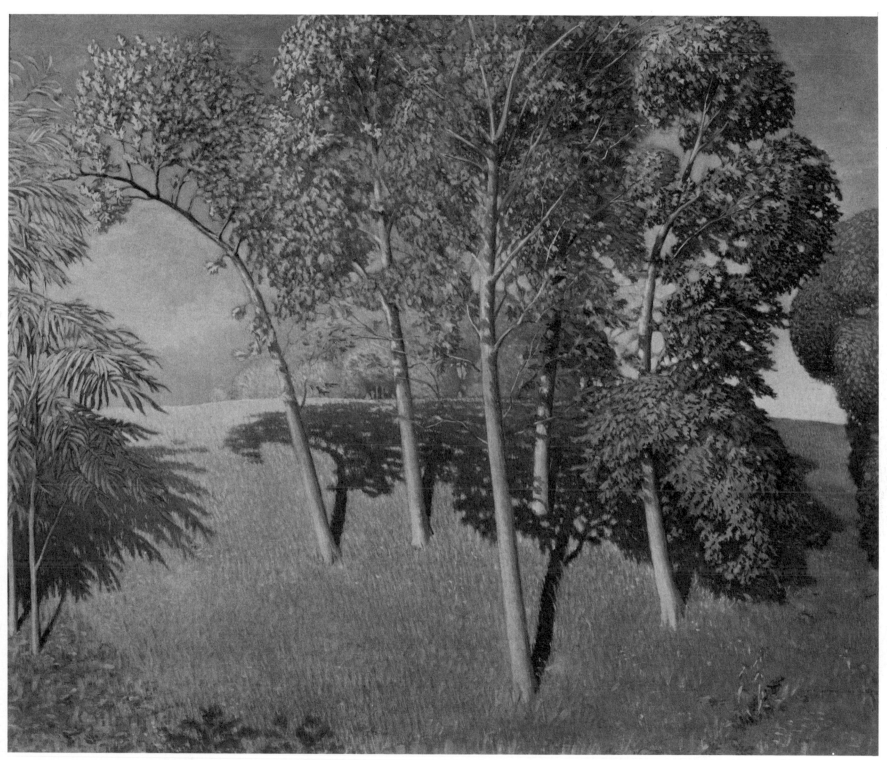

21. Grant Wood, Trees and Fields, *1932, oil on composition board, 31″ x 37″. Cedar Rapids Community Schools, Cedar Rapids, Iowa. Courtesy Associated American Artists.*

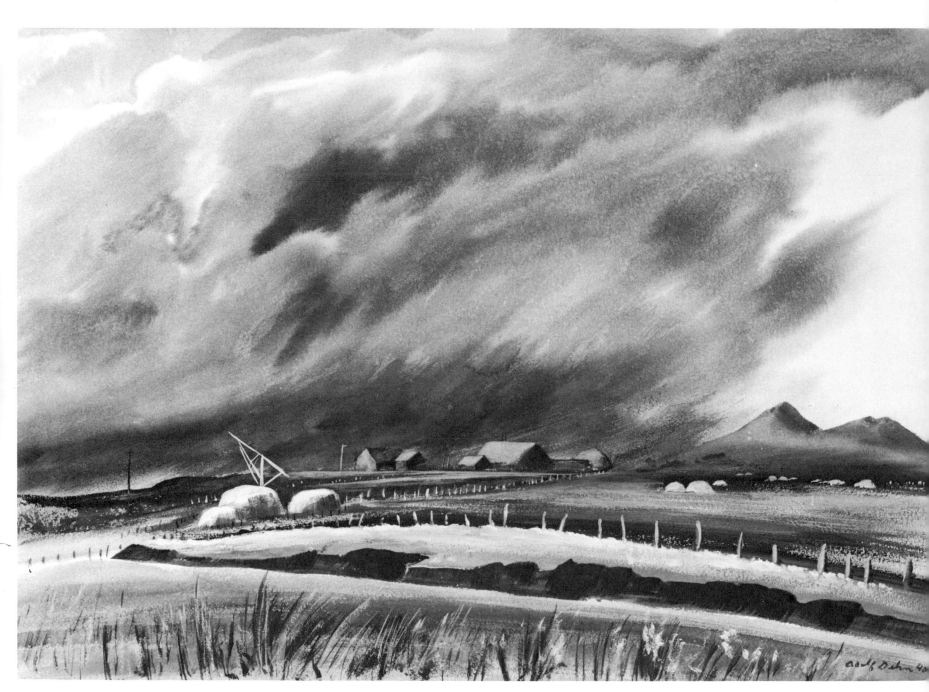

22. *Adolf Dehn*, Dust Storm, *1940, watercolor, 18-3/4″ x 26-3/4″. The Wichita Art Museum, Wichita, Kansas; Roland P. Murdock Collection, 1941.*

South, New England, the Southwest, and the Midwest.

Arnold Blanch's *Some Place in Georgia* (Plate 17) presents a view that is unmistakenly Southern. The palm trees and the home raised above the ground to keep out dampness are elements that would not be found in the United States outside the South. Blanch's landscape is Regionalist in that it emphasizes these uniquely Southern qualities.

In the same way, Luigi Lucioni gave prominence in his painting *Vermont Pastoral* (Plate 18) to elements usually associated with New England; the cultivated fields surrounded by stone fences, the rocky soil, and the low rolling hills are particularly evocative of that region. Low hills are also the subject of Edward Hopper's *Hills, South Truro* (Plate 28), in which Hopper based his composition on the repeated horizontals of the New England landscape.

The Southwest has attracted artists since the 1920s, when D. H. Lawrence settled in Taos hoping to establish a community of artists in that small New Mexican town. While Lawrence's community was never permanently established, artists flocked to the area, drawn to the Southwestern landscape. Peter Hurd, a native New Mexican, is an artist whose paintings of the Southwest capture elements unique to the region (Plate 30). Hurd's paintings—such as *Dry River* (Color Plate 20)—emphasize the vast spaces of the Southwest, with its bare hills and mountains. Only small human intrusions—ranch houses and rickety fences—disturb the emptiness of the scene.

While all areas of the country were recorded by Regionalist artists, the Midwest is most closely associated with Regionalist art. John Steuart Curry's *Wisconsin Landscape* (Color Plate 13) presents a typically Regionalist view of the Midwest. In Curry's painting, the Midwestern landscape is as vast as Hurd's Southwest. However, there is a significant difference. While the New Mexican landscape is sparsely populated and seemingly untamed, Curry's vision of the Midwest centers on its use as farmland. Curry presents the viewer with rows of neatly divided fields, each at a different stage of cultivation (in the foreground there are stacks of harvested grain, while in the middle ground are rows of maturing crops). He included not one, but several farms,

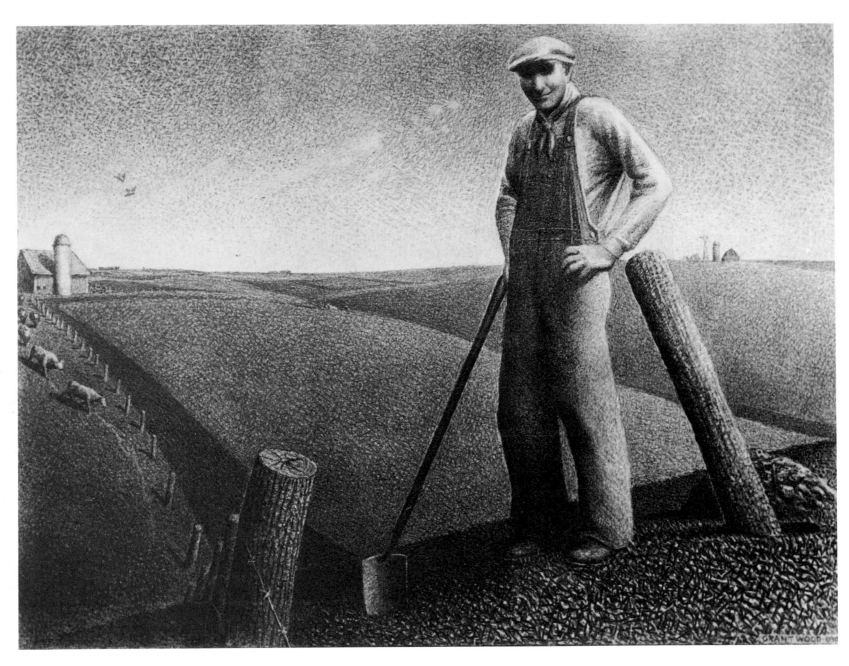

23. Grant Wood, In the Spring, *1939, pencil on paper, 18″ x 24″. The Butler Institute of Américan Art, Youngstown, Ohio. Courtesy Associated American Artists.*

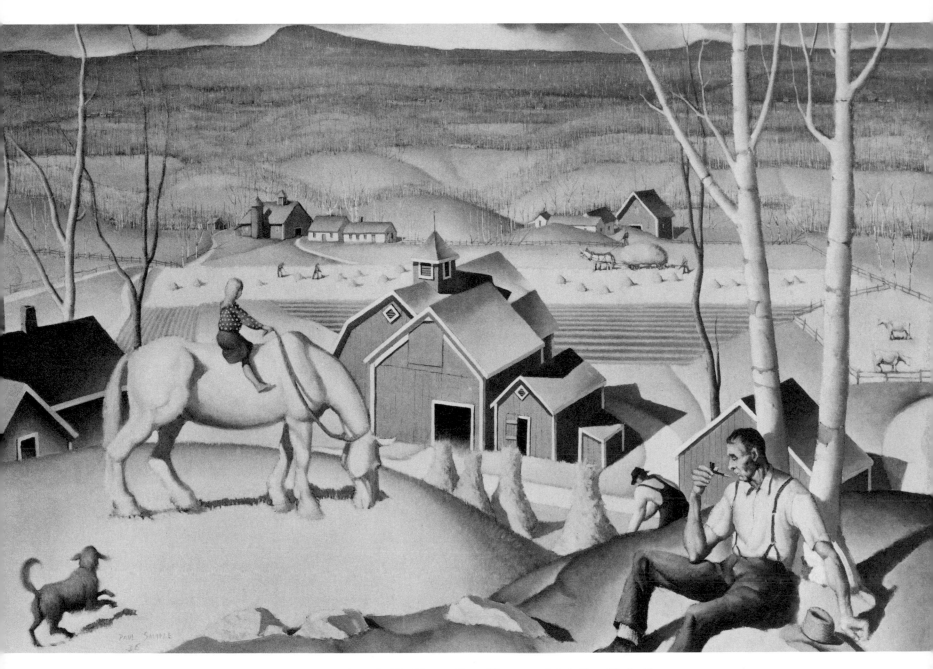

24. Paul Sample, Janitor's Holiday, *1936, oil on canvas, 26″ x 40″. The Metropolitan Museum of Art, New York, New York; Arthur H. Hearn Fund, 1937.*

25. Charles Burchfield, Black Iron, *1935, watercolor, 29″ x 41″. Private collection. Courtesy Kennedy Galleries.*

each a cluster of small domestic buildings beside a large red barn. Color is used to convey the fertility of the land; even the fallow fields appear fecund because their color is so rich and warm. For Curry and the Regionalists in general, the Midwestern landscape is only complete when depicted in relation to people. The Regionalist symbol for the Midwest was not a natural phenomenon, such as an indigenous plant or geological formation, but the farm. Their images of the Midwestern land usually included some reference to farm life (Plates 23, 80, 85, 86).

Many Regionalist painters of the Midwest were fascinated by the weather, perhaps because their image of the region was so closely related to its farm life. Curry's *Wisconsin Landscape* (Color Plate 13) again provides a good example. The sky in this painting is turbulent, filled with changing and moving clouds. Curry pays particular attention to the way in which the clouds cause patterns of light to fall over the fields. Thomas Hart Benton shared this concern with the weather in works such as *Rainy Day* (Plate 16) or *The Hailstorm* (Color Plate 11). In *Rainy Day* Benton used the gray tones of the lithographer's crayon to depict the dreariness of the scene: a rundown farm with bare trees and a lone animal in the yard. In this print Benton was less interested than Curry in actual meteorological conditions. Instead, Benton used the rain to suggest an overall somber mood.

Burchfield's *November Evening* (Color Plate 12) reveals his understanding of the importance of seasonal changes to rural people. Burchfield said that he "tried to express the coming of winter over the middle-west" in this painting. Indeed, he conveyed his feeling that the change in season makes a major difference in the life of a rural person. The clouds overhead are oppressive, and the rest of the scene seems to bend under their weight. The man on the wagon hunches his shoulders, the horses lower their heads; even the grass at the side of the road seems to collapse under the heavy atmosphere.

John Steuart Curry, Alexandre Hogue, and Adolf Dehn illustrated the most dramatic of rural weather conditions: the tornado and the dust storm. Curry's *Tornado over Kansas* (Plate 6) depicts a young farm family's rush

for their storm cellar before the approaching funnel cloud. Hogue's *Dust Bowl* (Color Plate 16) and Dehn's *Dust Storm* (Plate 22) both deal with the most topical of meteorological conditions, the dust storm. During the 1920s and 1930s hundreds of families were driven from their farms because of dust storms which made life unbearable and the land unusable. Hogue's *Dust Bowl* shows the destructive power of these storms, while the quality of beauty in Dehn's depiction is difficult to understand in the context of the actual desolation caused by the storms.

A popular theme for the Regionalists was people working on the land. (It is important to note that this subject was also treated by artists, such as Joe Jones (Color Plate 15), who are more accurately Social Realists.) Benton's work illustrates this Regionalist concern for depicting people doing agricultural labor. He painted the theme throughout his mature career; for example, in *Cotton Pickers, Georgia* (Plate 4), *Cradling Wheat* (Color Plate 2), *Threshing Wheat* (Color Plate 10), and *July Hay* (Color Plate 48). In paintings such as these, the fertility of the land as well as the dignity of farm labor is emphasized. This notion of the wholesome virtues of agricultural work stands in striking contrast to such paintings as Paul Sample's *Miners Resting* (Plate 26) or Charles Burchfield's *End of the Day* (Plate 32), which show the deleterious effects of industrial labor. The figures in Sample's and Burchfield's paintings seem worn and tired in contrast to the smiling farmer in Grant Wood's *In the Spring* (Plate 23). In Wood's drawing, a single farmer stands before his neatly manicured fields. There is no sign of farm machinery; in fact, the only tool shown is a simple post-hole digger. This picture reveals a nostalgia for the kind of farm life that existed before mechanization changed farms from single-family operations to large-scale agricultural corporations. In the next chapter a similar nostalgia is shown to exist in many Regionalist depictions of the American small town.

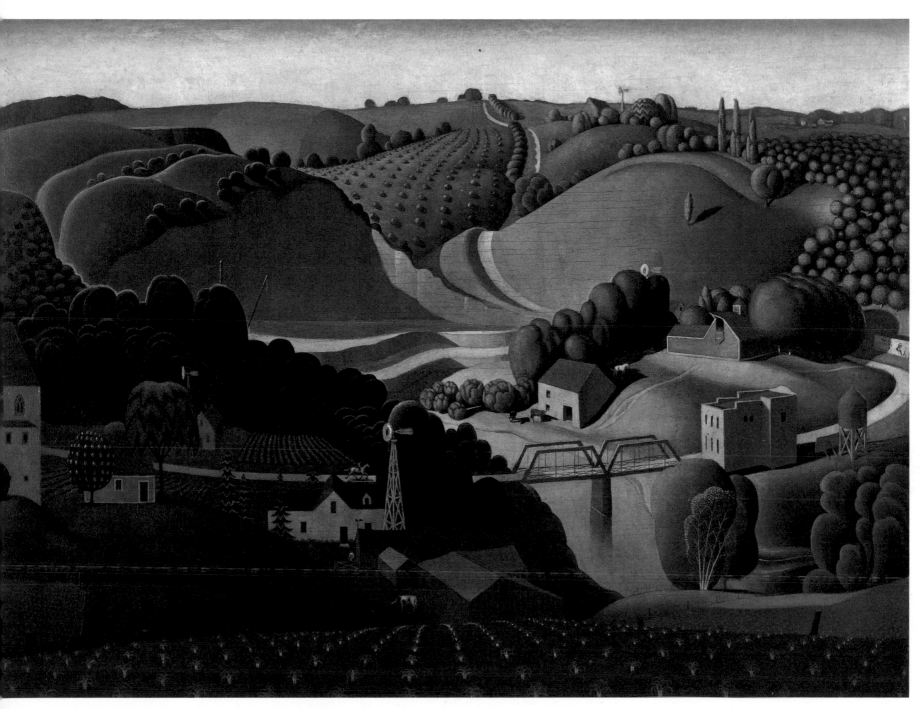

1. *Grant Wood,* Stone City, Iowa, *1930, oil on canvas, 30" x 40". Joslyn Art Museum, Omaha, Nebraska.*

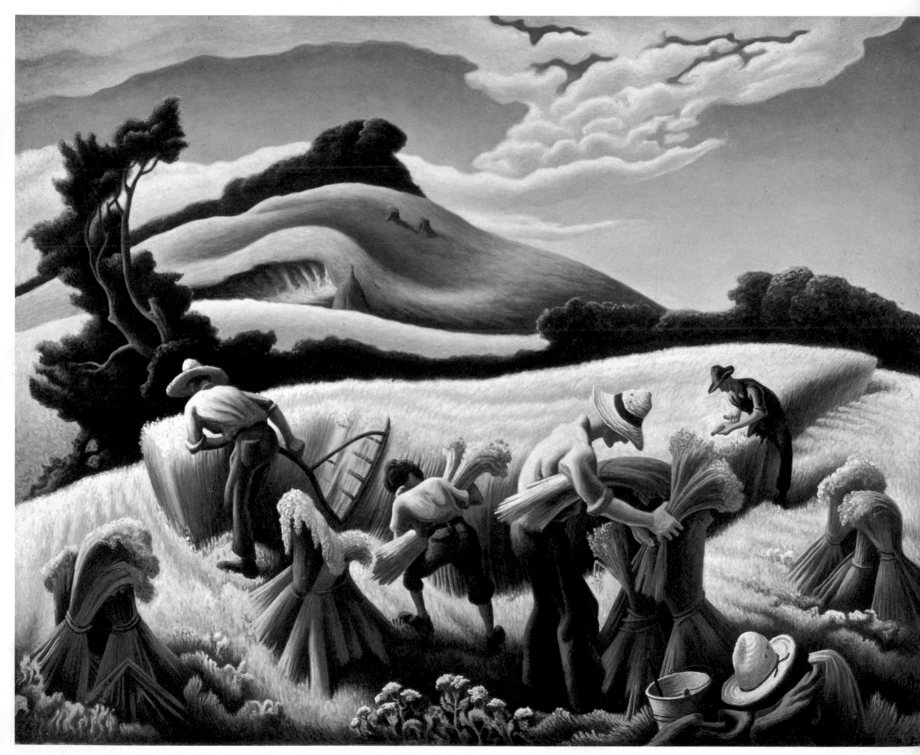

2. *Thomas Hart Benton*, Cradling Wheat, *1938, oil on canvas, 31" x 38". St. Louis Art Museum, St. Louis, Missouri.*

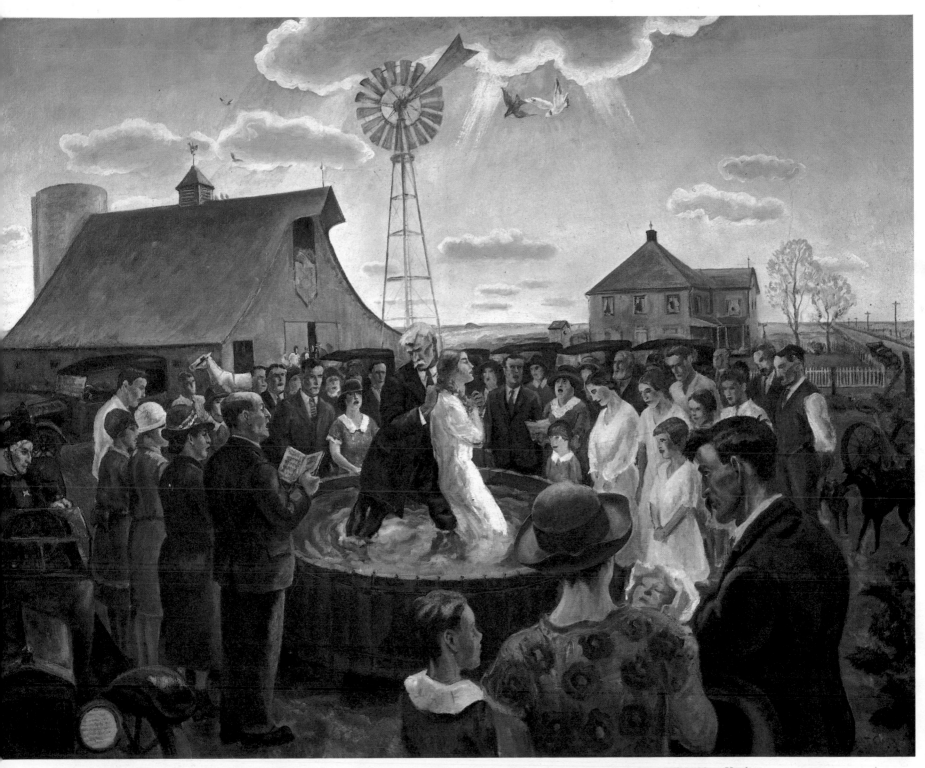

3. *John Steuart Curry*, Baptism in Kansas, *1928, oil on canvas, 40" x 50". Whitney Museum of American Art, New York, New York.*

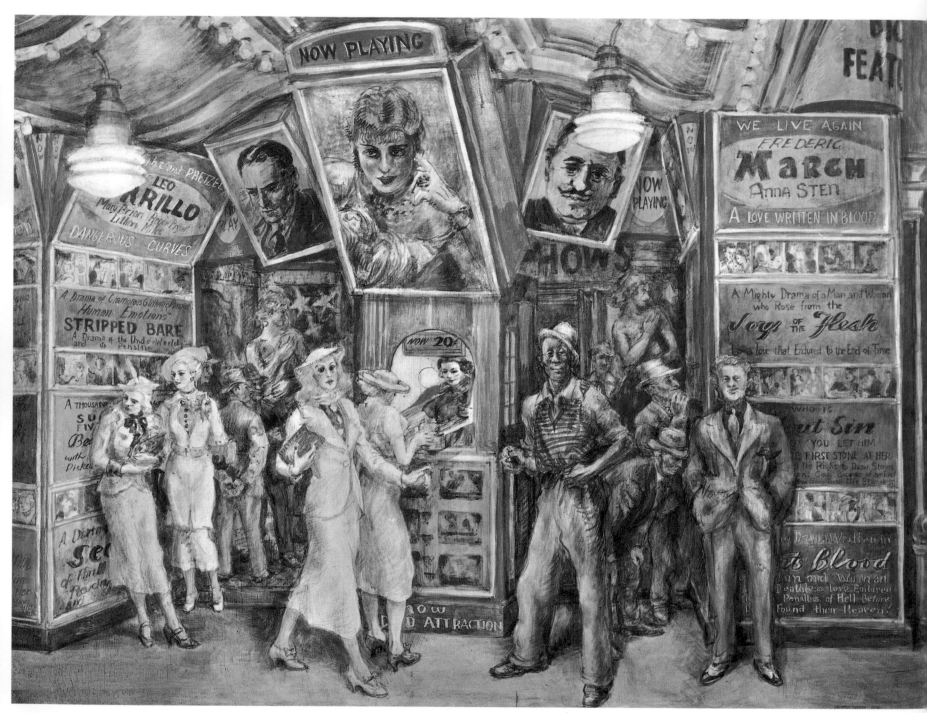

4. *Reginald Marsh*, Twenty Cent Movie, *1936, egg tempera on composition board, 40" x 40". Whitney Museum of American Art, New York, New York.*

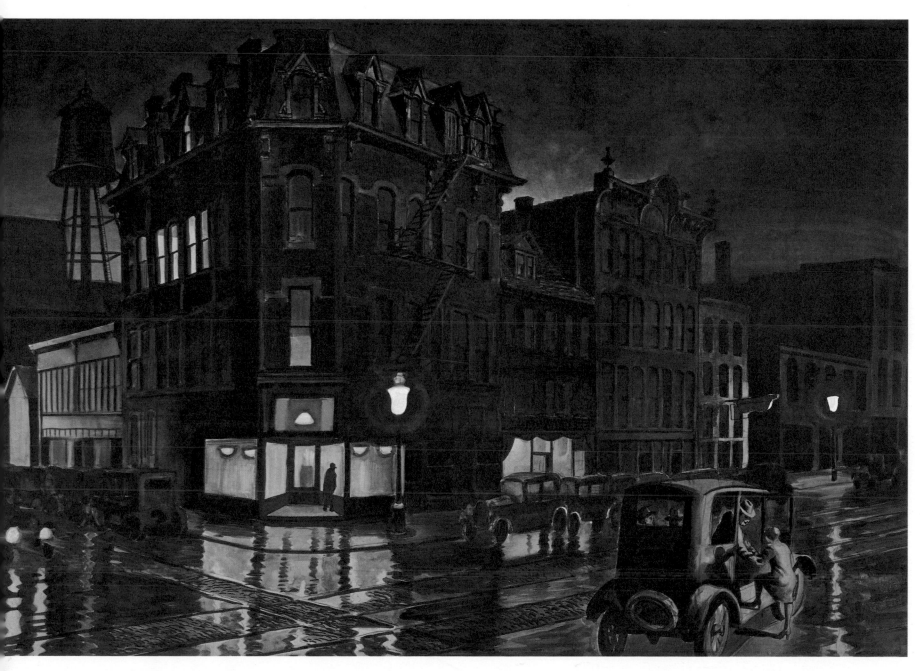

5. Charles Burchfield, Rainy Night, *1930, watercolor, 30" x 42". Fine Arts Gallery of San Diego, California; gift of Misses Anne R. and Amy Putnam.*

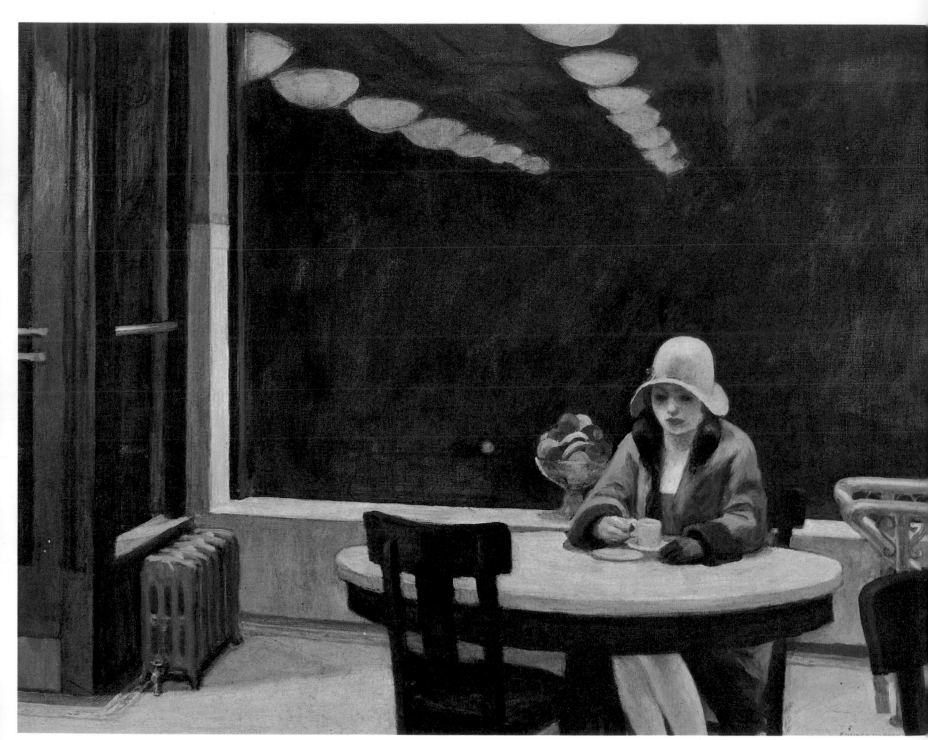

6. *Edward Hopper,* Automat, *1927, oil on canvas, 28" x 36". Des Moines Art Center, Des Moines, Iowa; James D. Edmundson Purchase Fund.*

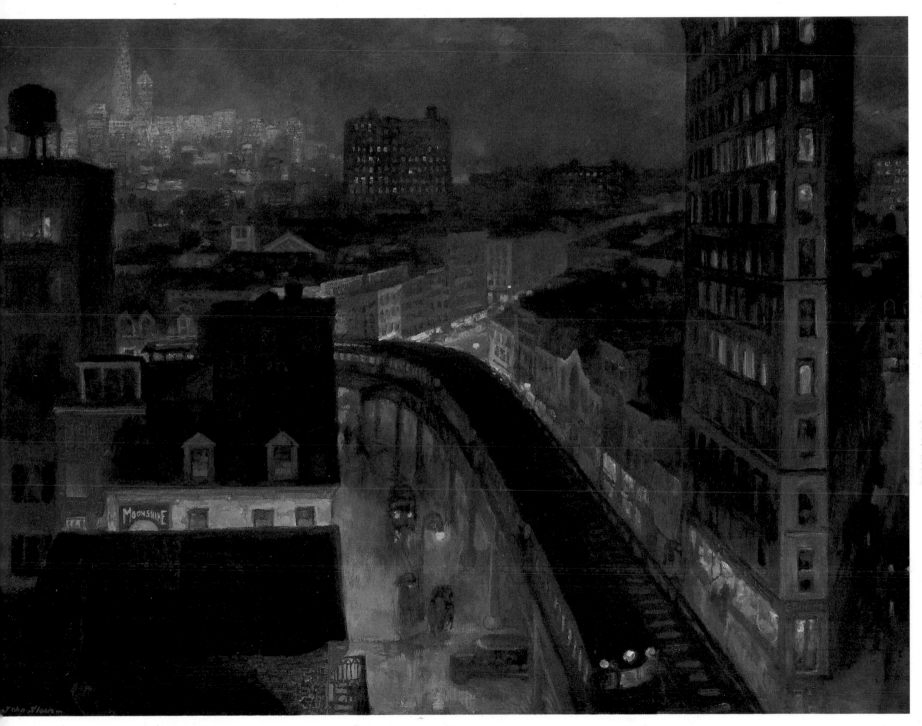

7. John Sloan, The City from Greenwich Village, *1922, oil on canvas, 26" x 34". National Gallery of Art, Washington, D.C.; gift of Helen Farr Sloan.*

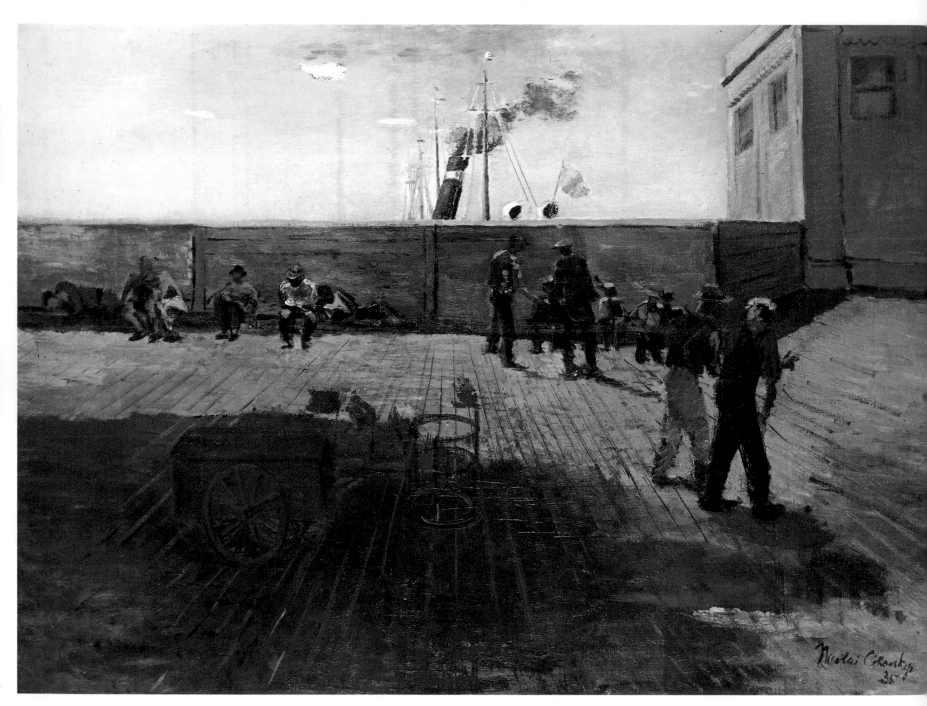

8. *Nicolai Cikovsky*, On the Riverfront, *1935, oil on canvas, 30" x 40". Courtesy ACA Galleries, New York, New York.*

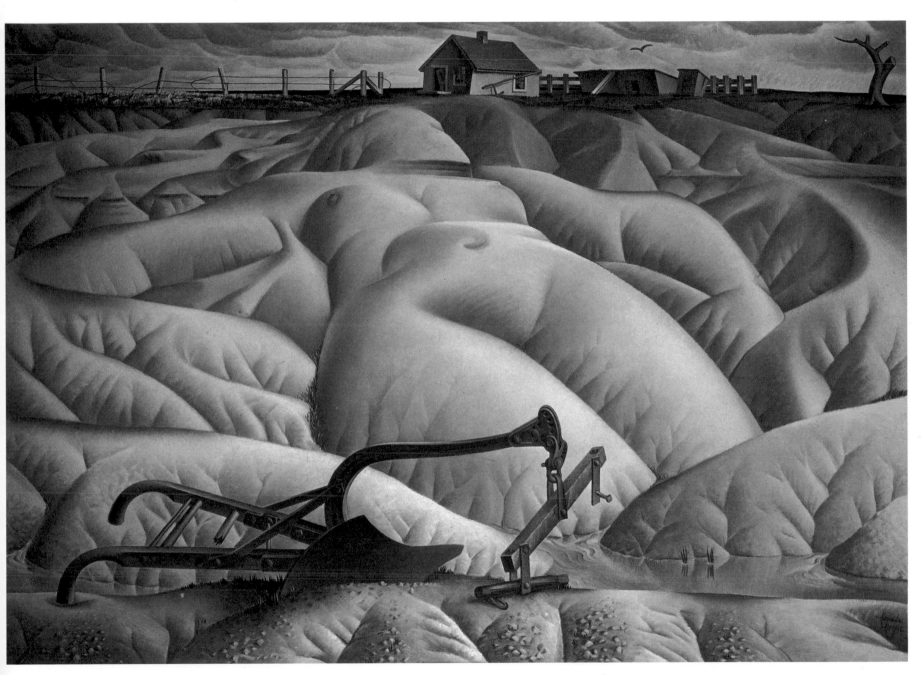

9. *Alexandre Hogue*, Erosion No. 2—Mother Earth Laid Bare, *1936, oil on canvas, 40″ x 56″. Philbrook Art Center, Tulsa, Oklahoma.*

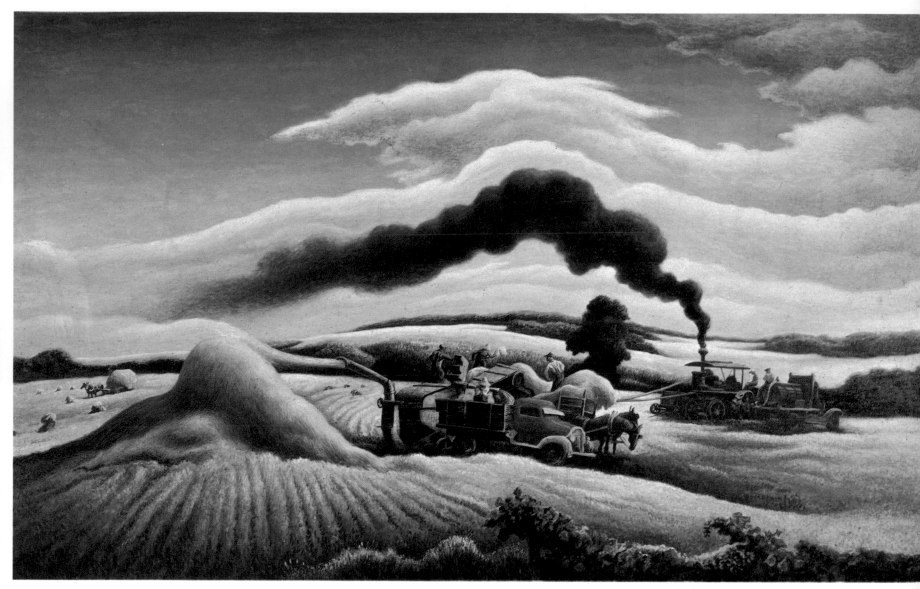

10. *Thomas Hart Benton,* Threshing Wheat, *1939, tempera, 36" x 45-1/4". The Sheldon Swope Art Gallery, Terre Haute, Indiana.*

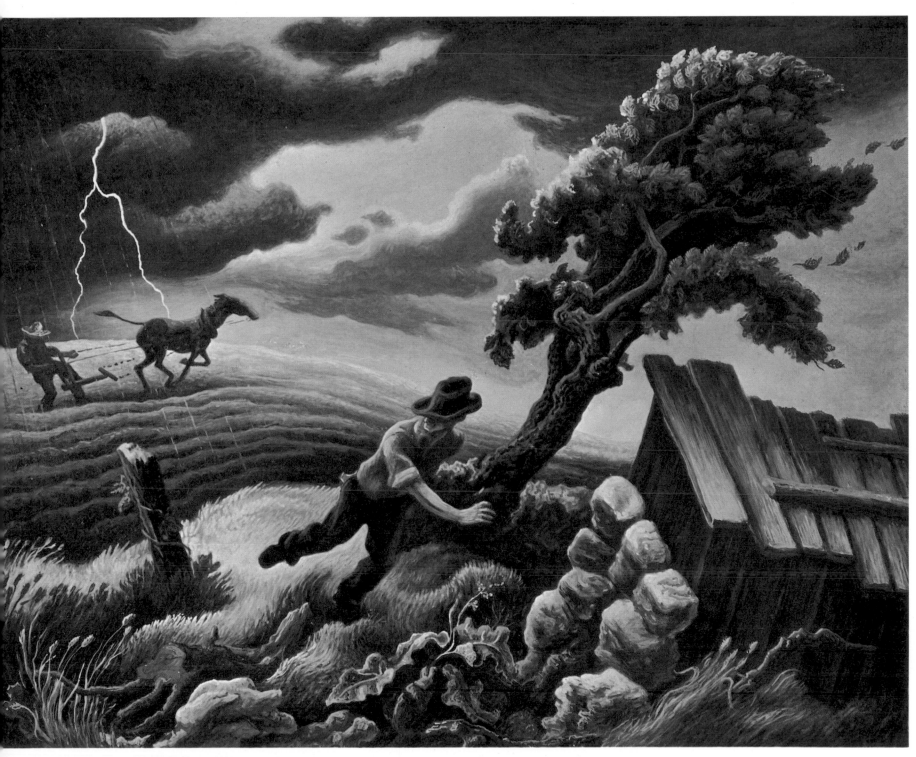

11. *Thomas Hart Benton*, The Hailstorm, *1940, tempera, 33" x 40". Joslyn Art Museum, Omaha, Nebraska.*

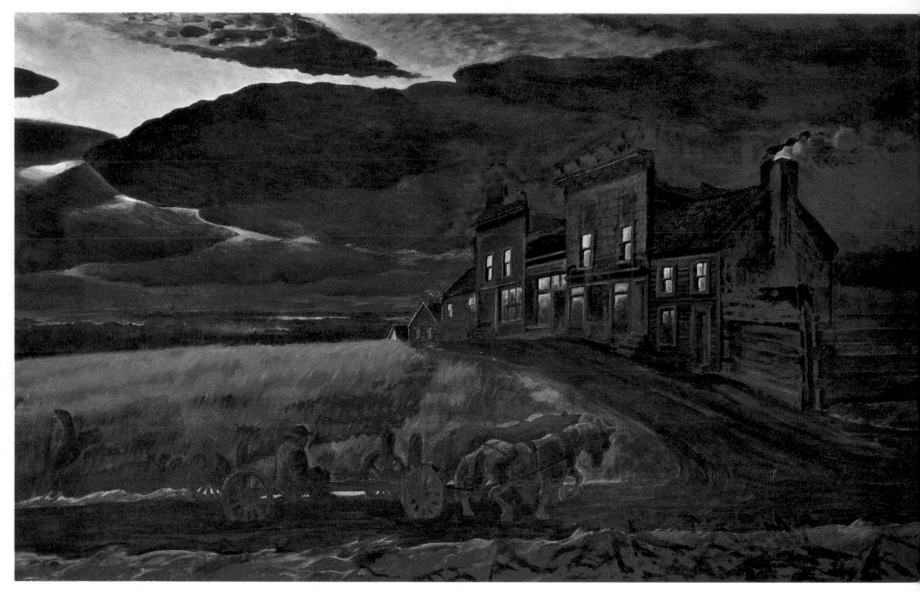

12. *Charles Burchfield,* November Evening, *1931–34, oil on canvas, 32-1/2" x 52". The Metropolitan Museum of Art, New York, New York; George A. Hearn Fund, 1934.*

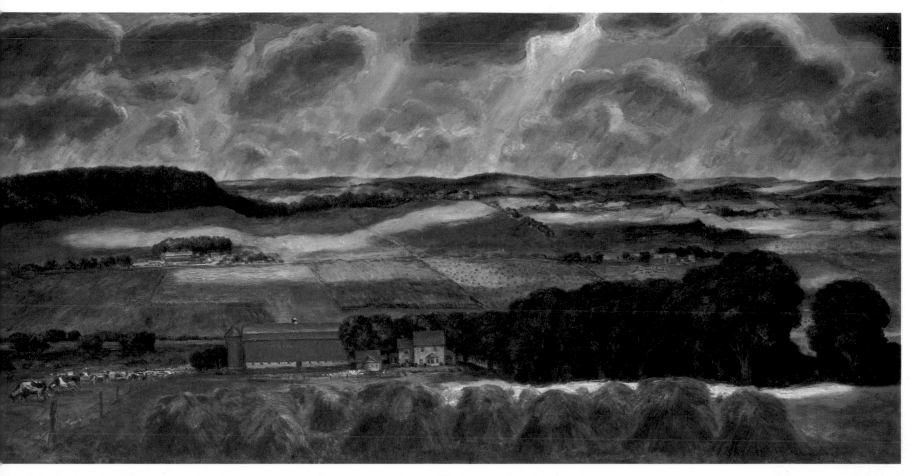

13. *John Steuart Curry*, Wisconsin Landscape, *1938–39, oil on canvas, 42″ x 84″. The Metropolitan Museum of Art, New York, New York; George A. Hearn Fund, 1942.*

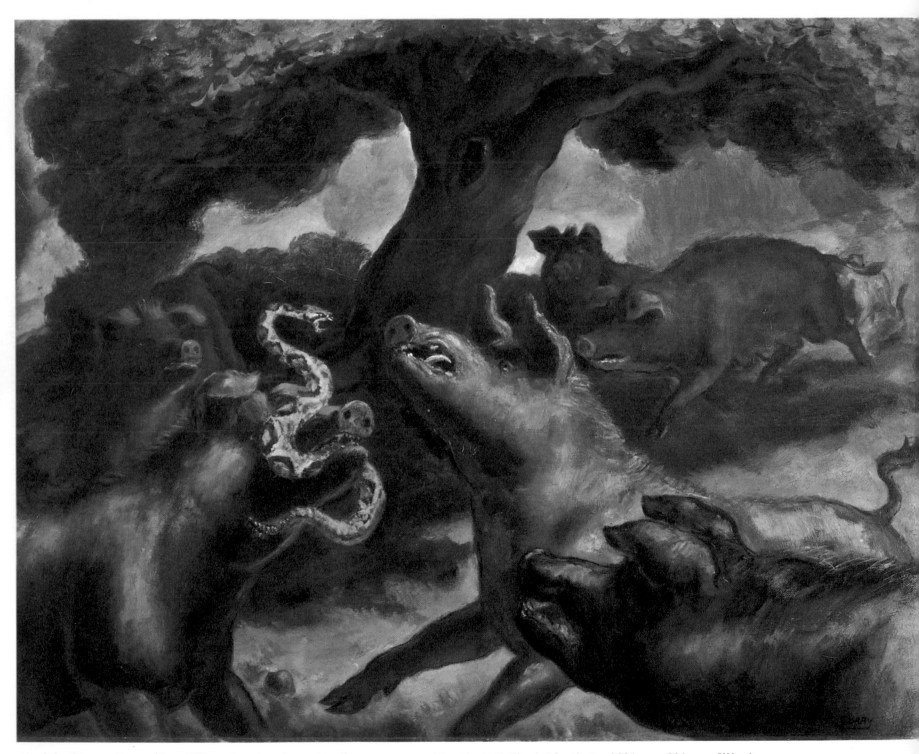

14. *John Steuart Curry*, Hogs Killing a Rattlesnake, *1930, oil on canvas, 30-3/8″ x 38-5/16″. The Art Institute of Chicago, Chicago, Illinois.*

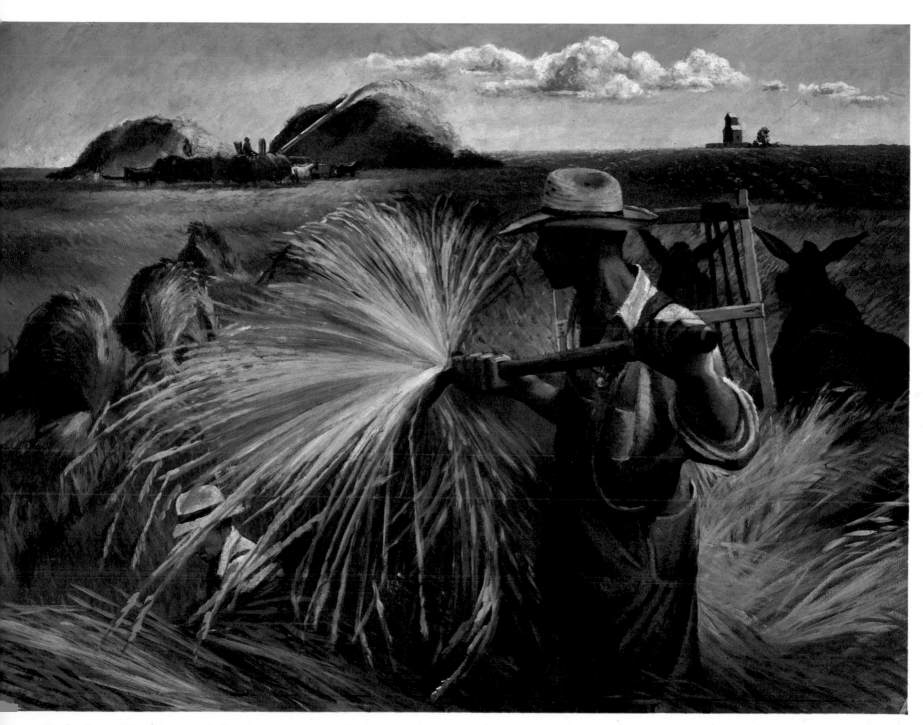

15. *Joe Jones,* Threshing, *1935, oil on canvas, 36" x 48". The Metropolitan Museum of Art, New York, New York; George A. Hearn Fund, 1937.*

16. *Alexandre Hogue*, Dust Bowl, *1933, oil on canvas, 24" x 33-1/8". National Collection of Fine Arts, Smithsonian Institution, Washington, D.C.*

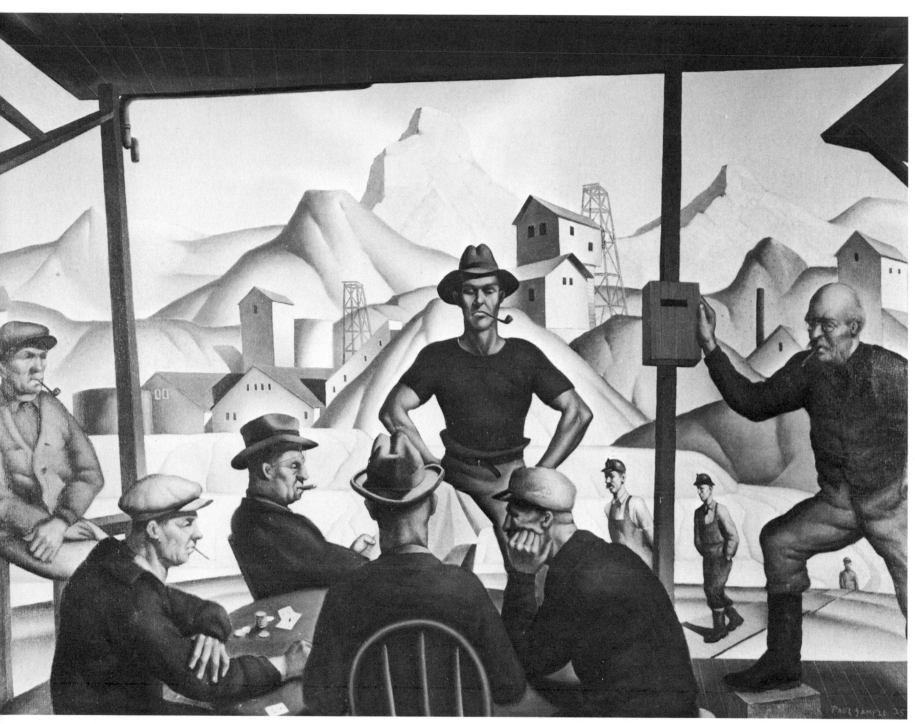

26. *Paul Sample,* Miners Resting, *1935, oil on canvas, 29″ x 38″. Sheldon Memorial Art Gallery, University of Nebraska, Lincoln, Nebraska; F. M. Hall Collection.*

27. *John Steuart Curry*, Stallion and Jack Fighting, *1930, watercolor, 22-1/4″ x 27″. Nelson Gallery, Atkins Museum of Fine Arts, Kansas City, Missouri; gift of Mr. Paul Gardner.*

28. *Edward Hopper*, Hills, South Truro, *1930, oil on canvas, 27-3/8″ x 43-1/8″. The Cleveland Museum of Art, Cleveland, Ohio; Hinman B. Hurlbut Collection.*

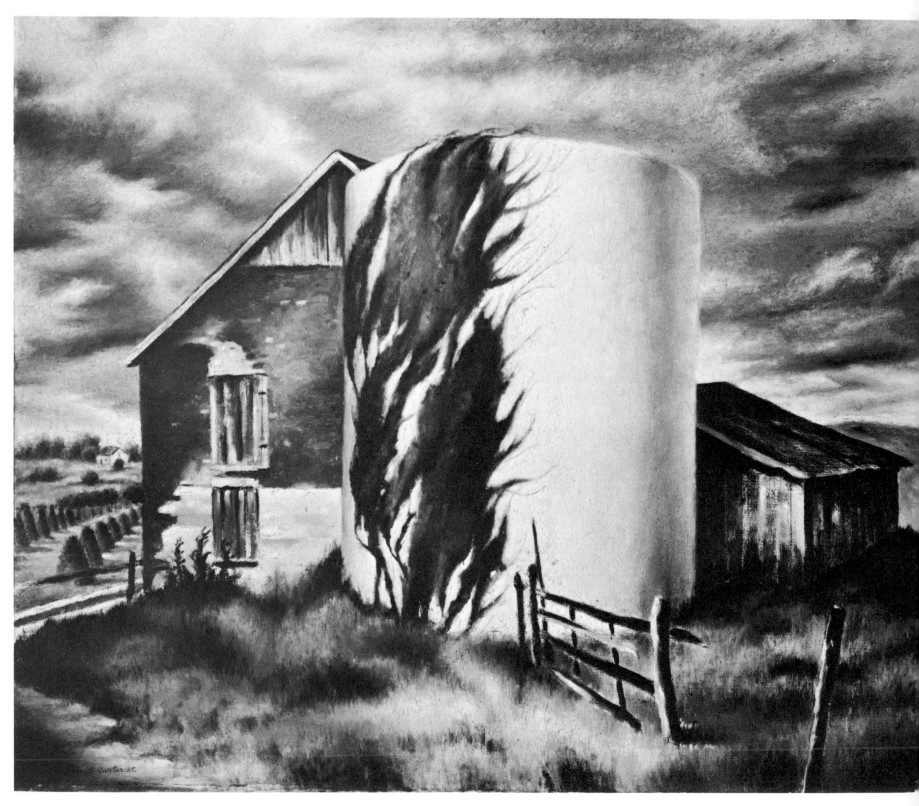

29. Clarence Carter, The Creepers, *1935, oil on canvas, 27″ x 32″. The Metropolitan Museum of Art, New York, New York; George A. Hearn Fund, 1937.*

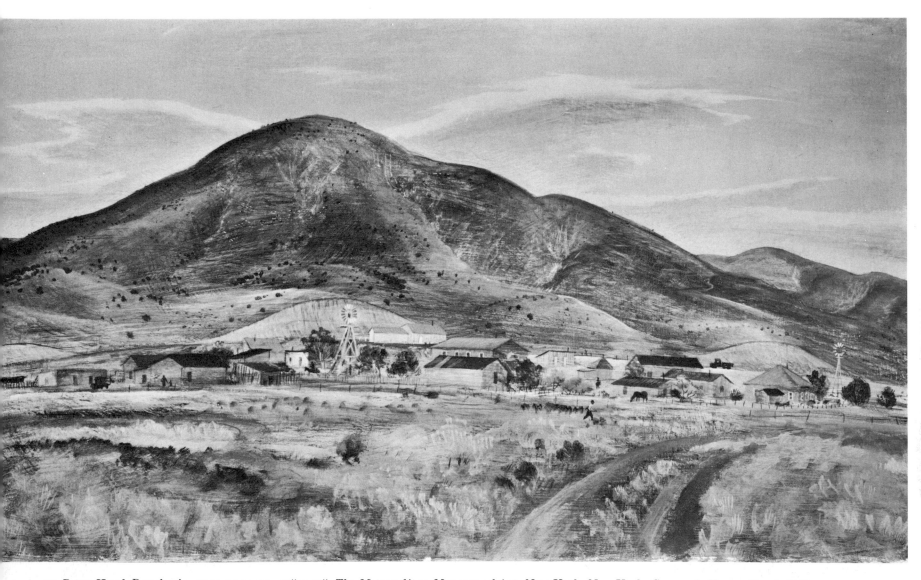

30. Peter Hurd, Rancheria, *1938, tempera, 24" x 42". The Metropolitan Museum of Art, New York, New York; George A. Hearn Fund, 1939.*

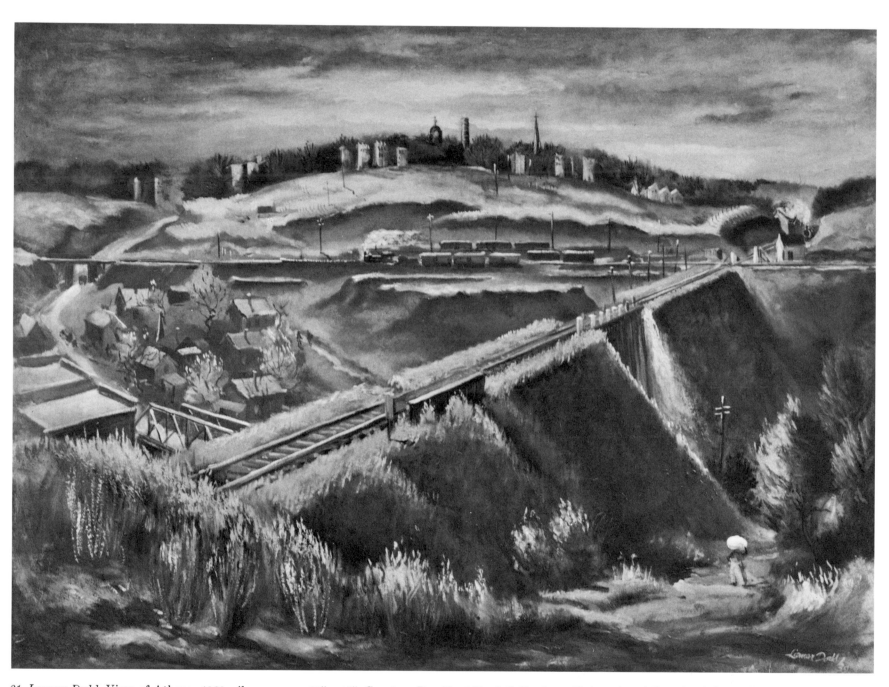

31. *Lamar Dodd,* View of Athens, *1939, oil on canvas, 30″ x 40″. Courtesy President Fred C. Davison, University of Georgia, Athens, Georgia.*

SMALL-TOWN AMERICA

"Back in 1905, in America, it was almost universally known that though cities were evil and even in the farmland there were occasionally men of wrath, our villages were approximately paradise. They were always made up of small white houses under large green trees; there was no poverty and no toil worth mentioning; every Sunday, sweet-tempered, silvery pastors poured forth comfort and learning. . . . But it was Neighborliness that was the glory of the small town. In the cities, nobody knew or cared; but back home, the Neighbors were one great big jolly family. They lent you money, without questioning, to send Ed to business college; they soothed your brow in sickness—dozens of them, twenty-four hours a day, kept charging in and soothing your brow without a moment's cessation; and when you had nevertheless passed beyond, they sat up with your corpse and your widow." (From Sinclair Lewis' Introduction the the 1937 edition of *Main Street*.)

Prior to the twentieth century, Americans generally regarded the small town as a bastion of unspoiled innocence in an increasingly urban and mechanized world. During the early 1900s, painters and writers continued to portray small towns according to this tradition, but in the second decade of the century, a significant change occurred in the way they depicted small-town America. A new kind of realism evolved, as painters and writers began to show both the relaxed, pastoral quality and the socially and intellectually limiting aspects of small-town life.

In literature, the so-called "revolt against the village," a critique of small-town life in the United States, began with Edgar Lee Masters' *Spoon River Anthology*, first published in 1915. Arranged as a series of free-verse monologs "spoken" by the inhabitants of the graves in the local cemetery above the mythical town of Spoon River, Masters' book was extremely influential. An immediate bestseller, *Spoon River* was widely read and reprinted.

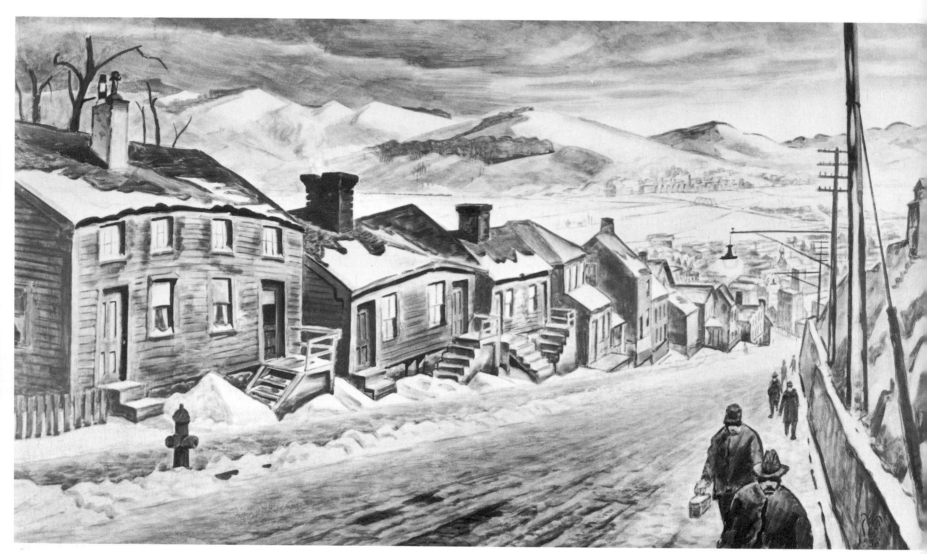

32. *Charles Burchfield,* End of the Day, *1936-38, watercolor on paper, 24" x 48". The Pennsylvania Academy of the Fine Arts, Philadelphia, Pennsylvania.*

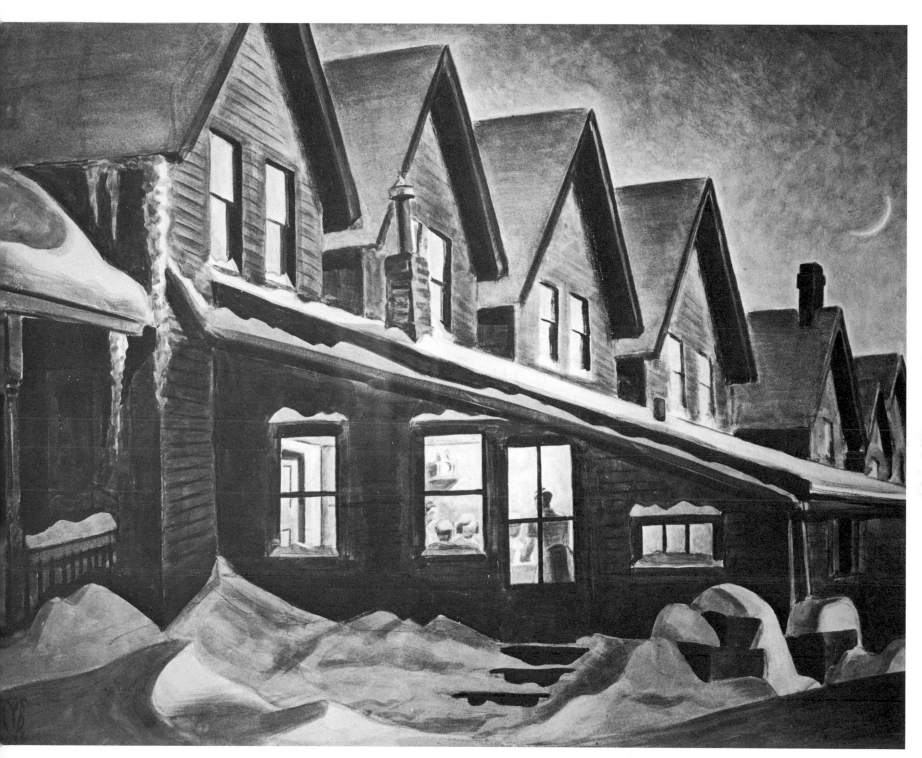

33. Charles Burchfield, Six O'Clock, 1936, watercolor, 24″ x 30″. Everson Museum of Art of Syracuse and Onondaga County, Syracuse, New York.

Spoon River exemplifies the American ambivalence toward the small town. The people whose lives Masters examines held various types of positions in life, from reverend to doctor to schoolteacher to village drunkard. Their attitudes about their former lives vary; some of the dead desperately miss the pleasures of daily life and the companionship of their loved ones. But many of the Spoon River dead are exceedingly bitter, full of unresolvable hatred toward their parents, their spouses, their hometown, and life in general. What makes Masters' poem so important in the history of American literature is precisely this exploration of the darker side of rural life.

A similar kind of ambivalence exists in the writings of Sinclair Lewis. In 1905, on a summer vacation from his studies at Yale University, Lewis visited his home in Sauk Center, Minnesota, and began writing about the American small town as he knew it. This essay eventually became Lewis' famous novel, *Main Street*, first published in 1920. Based on the same sort of love-hate relationship that Masters displayed in *Spoon River, Main Street* demonstrates that Lewis, despite his deep appreciation for the rural experience, found much to criticize in the American small town.

Lewis' heroine in the book is Carol Milford, a young woman from Minnesota who has had the benefit of a higher education at Blodgett College in St. Paul. Early in the novel, Carol marries a rural doctor, Will Kennicott, and goes to live with him in the small town of Gopher Prairie, Minnesota. The remainder of the book focuses on the difficulties of Carol's adjustment to small-town life, which she finds singularly ugly and stifling. Lewis describes his heroine's first view of Gopher Prairie as follows:

> When Carol had walked for thirty-two minutes she had completely covered the town, east and west, north and south; and she stood at the corner of Main Street and Washington Avenue and despaired.
>
> Main Street with its two-story brick shops, its story-and-a-half wooden residences, its muddy expanse from concrete walk to walk, its huddle of Fords and lumber-wagons, was too small to absorb her. The broad, straight, unenticing gashes of the street let in the grasping prairie on every side. She realized the vastness and the emptiness of the land. The skeleton iron windmill on the farm a few blocks away, at the north end of Main Street, was like the ribs

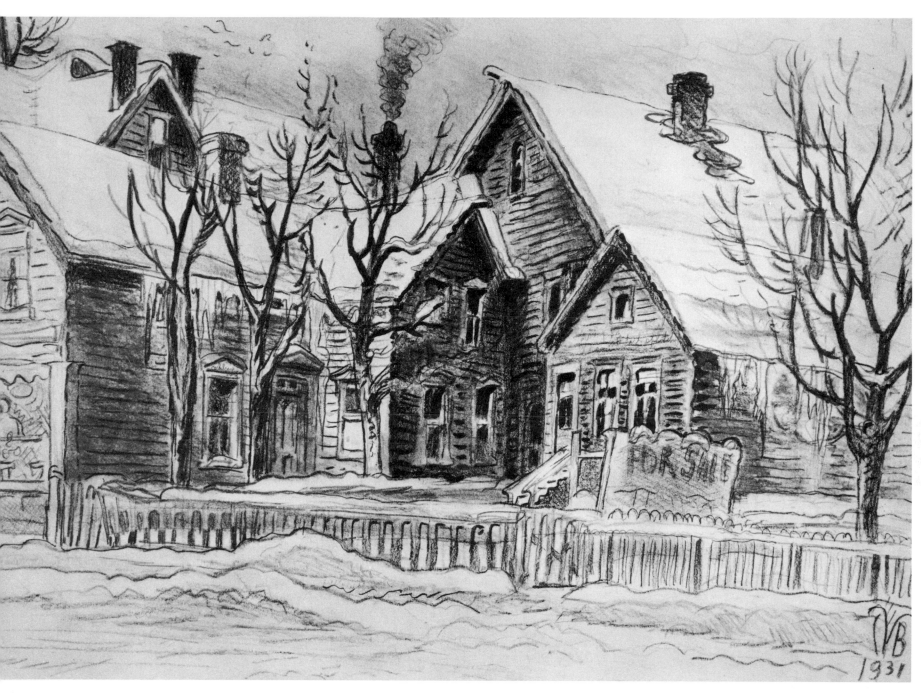

34. Charles Burchfield, Study for Winter, *1931, charcoal, pencil, and Conté crayon, 12-1/2″ x 17-3/4″. Mrs. Morris W. Primoff, New York, New York.*

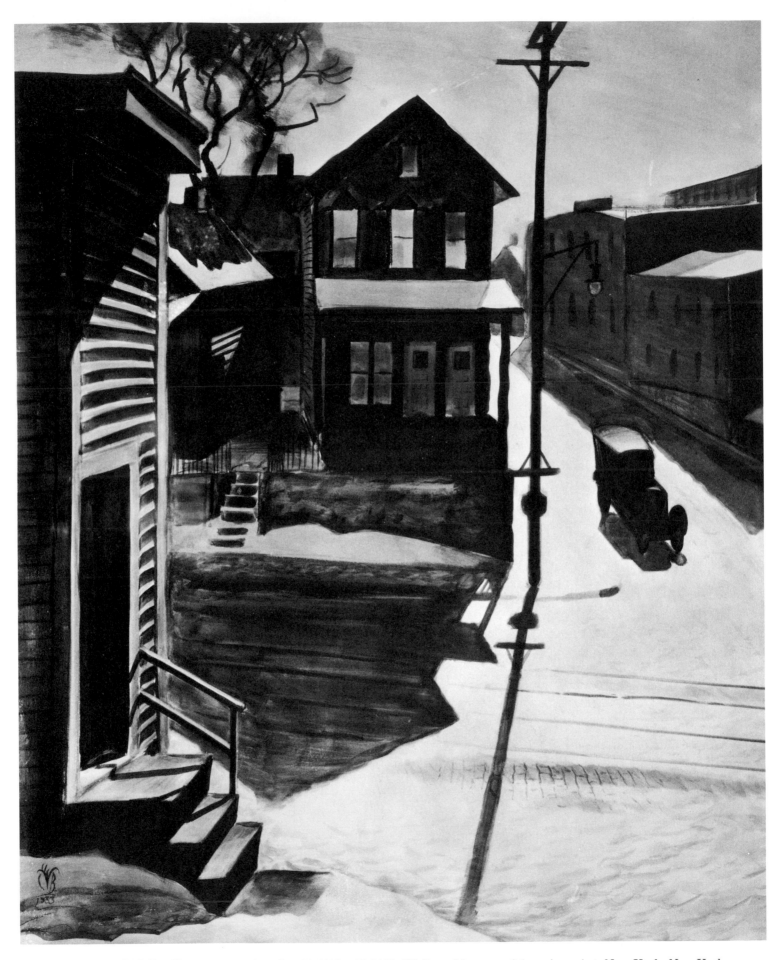

35. Charles Burchfield, *Ice Glare*, 1933, watercolor, 30-3/4" x 24-3/4". Whitney Museum of American Art, New York, New York.

of a dead cow. She thought of the coming of the Northern winter, when the unprotected houses would crouch together in terror of storms galloping out of that wild waste. They were so small and weak, the little brown houses. They were shelters for sparrows, not homes for warm laughing people.

But then Carol Kennicott never meets many "warm laughing people" in Gopher Prairie. In her eyes, the town's residents are primarily narrow-minded folk who seem to derive most of their enjoyment in life from playing bridge and criticizing their doctor's "citified" young wife.

The biting satire typically employed by Lewis in his descriptions of rural Midwestern townspeople has its visual counterpart in certain paintings by Grant Wood. Works such as his *American Gothic* (Color Plate 45) demonstrate Wood's ability to present a memorable image of the archetypal American farm couple—sturdy, hard-working, and God-fearing—whom the artist also seems to regard with some amusement. These two people are quintessential rural Americans, as can be seen from the absolute cleanliness of the farmhouse in the background, the utter clarity of the details of their clothes, plus the man's drawn and wrinkled face and the woman's worried, distracted expression.

There is a direct parallel between the works of Sinclair Lewis and Grant Wood because, in 1937, Wood supplied the illustrations for a special limited edition of *Main Street*. In one of these illustrations, *The Good Influence* (Plate 46), Wood depicts a plump woman wearing a black dress, hat, veil, and gloves, standing before a white-clapboard village church. The woman smiles as she looks at the viewer, and her smile is the self-important smirk of one who considers herself infinitely superior to the rest of the world. While not quite a caricature, this fictional portrait nevertheless contains the same sort of savage commentary that is evident in Lewis' book.

Similarly, Wood's painting of the *Practical Idealist* (Plate 45) presents the image of a woman who seems entirely too good to be true or palatable. Dressed in overwhelmingly modest and "sensible" clothing, with a dark sweater over her librarian-plain white shirt, the collar of which is fastened

36. Charles Burchfield, House of Mystery, *1924, tempera with oil glaze on composition board, 29-1/2'' x 24-1/2''.*
The Art Institute of Chicago, Chicago, Illinois; Watson F. Blair Purchase Prize.

37. Edward Hopper, House on Pamet River, *1934, watercolor on paper, 19-3/4″ x 24-7/8″. Whitney Museum of American Art, New York, New York.*

38. Charles Burchfield, The Black Barn, *1930, watercolor, 23″ x 31-1/2″. Indianapolis Museum of Art, Indianapolis, Indiana; Martha Delzell Memorial Fund.*

39. Charles Burchfield, Old House and Elm Trees, *1933-40, watercolor, 27″ x 40″. Virginia Museum of Fine Arts, Richmond, Virginia; John Barton Payne Fund.*

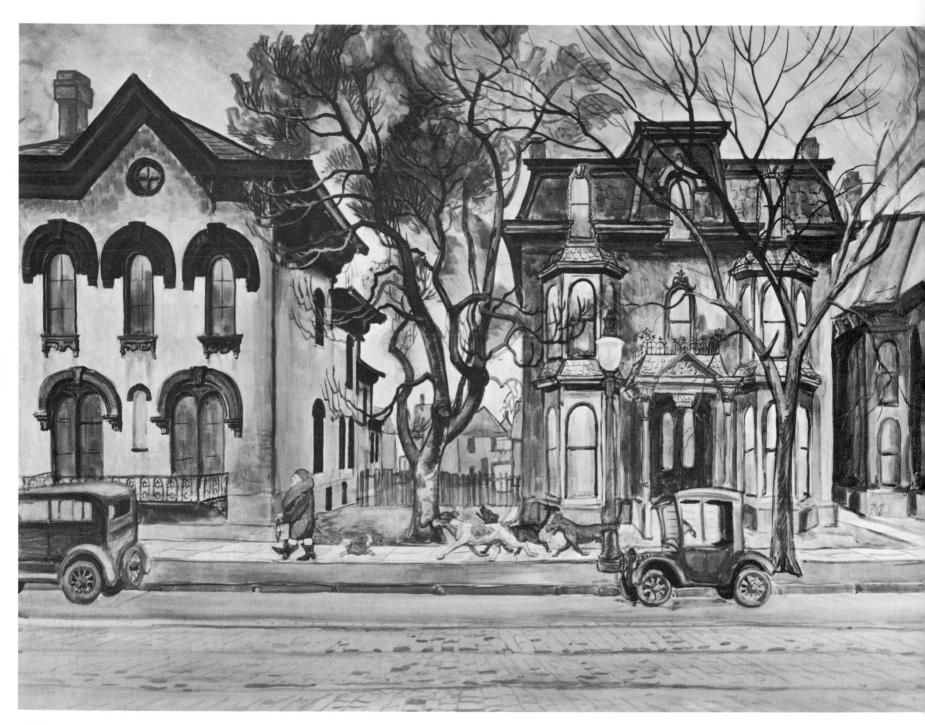

40. Charles Burchfield, Promenade, *1927-28, watercolor, 32″ x 42″. Mr. and Mrs. Theodore G. Kenefick, Buffalo, New York.*

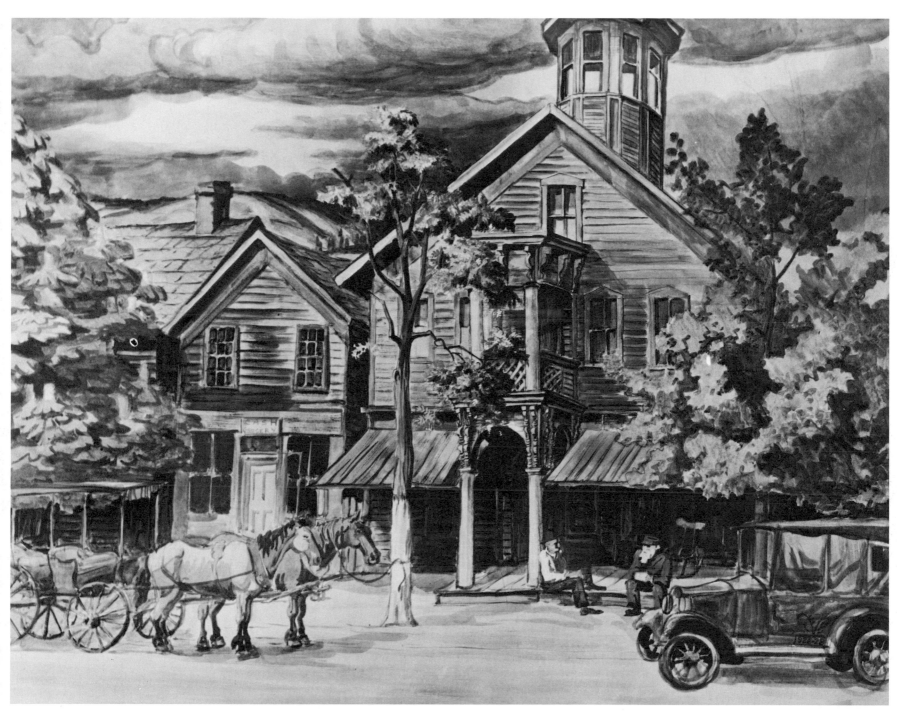

41. Charles Burchfield, Old Tavern at Hammondsville, Ohio, *1926–28, watercolor, 25-3/4″ x 33″.*
Addison Gallery of American Art, Phillips Academy, Andover, Massachusetts.

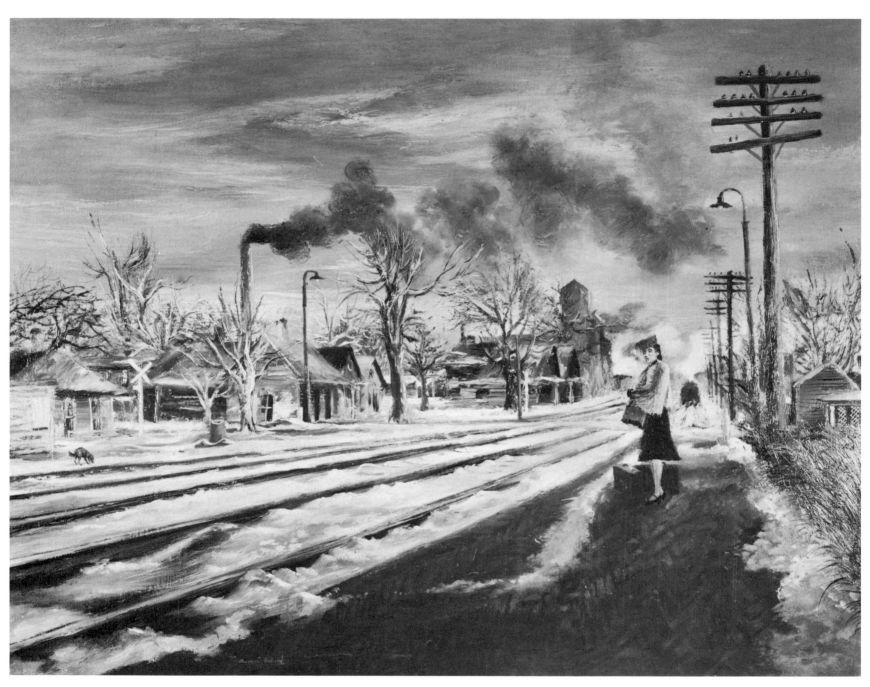

42. Aaron Bohrod, Waiting for the 3:30, *1941, oil on canvas, 27″ x 36″. Harry S. Truman Library and Museum, Independence, Missouri.*

with a simple round pin, the woman gazes out of the picture, wearing a smiling yet somehow overly pious expression; her upper body is silhouetted against some insufferably dainty wallpaper—covered with tiny polka-dots and minuscule flowers. In the images of these two women can be found all the pettiness that upset Carol Kennicott. Such pictures also represent a more general negative comment concerning the provincial, and sometimes destructive, nature of the typical American small town.

Aside from these works by Grant Wood, little American art from the features the same intensely critical commentary contained in *Spoon River Anthology* and *Main Street*. Apparently, few painters regarded small-town life with as much bitterness as Sinclair Lewis, who once referred to "the ghetto-like confinement of small towns . . . [which] so easily could be—a respectable form of hell." Nevertheless, the Regionalist painters, and other related representational artists of the time, produced many works which reflect a milder form of this new attitude toward rural life in America.

A number of Regionalist paintings portray small-town America as a cold and desolate place, with little or no reference to its inhabitants. For example, in Lamar Dodd's *View of Athens* (Plate 31), the town is merely a thin line of buildings—a few low apartment houses, some sort of tower, and a church—atop a hill. The town itself is relatively neutral in appearance, but its placement within the picture (far back in the distance, and separated from the viewer by a broad expanse of traintracks running horizontally and diagonally across the canvas) emphasizes the distant quality of the townscape. In this painting, humanity is reduced to a few barely discernible figures standing by the group of shabby houses at the left, and one tiny person in the lower right-hand corner, shouldering an enormous burden, who is completely dwarfed by the traintracks, the hill, and the weeds. While not precisely critical of village life, this picture completely lacks the attractive, inviting quality of a rural scene such as Curry's *Wisconsin Landscape* (Color Plate 13).

Charles Burchfield painted many pictures which stress the loneliness of small-town life. In his peopleless works, such as *Study for Winter* (Plate 34),

Ice Glare (Plate 35), and *House of Mystery* (Plate 36), Burchfield evokes a gray world of February weather in which the streets and sidewalks are covered with muddy snow and the empty-looking houses with shuttered windows are perpetually for sale. Even in his nonwinter scenes, Burchfield retains this feeling of ominous quiet and desolation. In *The Black Barn* (Plate 38), a portrait of an empty street and an empty building, the only sign of life is a horse and buggy tied to a telephone pole. These paintings by Burchfield also resemble the townscapes of Edward Hopper, such as *House on Pamet River* (Plate 37), where the true subject is the pattern of sunlight on the empty house's walls, rather than the unused tractor and boarded-up building

When Burchfield paints the inhabitants of his small towns, they are quite different, both from the happy rural folks depicted by Thomas Hart Benton and from the disturbingly severe, iconlike images of Grant Wood (Color Plate 21). Burchfield's people are often as desolate as his winter townscapes. In *End of the Day* (Plate 32), the workmen returning home with their lunchpails are tired, defeated-looking laborers, trudging slowly up the steep, icy hill lined with ramshackle row houses.

Burchfield's *Six O'Clock* (Plate 33) again resembles the paintings of Edward Hopper in the way the family members can be seen seated inside their home, their faces as blank as the windows in the deserted upper story. Like Hopper's people, those painted by Burchfield often seem to be waiting for something that will never arrive—as in *Old Tavern at Hammondsville, Ohio* (Plate 41), where two old men lounge on the tavern's rickety porch, near an ancient car and a horse-drawn carriage.

Other artists also painted scenes showing the less positive aspects of small towns. For example, in Aaron Bohrod's *Waiting for the 3:30* (Plate 42), a woman waits, with two shabby suitcases, on the frozen mud by the side of the snowy rails. Compared with the strong lines of the tracks and the tall street lamps and telephone poles, she seems insignificant and lonely. The only other signs of life in the painting are the smoke that billows from a chimney on the other side of the traintracks, and a lone dog grubbing in the snow. Even

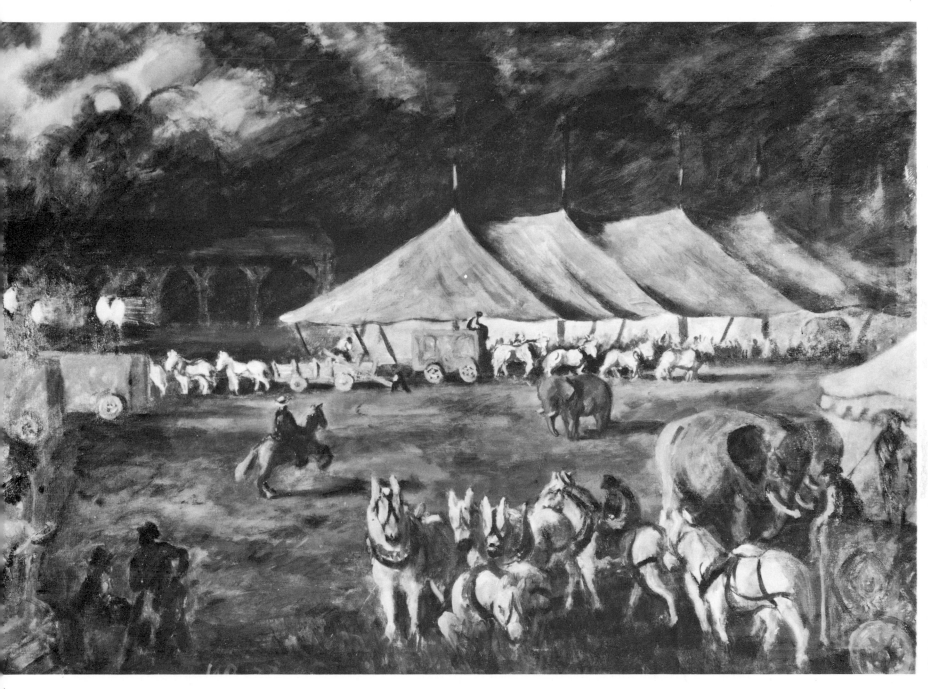

43. Waldo Peirce, After the Show, *1933, oil on canvas, 32-1/4" x 46". Whitney Museum of American Art, New York, New York.*

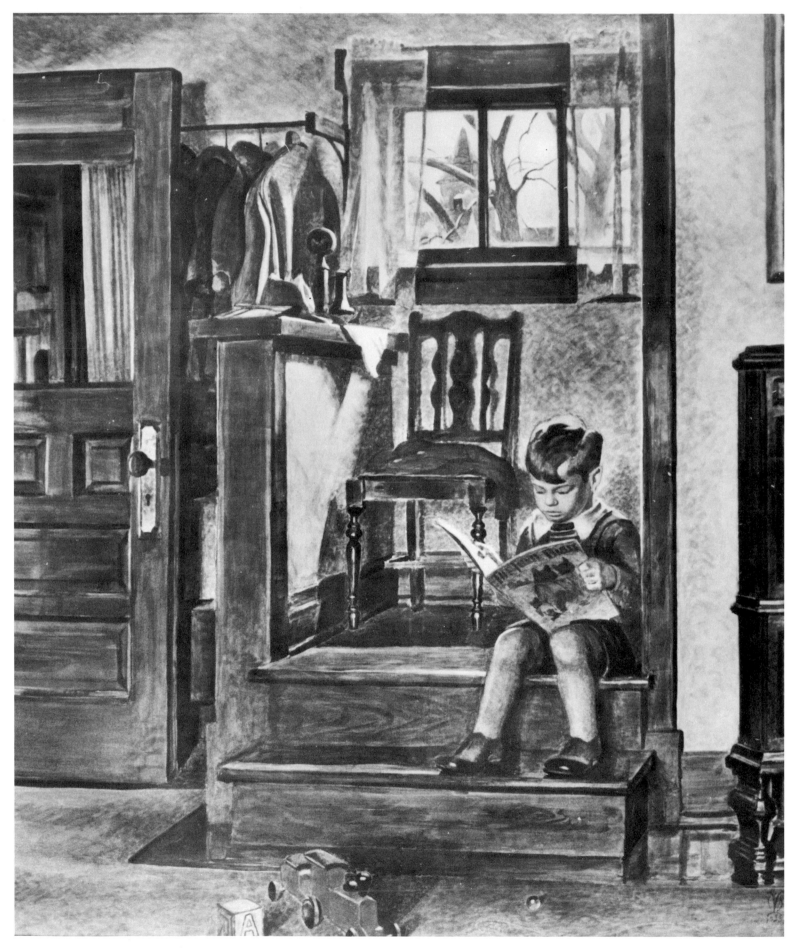

44. Charles Burchfield, Rainy Day, 1935, watercolor, 37-1/4″ x 31-1/4″. Courtesy Mr. and Mrs. C. Burchfield.

Waldo Peirce's circus scene (Plate 43), which one would expect to be a cheerful painting, emphasizes not the pleasures of watching a circus, but the sheer physical labor involved in taking down a small-time traveling show. The animals, munching on grass in the foreground or hitched in lines to pull the heavy wagon, look tired. The men, driving the animals or leaning on their tools, seem equally tired and bored. This contrasts strongly with the dynamism and excitement portrayed in John Steuart Curry's circus scenes (Plate 90) or those painted by Paul Cadmus (Plate 91).

However, much of the painting—and literature—produced in the United States during the 1930s was not critical of small towns. Concurrent with the negative attitude toward village life just described, the older tradition, which praised the American small town, continued, and grew stronger.

The chief literary expression of this rural nostalgia was Thornton Wilder's play *Our Town*, first performed in 1938. Wilder's play purports to describe several ordinary days in the small town of Grover's Corners, New Hampshire, during the first decades of the twentieth century. Grover's Corners is the classic example of the American small town. It has one doctor, and a newspaper that comes out twice a week and discusses primarily social and agricultural items of local interest. Milk is delivered door-to-door in a horse-drawn cart; and everyone knows everyone else—indeed, the natives are proud that the names on the oldest tombstones in the graveyard are the same as those in the current phonebook.

The action of the play consists of events that might occur in any town: people are born, others die; couples get married, or are disappointed in love. Most important, everyone stays in Grover's Corners, so that the continuity of the cast—and of town life—is preserved. The homey quality of *Our Town* is reinforced in the third act when Emily Gibbs, who has just died in childbirth, finds herself among the dead of Grover's Corners. Although the concept of a graveyard filled with people one has known before, people who have things to say, is undoubtedly related to Masters' *Spoon River*, the atmosphere of the Grover's Corners cemetery is entirely different. Whereas the Spoon River

dead railed for eternity against the stupidity and injustice of their earthly lives, Grover's Corners' departed souls continue to act exactly as they did when they were alive, talking laconically about the weather, the crops, and recounting local gossip. Sitting in the graveyard, Emily laments that living people never realize how marvelous even the simplest aspects of life are—ordinary things like "clocks ticking . . . and sunflowers. And food and coffee. And new-ironed dresses and hot baths . . . and sleeping and waking up."

Our Town also includes a few negative aspects of small-town life, such as complaints that the recent influx of automobiles has made the town's streets dangerous. Even as *Our Town* sings the praises of the American small town, the people are aware that it is quickly becoming obsolete.

It is precisely this kind of threat to the village from contemporary evils such as overpopulation, industrialization, and urban sprawl—not to mention the more specific threats of the thirties (war and economic depression)—that encouraged the production of artwork that looks back with fondness on a simpler time that can never be recaptured or repeated. A significant number of these positive depictions of small-town life appeared in American painting during the 1930s.

Although Charles Burchfield produced many dreary small-town pictures, he also painted some attractive views of village life such as *Promenade* (Plate 40), *The Great Elm* (Plate 87), and *Backyards in Spring* (Plate 88). In *Promenade*, a stout woman dressed in winter boots and a fur-trimmed coat walks her tiny dog beside a line of Victorian gingerbread houses. Three larger dogs, presumably neighborhood mutts, follow this comical pair with great interest. The other two Burchfield works explore summer and spring, emphasizing the lushness of nature, rather than its potential bleakness.

Working in a similar vein, many other Regionalist painters produced fondly appreciative or nostalgic small-town views. Even Grant Wood, who as we have seen was capable of producing works which savagely criticized village people, also painted a large number of happy small-town pictures, such as *Spring in Town* (Color Plate 47).

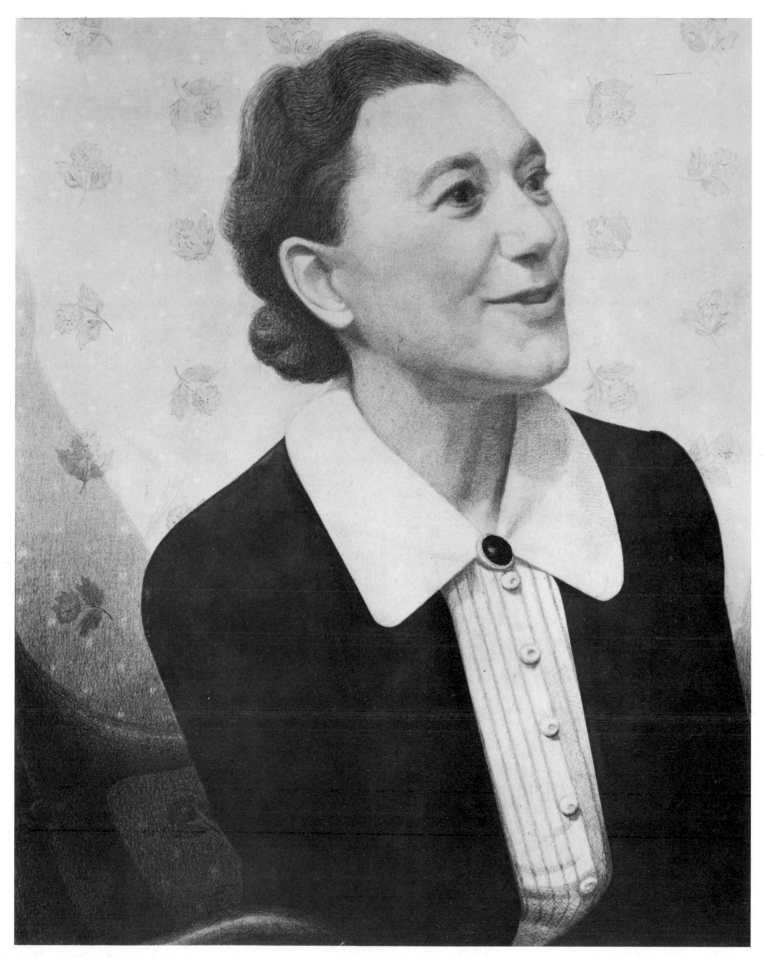

45. Grant Wood, Practical Idealist, *1936, crayon on paper, 20-1/2″ x 16″. Private collection. Courtesy Associated American Artists.*

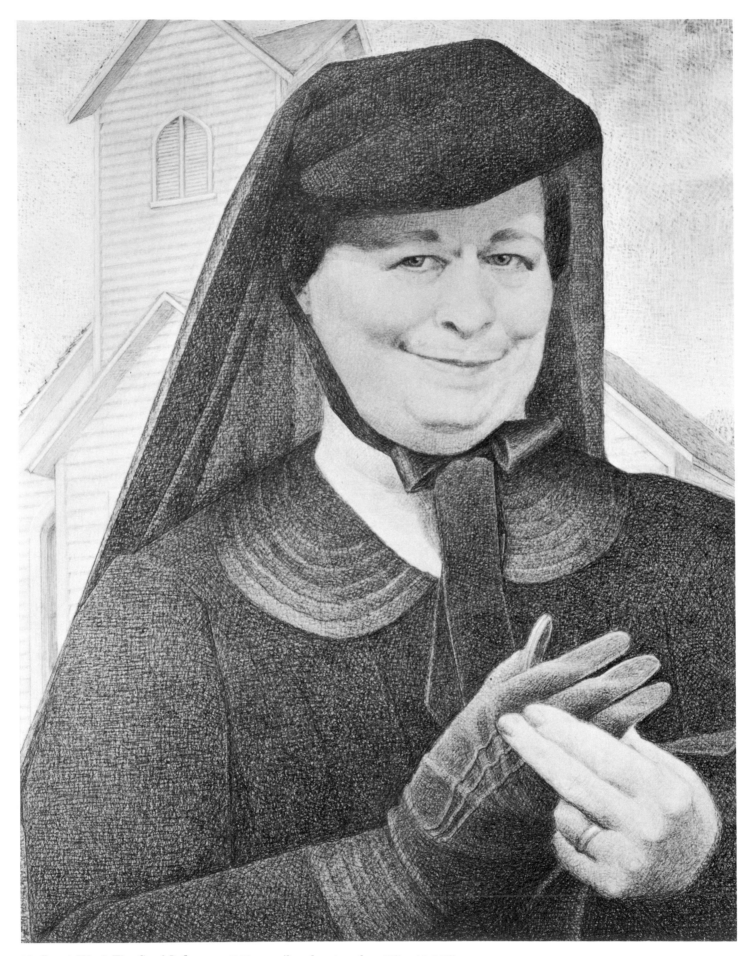

46. Grant Wood, The Good Influence, *1936, pencil and watercolor, 20" x 16-1/2".*
The Pennsylvania Academy of the Fine Arts, Philadelphia, Pennsylvania.

It should not be surprising to find Wood working in these two different manners. His ambivalent attitude toward the American village, like that of many of his fellow painters, was related to his own love-hate relationship with small towns.

Many of the Regionalist artists who painted small-town scenes were extremely sophisticated, well-traveled, highly educated people, who also happened to love certain aspects of village life. After all, Benton, Curry, and Wood were hardly country "hayseeds"; these men all studied art in Europe, taught at major American universities, and were the subjects of considerable publicity. Benton, in particular, wrote a great deal, including two autobiographies that comment extensively on American art. Other lesser known Regionalists were equally cosmopolitan.

The paintings produced by many of these artists reflect their keen awareness of the deficiencies of village living. And yet, at the same time, their work reveals an inherent appreciation for the positive aspects of American small-town life.

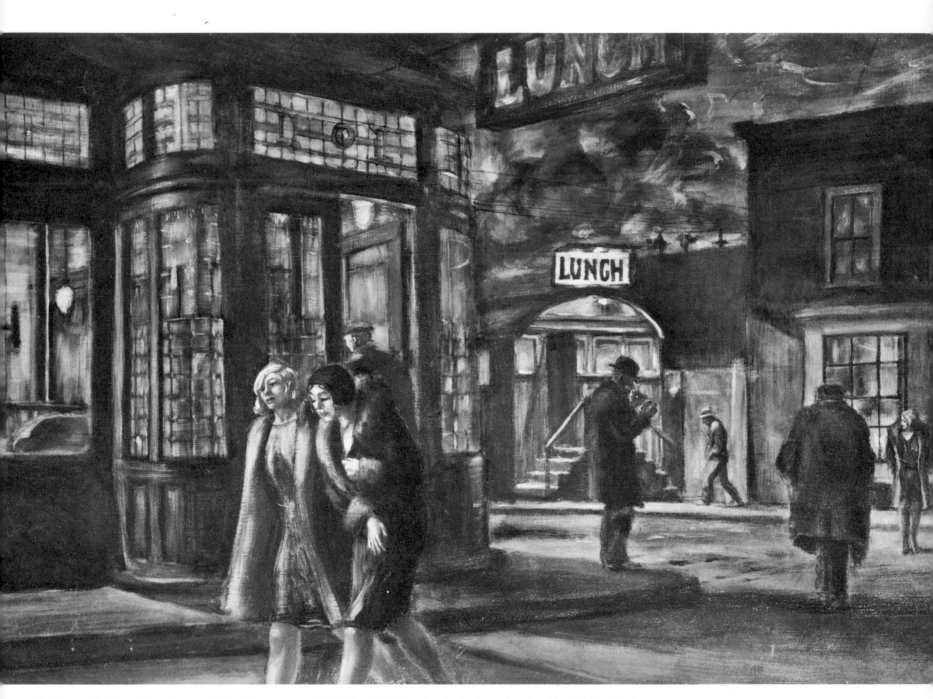

47. *Reginald Marsh, Lunch, ca. 1927, oil on canvas, 23-7/8″ x 36″. Mrs. Reginald Marsh, New York, New York.*

IV

URBAN AMERICA

" 'Do you know how long God took to destroy the tower of Babel, folks? Seven minutes. Do you know how long the Lord God took to destroy Babylon and Nineveh? Seven minutes. There's more wickedness in one block in New York City than there was in a square mile in Nineveh, and how long do you think the Lord God of Sabbaoth will take to destroy New York City . . .?" Seven seconds.' "

So says a tramp, one of the characters in John Dos Passos' 1925 novel *Manhattan Transfer*. Despite its melodramatic tone, this comment reflects a relatively widespread view of the American city. The concept of the city as an irredeemably evil place, filled with murderers and filth, is time-honored, extending back well beyond Biblical times. Indeed, the image of the Evil City persists today, and is frequently invoked by the nonurban population to try and dissuade their youth from venturing forth into these dens of iniquity.

But people have always flocked to the cities, despite news features about the grisly crimes committed there, the rampant political corruption, and the debilitating effects of continued exposure to pollution, noise, and intense social and economic competition. People come to the cities because they believe in the other major urban myth: the myth of the city as a magical place. For them, the city is an incomparably enchanting place, with limitless opportunities, where small businessmen can achieve unprecedented levels of success and poor Midwestern secretaries can meet and marry sophisticated millionaires. The city, according to this view, is a rich and exciting place, the headquarters of high fashion, where every imaginable kind of service and product is readily available.

In a 1907 letter to his novelist brother Henry, the American psychologist William James followed an American tradition by insisting the city is dangerous and corrupt, while continuing to live and work there. James com-

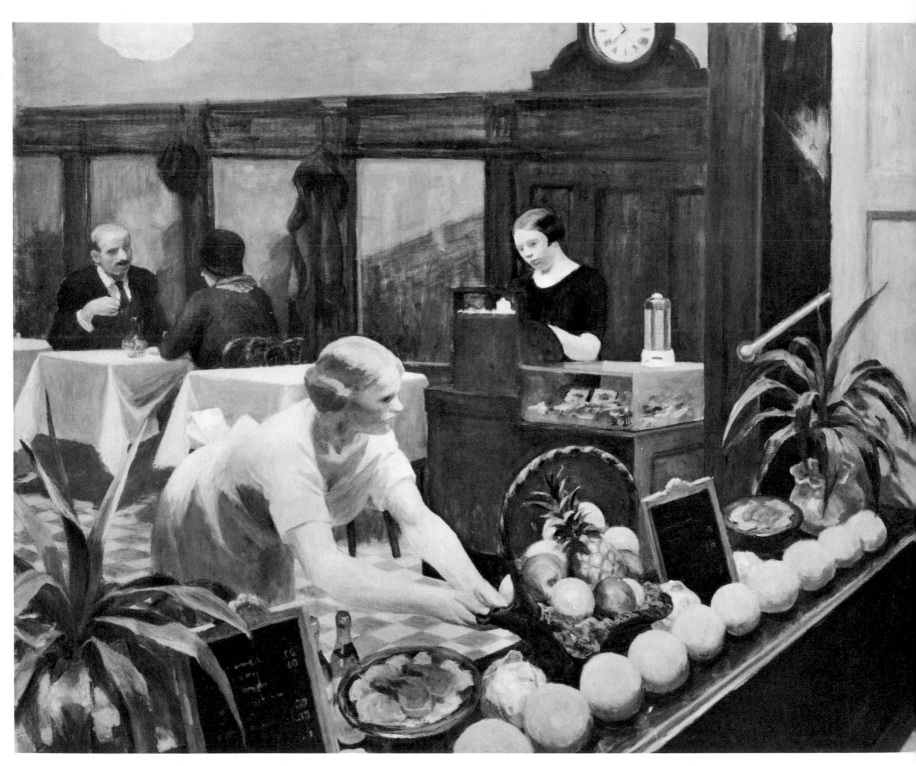

48. *Edward Hopper,* Tables for Ladies, *1930, oil on canvas, 48-1/4″ x 60-1/4″. The Metropolitan Museum of Art, New York, New York; George A. Hearn Fund, 1931.*

17. *Clarence Carter,* Jane Reed and Dora Hunt, *1941, oil on canvas, 36" x 45". Museum of Modern Art, New York, New York.*

18. Clarence Carter, The Guardian Angel, *1936, watercolor on paper, 21-1/2" x 14-1/2". Whitney Museum of American Art, New York, New York.*

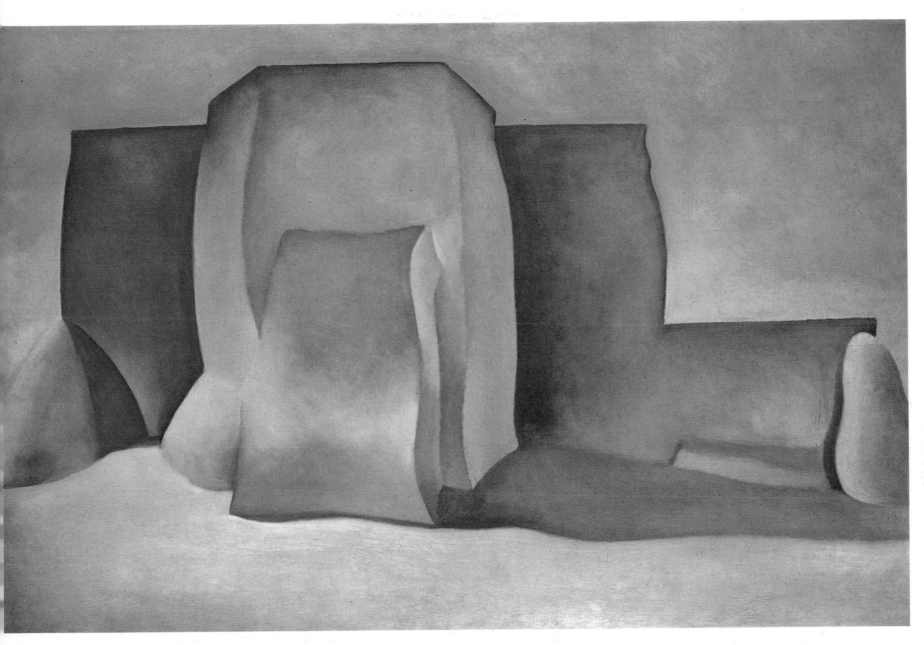

19. *Georgia O'Keeffe*, Ranchos Church, *1929, oil on canvas, 24" x 36". The Phillips Collection, Washington, D.C.*

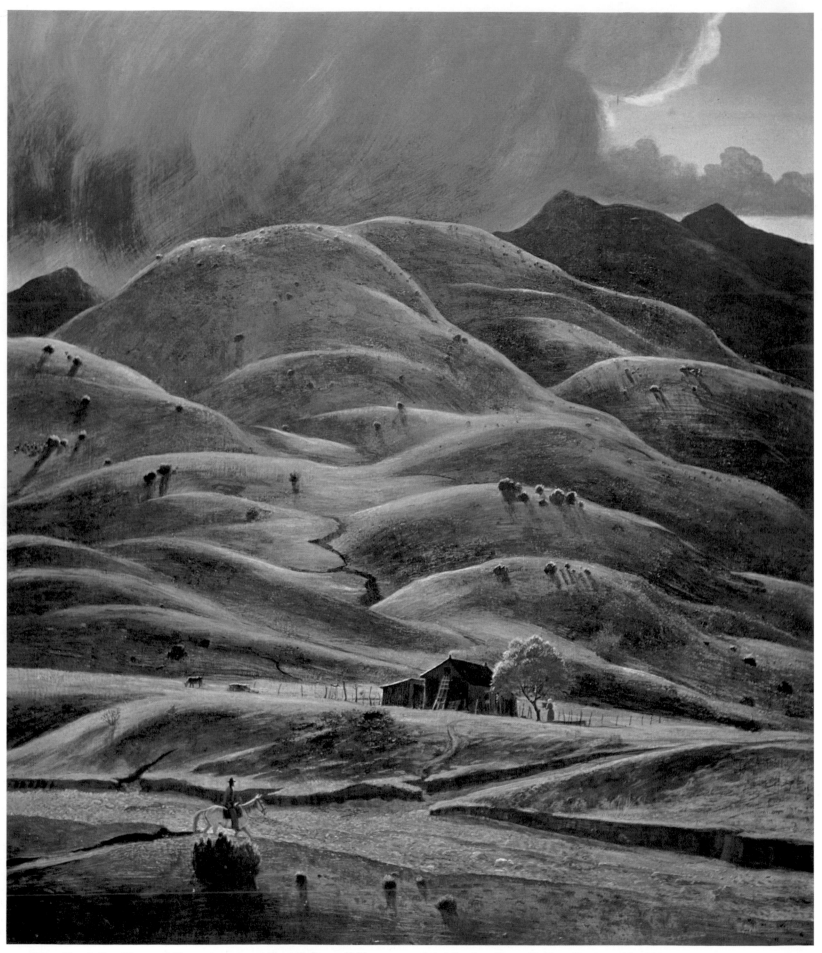

20. Peter Hurd, Dry River, *1938, egg tempera, 48" x 42". Roswell Museum and Art Center, Roswell, New Mexico; gift of Mr. and Mrs. Daniel Longwell.*

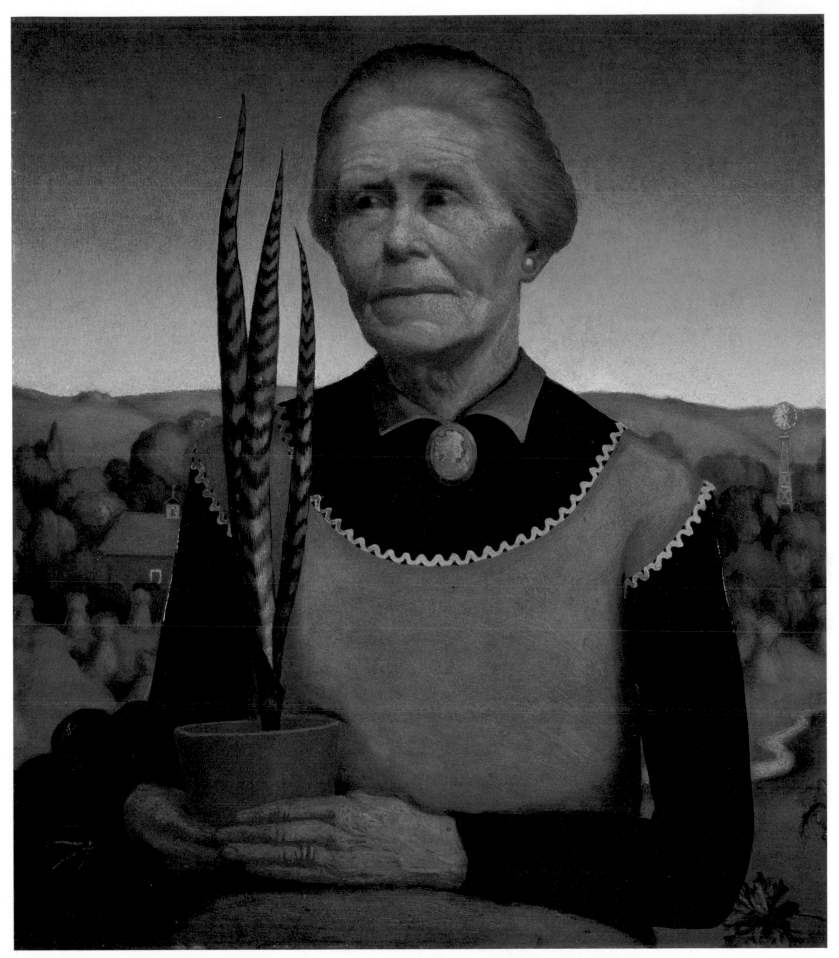

21. *Grant Wood*, Woman with Plants, *1929, oil on canvas, 20-1/2" x 17-1/2". Cedar Rapids Art Center, Cedar Rapids, Iowa.*

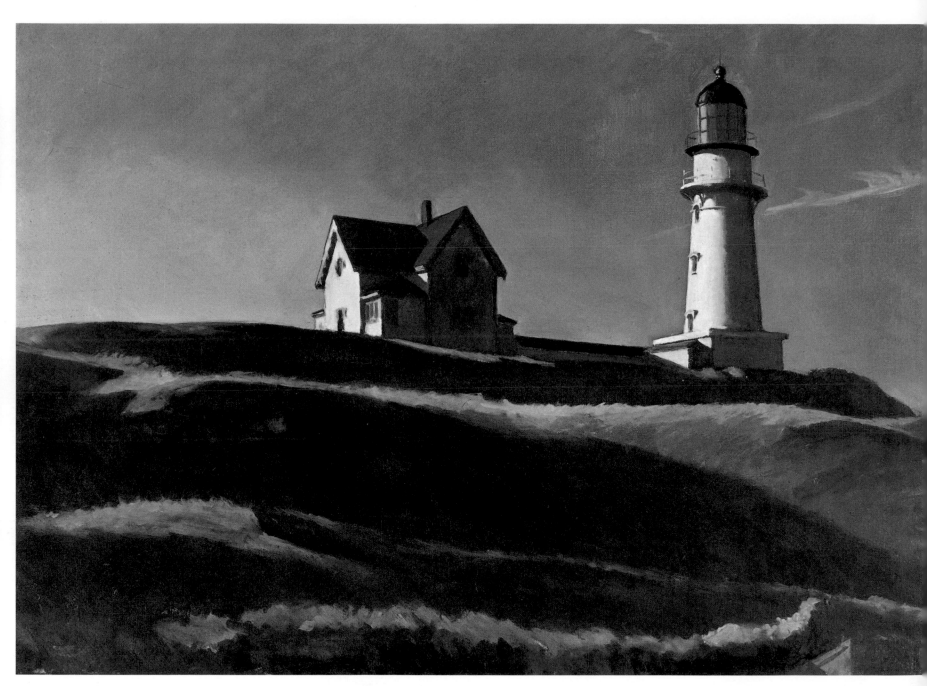

22. *Edward Hopper,* Lighthouse Hill, *1927, oil on canvas, 28-3/4" x 40-1/8". Dallas Museum of Fine Arts, Dallas, Texas; gift of Mr. and Mrs. Maurice Purnell.*

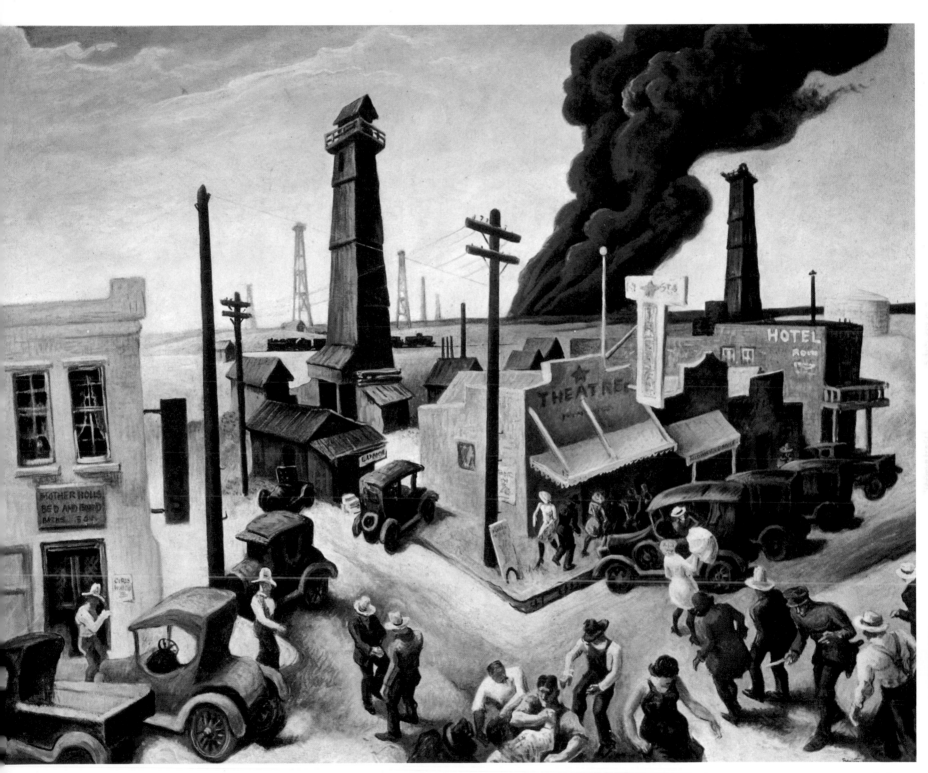

23. *Thomas Hart Benton,* Boomtown, *1928, oil on canvas, 45" x 54". Memorial Art Gallery of the University of Rochester, New York; Marion Stratton Gould Fund.*

24. *Alexander Brook,* Twentieth Century Ruin, *1932, oil on canvas, 25-3/4" x 35-7/8". The Art Institute of Chicago, Chicago, Illinois.*

25. *Aaron Bohrod,* Landscape near Chicago, *1934, oil on composition board, 24" x 32". Whitney Museum of American Art, New York, New York.*

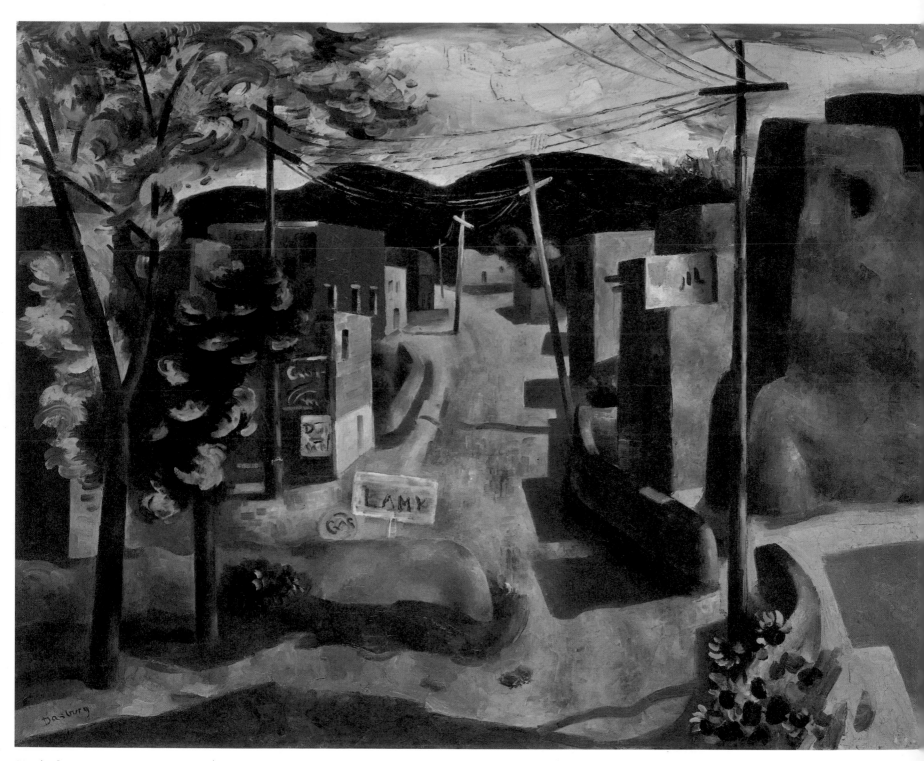

26. *Andrew Dasburg*, Road to Lamy, *1923, oil on canvas, 24" x 29-1/2". The Metropolitan Musem of Art, New York, New York.*

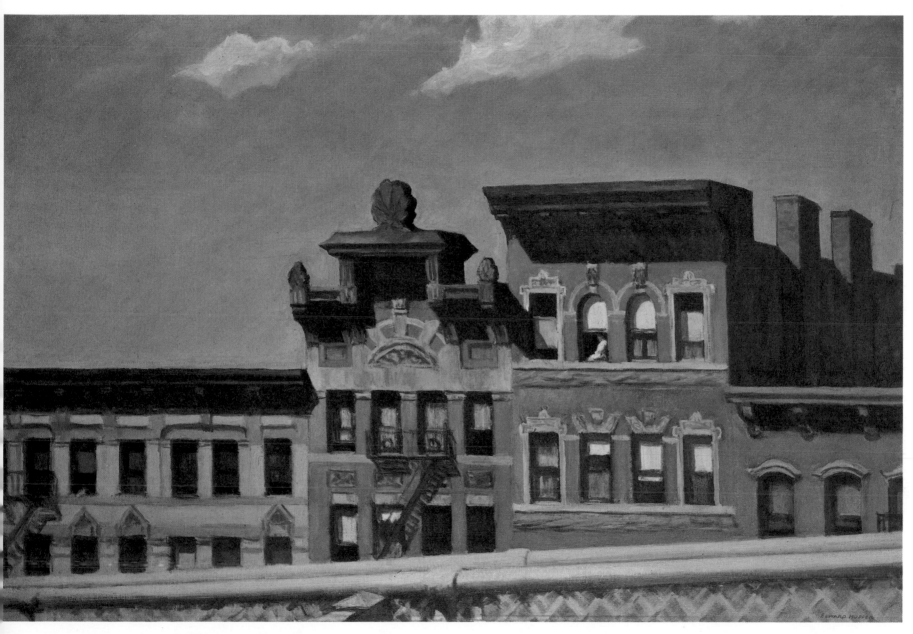

27. *Edward Hopper*, From Williamsburg Bridge, *1928, oil on canvas, 29" x 43". The Metropolitan Museum of Art, New York, New York; George A. Hearn Fund, 1937.*

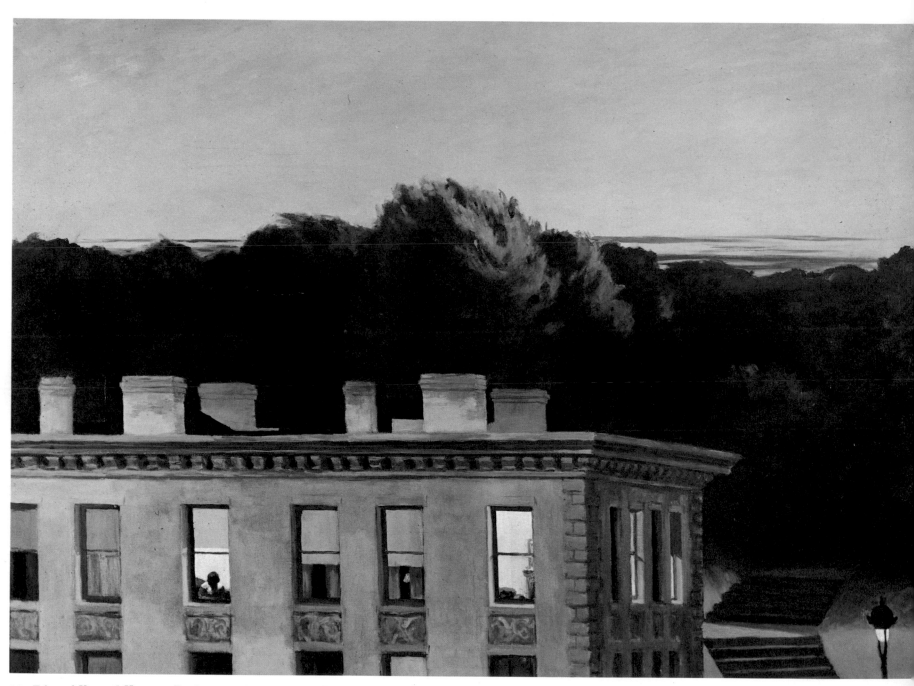

28. *Edward Hopper*, House at Dusk, *1935, oil on canvas, 36-1/4" x 50". Virginia Museum of Fine Arts, Richmond, Virginia.*

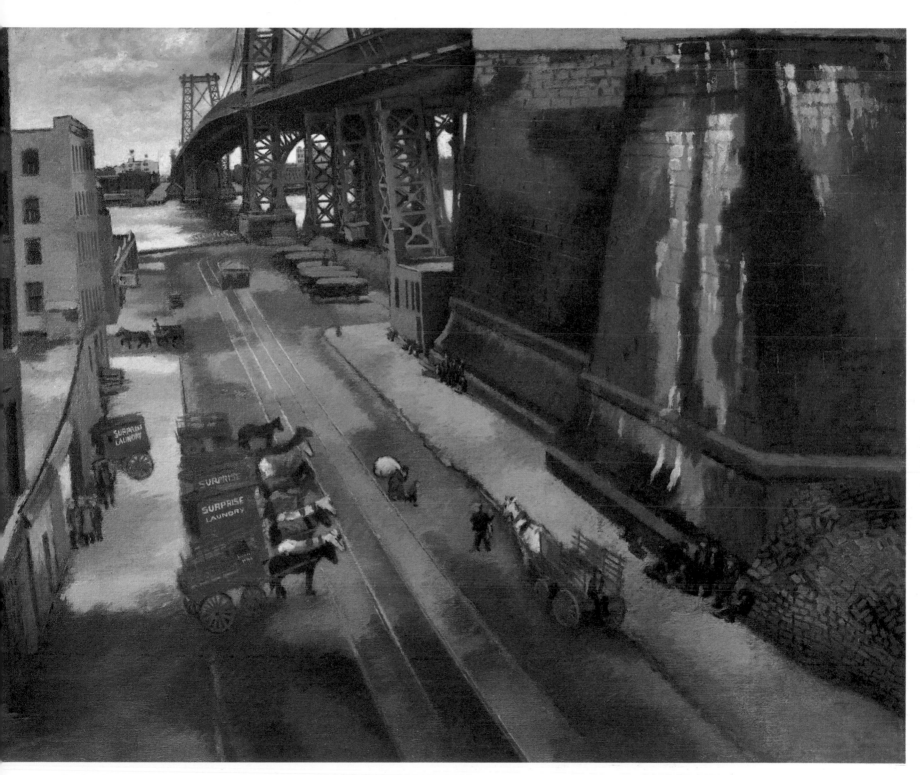

29. *Raphael Soyer*, Under the Bridge, *ca. 1932, oil on canvas, 26-1/4" x 32-1/8". Dr. and Mrs. Arnold Lieber, New York, New York.*

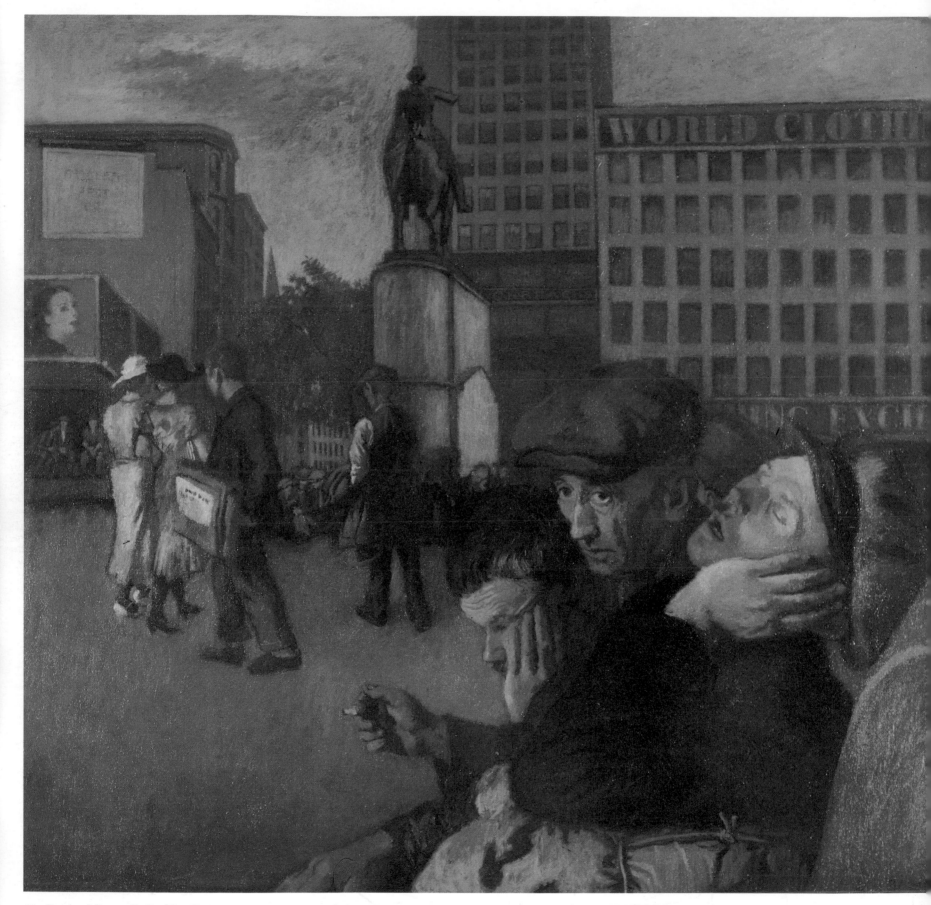

30. *Raphael Soyer,* In the City Park, *ca. 1934, oil on canvas, 38" x 40". Raphael Soyer estate, New York, New York.*

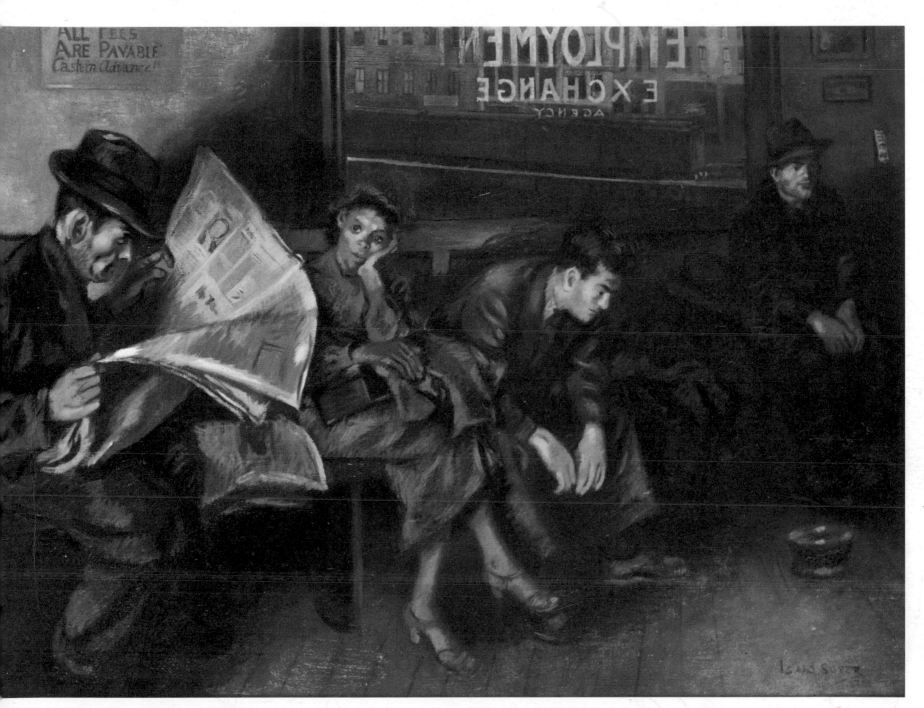

31. Isaac Soyer, Employment Agency, *1937, oil on canvas, 34-1/4" x 45". Whitney Museum of American Art, New York, New York.*

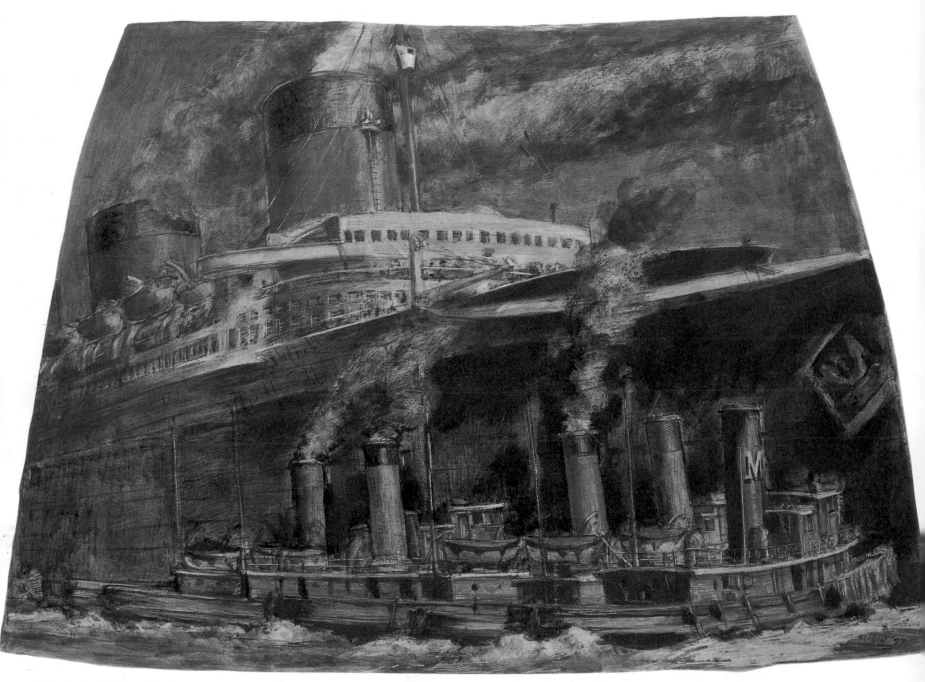

32. *Reginald Marsh*, Atlantic Liner in Harbor with Tugs, *1937, tempera, 16" x 22". National Collection of Fine Arts, Smithsonian Institution, Washington, D.C.*

mented, "The first impression of New York . . . is one of repulsion at the clangor, disorder, and permanent earthquake conditions. But this time, installed . . . in the center of the cyclone, I caught the pulse of the machine, took up the rhythm . . . and found it simply magnificent. . . . The courage, the heaven-scaling audacity of it all, and the *lightness* withal, as if there was nothing that was not easy, and the great pulses and bounds of progress . . . give a kind of *drumming background* of life that I never felt before. I'm sure that once *in* that movement, and at home, all other places would seem insipid."

Many of our artists have come from urban areas; and virtually every painter and sculptor of note has found it necessary to spend some time in a city in order to study with a recognized master, to make a living in a related field (such as commercial art), to show and sell his works, or simply to be near other producing artists. Until recently, however, American artists seldom took their subject matter from the city. One reason for this neglect of urban subjects was the state of the cities themselves. Until this century, many United States cities were relatively raw, unbeautiful places. There were few parallels in this country to such venerable and fashionable European cities as Paris or Venice, long celebrated by artists of all nationalities. Furthermore, even if Americans had painted city pictures, they would undoubtedly have been rejected by the majority of critics and art lovers as being "unimportant" or "unpleasant" subjects, because this country had no true artistic tradition of city scenes.

Art historian Lloyd Goodrich traces the history of American artists' attitudes toward the city in his book about Edward Hopper. According to Goodrich, it was the American tradition of romanticism which had engendered a certain hostility toward urban subject matter.

The American artist's picturing of America has been romantic from its beginning. The painters of the Hudson River School devoted themselves to the wild and spectacular features of the continent—the wilderness, the mountains, the sea—and disregarded the works of man. The early genre painters focused on rural life, and avoided the city and industrialism. . . . Even the naturalistic Winslow Homer turned his back on the city to paint na-

ture and man at their most primitive. The American impressionists selected the idyllic aspects of our country; if they sometimes pictured New York, it was Fifth Avenue and not Seventh. Until the end of the nineteenth century few artists . . . had attempted to picture the American city. . . .

One of the first American painters to tackle this subject in any significant way was John Sloan. Sloan, along with Robert Henri and the other young painters known as "The Eight," helped to make radical changes in American art. At the turn of the century, the taste of this country's artistic Establishment, embodied in the conservative National Academy of Design, still championed European-style, academic paintings of traditional historical and allegorical subjects. Thus, it is understandable that Sloan's brand of realism—dark-toned, loosely brushed pictures of his Lower-East-Side neighbors sunning themselves on tenement rooftops; stray cats running through snow-filled alleyways lined with hanging wash; and disreputable "low-life" scenes such as tavern interiors (Plate 12)—was condemned by most art critics as vulgar, while the Sloan/Henri manner was facetiously dubbed the "Ash-Can School" of painting. In historical perspective, Sloan's art can be seen as the forerunner of the popular city pictures that were produced in large numbers during the 1930s.

Reginald Marsh is the Regionalist painter most closely identified with the so-called urban realism of the thirties, largely because of the American art critic Thomas Craven, who championed Marsh as such. Marsh is clearly aware of the unsavory aspects of city life. His paintings often include scenes of pathetic figures: tired, lonely city dwellers, both young and old, shuffling through their daily lives (Plate 47), and bedraggled Bowery bums barely subsisting on the outskirts of polite society (Plates 49, 55). And yet Marsh manages to invest even the saddest of his subjects with a certain amount of vigor, attractiveness, and visual interest. This quality is most apparent in Marsh's more typical works: his crowd scenes. In his paintings of the New York City subway (Plates 53, 54), Marsh includes all the potentially abhorrent aspects of urban commuting. He captures the sense of utter chaos that exists when a

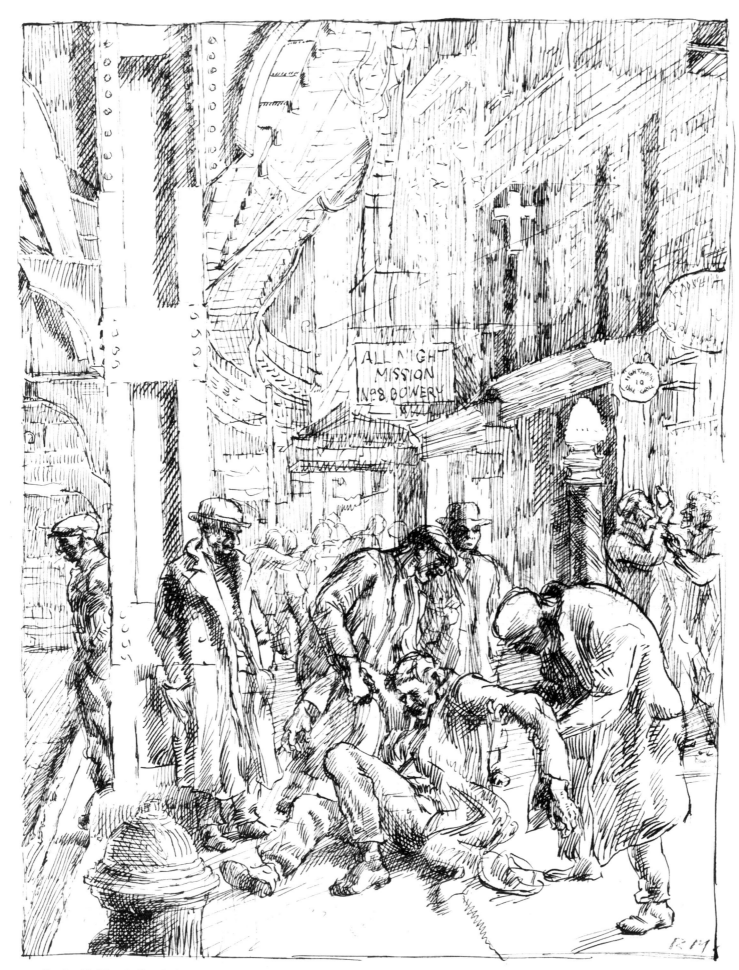

49. Reginald Marsh, Smokehounds, *1934, study, pen and ink, 14" x 10". Fogg Art Museum,*
Harvard University, Cambridge, Massachusetts; gift of Mrs. Reginald Marsh.

50. Joe Jones, View of St. Louis, *ca. 1939, oil on canvas, 25" x 50-1/4". The St. Louis Art Museum, St. Louis, Missouri; gift of Mrs. Robert Elman.*

51. *Edward Hopper,* East Wind over Weehawken, *1934, oil on canvas, 34-1/2″ x 50-1/2″. The Pennsylvania Academy of the Fine Arts, Philadelphia, Pennsylvania.*

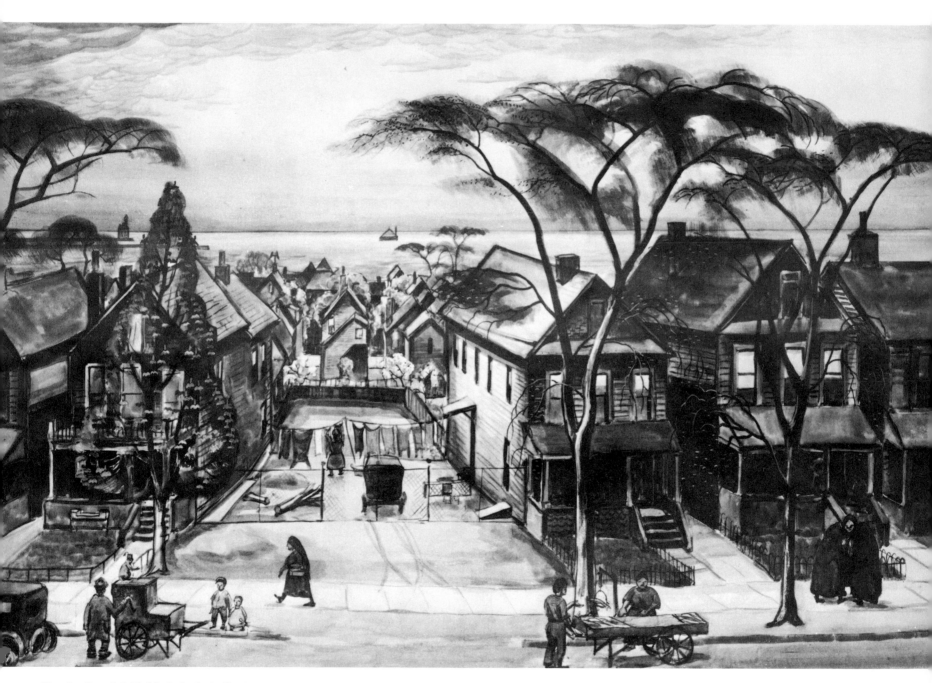

52. *Charles Burchfield,* Little Italy in Spring, *1927–28, watercolor, 26-1/2″ x 39-1/2″. Charles Rand Penney, Olcott, New York.*

rush-hour crowd frantically pushes its way out of a packed subway car. People are shown striding forth purposefully, each individual oblivious of every other individual, their fleshy bodies pressing against each other. In these pictures, Marsh conjures up the mixture of noxious smells, the deafening noise, and most of all, the sense of continuous movement that is characteristic of the subway in real life. But Marsh is not repelled by all this. Rather, he seems to thrive on it, and his art reflects his positive attitude toward the exuberance and dynamism which are also an important part of the subway experience.

Marsh paints a kind of urban excitement analogous to that described by Dos Passos in *Manhattan Transfer*:

> Dusk gently smooths crispangled streets. Dark presses tight the streaming asphalt city, crushes the fretwork of windows and lettered signs and chimneys and watertanks and ventilators and fire-escapes and moldings and patterns and corrugations and eyes and hands and neckties into blue chunks, into black enormous blocks. Under the rolling heavier heavier pressure windows blurt light. Night crushes bright milk out of arclights, squeezes the sullen blocks until they drip red, yellow, green into streets resounding with feet. All the asphalt oozes light. Light spurts from lettering on roofs, mills, dizzily among wheels, stains rolling tons of sky."

Like Dos Passos' verbal evocation, Marsh's nervous lines, bulging forms, and intense, often clashing colors emphasize the raucous excitement of the Eastern American city. When he depicts urban people at play, Marsh positively revels in the sensuality of their situation. For Marsh, merry-go-round riders are not innocent, lollipop-sucking children, but rather voluptuous, heavily made-up young women, ogled by cigarette-puffing, suspicious young men (Plate 61). His beach scenes feature a wild assortment of seminude bodies, male and female, young and old, in all kinds of peculiar positions, taking up every available inch of Coney Island sand (Plate 62, Color Plate 33).

Another popular "play" theme for urban Regionalist painters is the theater. While Marsh (Plate 75), like Kenneth Hayes Miller (Color Plate 38), occasionally chooses to portray the onlookers at a high-culture event such as

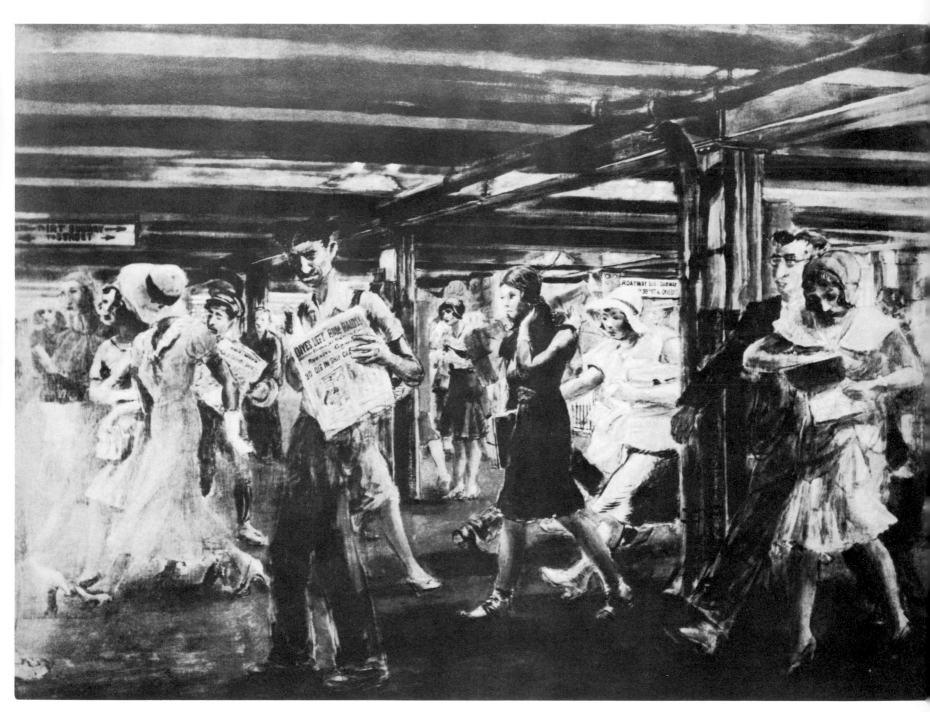

53. *Reginald Marsh*, Subway Station, Fourteenth Street, *1930, egg tempera on composition board, 36" x 48". Mr. and Mrs. Louis D. Cohen, New York, New York.*

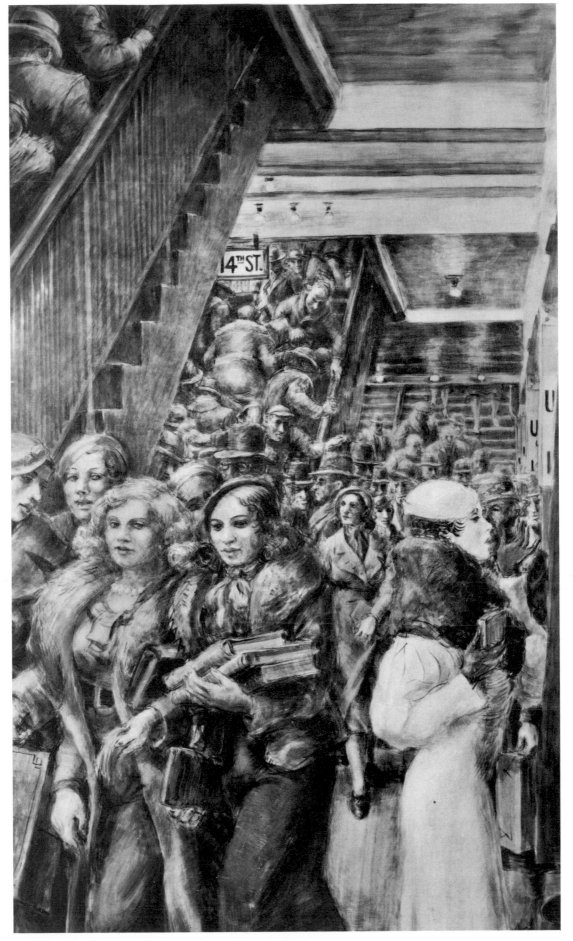

54. *Reginald Marsh,* BMT, Fourteenth Street, *1932, egg tempera on composition board, 60″ x 36″. Julie and R. Scott Schafler, c/o Mrs. Norman I. Schafler, New York, New York.*

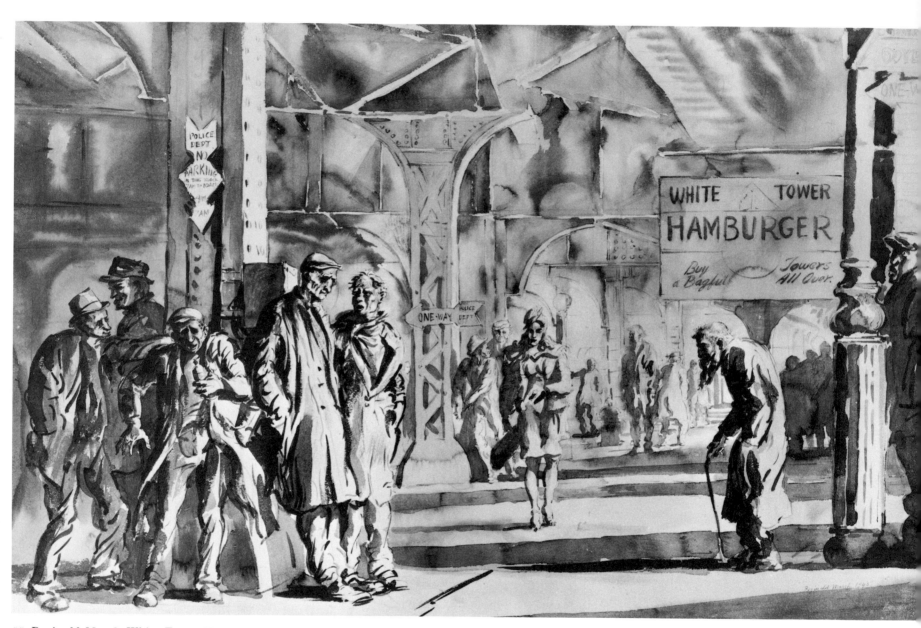

55. *Reginald Marsh,* White Tower Hamburger, *1945, ink, 26-1/4" x 39-3/4". Whitney Museum of American Art, New York, New York.*

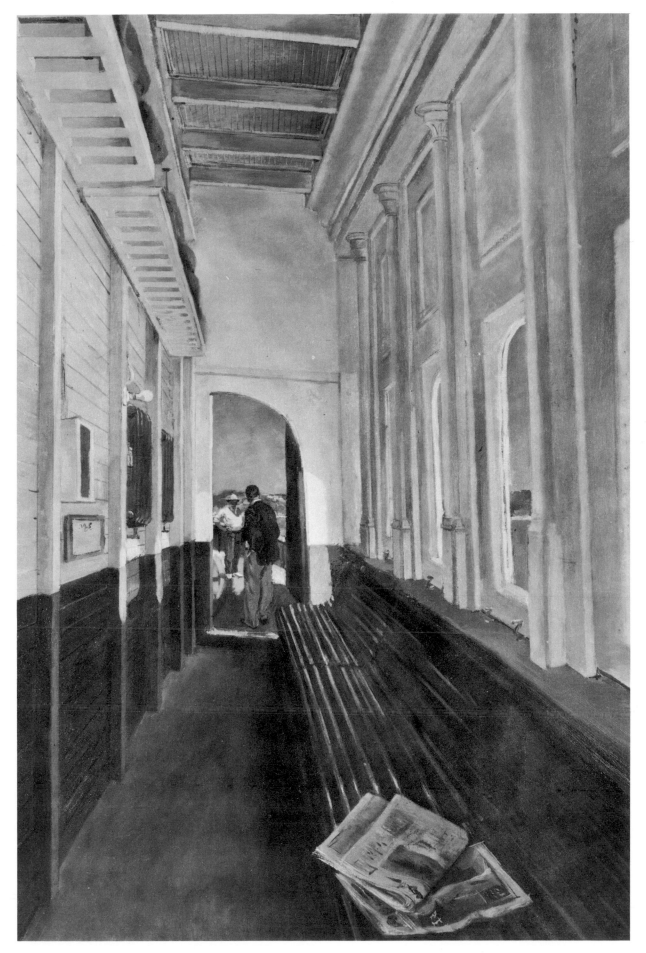

56. Louis Bouché, Ten Cents a Ride, *1942, oil on canvas, 45″ x 30″. The Metropolitan Museum of Art, New York, New York; George A. Hearn Fund, 1942.*

57. Isabel Bishop, Waiting, *1938, tempera and oil on Masonite, 34″ x 20″. The Newark Museum, Newark, New Jersey.*

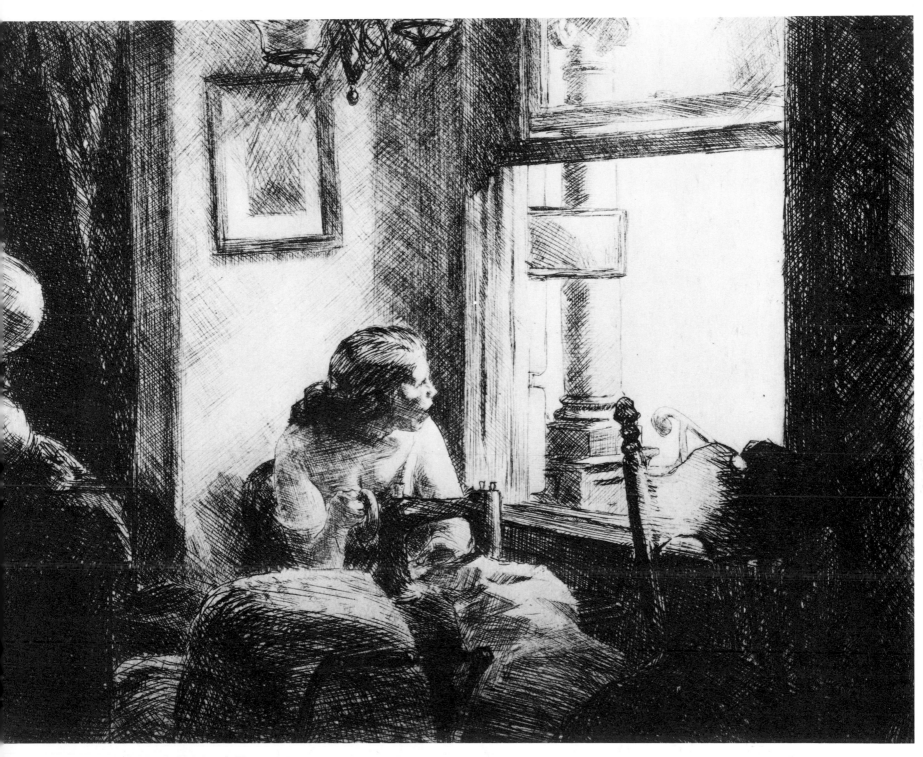

58. *Edward Hopper,* East Side Interior, *1922, etching, 8″ x 10″. Philadelphia Museum of Art, Philadelphia, Pennsylvania; The Harrison Fund. Courtesy Library of Congress.*

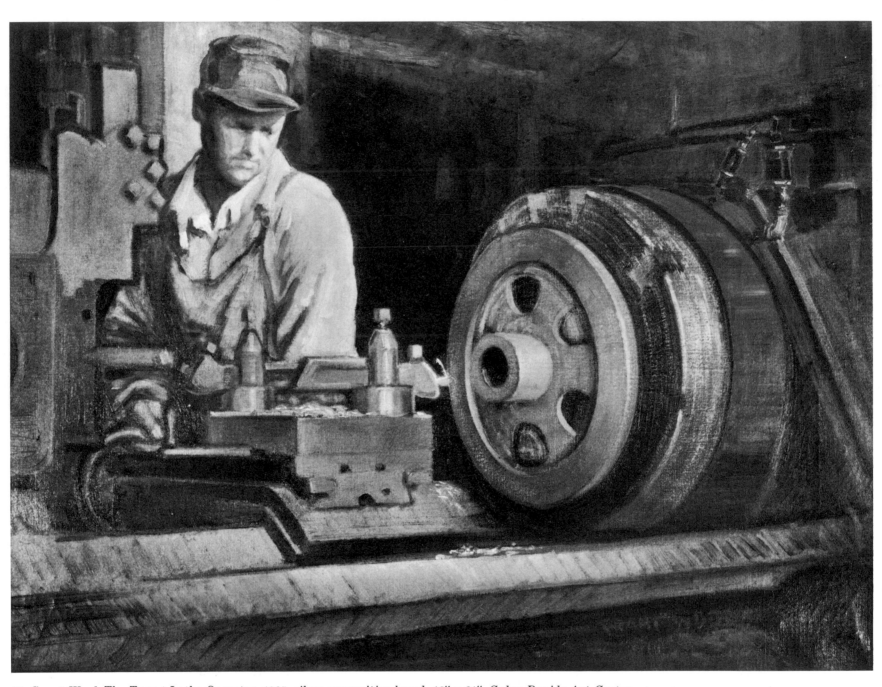

59. *Grant Wood,* The Turret Lathe Operator, *1925, oil on composition board, 18″ x 24″. Cedar Rapids Art Center, Cedar Rapids, Iowa. Courtesy Associated American Artists.*

an opera performance, Marsh typically paints more mundane types of culture. An example of this is his etching *Star Burlesque* (Plate 63), in which the artist caricatures the mindless crowd of men, oohing and aahing over the buxom, scantily clad stripper who is portrayed as a colossus towering over the tiny faces of her audience.

An artist whose work is related to Marsh's, both in terms of style and subject matter, is Isabel Bishop. Although she occasionally paints quiet, rather contemplative scenes such as *Waiting* (Plate 57), she more often—like Marsh—portrays exuberant figures enjoying the pleasures of urban existence, as in *Ice Cream Cones* (Color Plate 36).

If Reginald Marsh's work exemplifies the positive, dynamic side of urban Regionalist painting (derived from the robust artistic tradition of John Sloan), then the paintings of the Soyer brothers (Moses, Isaac, and Raphael) represent the opposite pole: that is, the dehumanizing aspects of city life. Although they are labeled Social Realists, the Soyers also painted pictures that fall into the category of urban Regionalism. For example, while Isaac Soyer's *Employment Agency* (Color Plate 30) is, in part, a statement against the exploitation and degradation of the workers by America's capitalist economy, it lacks both the specificity and the power of a more typical Social Realist painting such as Joseph Hirsch's *Amalgamated Mural* (Plate 74). Compared with Hirsch's pictures, the Soyer painting appears less pointed; but it remains the moving and sympathetic portrait of an unfortunate human condition.

As mentioned in the first chapter, Edward Hopper cannot be considered a true Regionalist because he was essentially a formalist who was more interested in the play of light on the angles of buildings than he was in the lives of the people who inhabited those buildings or in the land on which the buildings stood. When he chose to depict urban dwellers, Hopper stressed the alienation of city life. If Reginald Marsh portrays crowds of city-dwellers, and Isaac and Raphael Soyer stress the down-and-out people who spend their days waiting on unemployment lines, then Edward Hopper depicts the loneli-

60. *Reginald Marsh*, The Bowl, *1933, egg tempera on pressedwood panel with gesso, 35-7/8″ x 59-15/16″.*
The Brooklyn Museum, Brooklyn, New York; gift of Mr. William T. Evans.

61. Reginald Marsh, Merry-go-round, 1930, etching, 6-3/4″ x 9-3/4″. Courtesy Library of Congress, Washington, D.C.

ness of urban living, a theme that had been fashionable during the 1920s, but that Hopper never gave up.

The human figures in Hopper's paintings always seem to be cut off from each other and from the viewer. For instance, in *Tables for Ladies* (Plate 48), the waitress reaching over to grasp the basket of fruit seems completely isolated from the other people in the restaurant; her back is to the customers, and she is ignored by the bored, pasty-faced cashier. As she bends forward, the waitress looks off beyond the counter with a melancholy expression. Her gaze is directed toward the void in the lower right-hand corner of the picture, from which she is separated by the diagonal of the counter, its thrust into space emphasized by the carefully arranged row of grapefruits set on its far edge. The counter makes the viewer feel blocked from "entering" the space of the paintings. Just as the observer is cut off from the interior space here, so the two customers are separated from the cashier and the waitress. The female diner's head is turned toward the other women, and her face is hidden almost entirely by a close-fitting hat. Her companion's visage is curiously blank, partly because his strongly shadowed eye-sockets obscure his eyes; thus, he appears as uncommunicative as his dinner partner.

Another example of Hopper's tendency to show urban eating establishments as places where people go to be alone is his *Automat* (Color Plate 6). Both this painting and the preceding example demonstrate how different Hopper's conception of city restaurants is from that of Reginald Marsh. It also differs markedly from that of the earlier painter, John Sloan, who produced an entire series of pictures based on *McSorley's Bar* (Plate 12) and other drinking and dining establishments. Sloan depicted these places as crowded, noisy, and above all friendly, places where city people (including the artist) habitually went to have a good time. In contrast, it is difficult to imagine Hopper's diners having fun or even enjoying their food.

Even in his most sensitive, lyrical works, such as *East Side Interior* (Plate 58), Hopper stresses a feeling of isolation. In this etching, a woman seated at her sewing machine inside what appears to be a dark, crowded, and rather

62. Reginald Marsh, Coney Island Beach, Number 1, *1942, watercolor and ink, 21-1/2″ x 29-1/2″. Whitney Museum of American Art, New York, New York.*

63. *Reginald Marsh*, Star Burlesque, *1933, etching, 11-3/4″ x 8-7/8″. Courtesy Library of Congress, Washington, D.C.*

shabby apartment looks through an open window toward something the viewer cannot see. Her expression is one of extreme melancholy. This emphasis on isolation and sadness, plus his overriding interest in the formal quality of his work, combine to differentiate Hopper from the Regionalist painters.

Although Regionalism in painting is most often associated with pictures of the rural Midwest, as has been demonstrated here, Regionalist painting also includes many urban scenes, a significant number of which have either direct or implied critical content. This criticism varies in strength from the relatively light-hearted satire of Paul Cadmus' *Aspects of Suburban Life* (Color Plate 39) to the sober and empathetic views of city life painted by the Soyers.

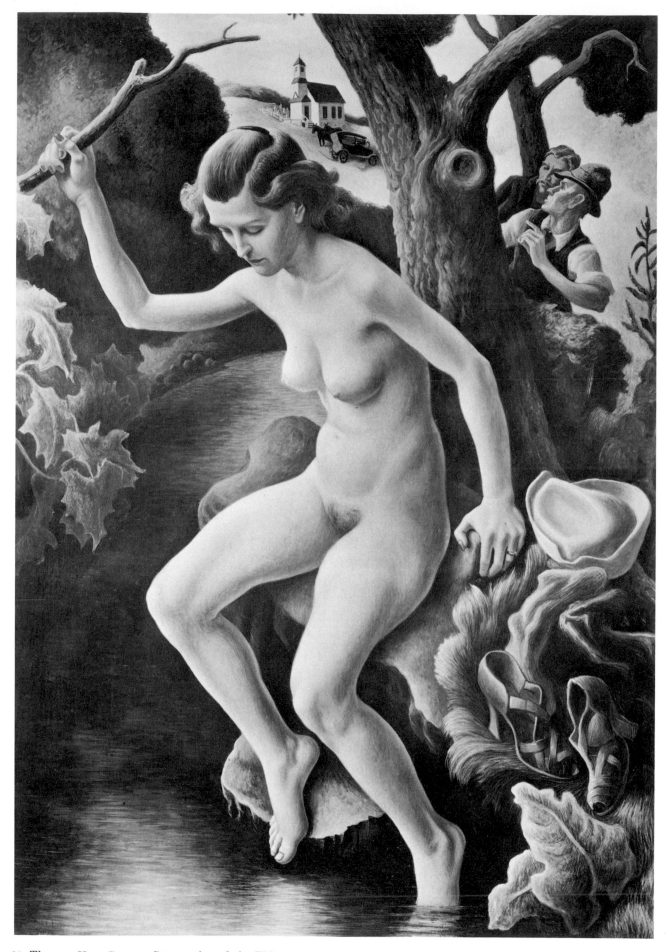

64. *Thomas Hart Benton,* Susannah and the Elders, *1938, egg tempera on panel, 60″ x 42″.*
California Palace of the Legion of Honor, San Francisco, California.

V

MYTH, HISTORY, AND SOCIAL COMMENTARY

The awakened interest in America's unique culture has already been mentioned as one of the factors that gave rise to Regionalism. Faced with economic disaster on the home front and the increasingly ugly and chaotic situation developing in Europe, Americans searched their history, hoping to find at least two things. First, they looked for evidence that would prove America sufficiently different from Europe to be somehow immune from the Fascist cancer that was growing there. Second, many looked to the American past for reassurance that Americans were of hearty stock and that the country would weather the hard times.

This search for America's unique qualities took many forms. Reporters and photographers roamed America documenting what they found. No theme seemed unimportant, no person ordinary. Everything they found contributed to an understanding of America and of themselves. Similarly, teams of folklorists traveled through remote areas, recording and documenting the songs, stories, and dances they observed. Many collections of folk songs and folk legends were published during the thirties and read by people interested in the indigenous art forms of America. Even jokes came under serious scrutiny when, in 1931, cultural historian Constance Rourke published her study, *American Humor.*

Artists, too, were involved in this documentary quest for America, collecting and recording objects of American folk art. Perhaps their most notable contribution in this area was the *Index of American Design*, a federal work-relief project which employed artists to catalog and illustrate some 22,000 American folk art objects.

Similarly, interest grew in American history. It was found to be suitable

material for scores of successful novels, such as *Gone with the Wind* (1936), and films. Biographies of figures from American history, both real and legendary, were also popular, with Sandburg's multi-volume history of Lincoln being perhaps the most remarkable example of this special form of history.

Like history, American literature and legend attracted writers, film-makers, and artists. Writers who had left America in the previous decade to work in Europe returned home to write. Often they rejected the modern European styles of literature (just as many painters rejected European modernism) and began to re-read American writers, especially Twain and Whitman. Hollywood presented the public with films based on American literature, such as *An American Tragedy* (1931) and *Arrowsmith* (1931), as well as films based on lives of legendary Americans ranging from Billy the Kid to "Honest Abe" Lincoln.

Literary critic Alfred Kazin once wrote of the thirties, ". . . never before did a nation seem so hungry for news of itself." Given this intense interest in all things American, it is not surprising that painters should have been drawn to the American landscape as well as to American history, folk legends, and folk music as subjects for their work.

The first of the Regionalist artists to turn his attention to American history as subject matter for his painting was Thomas Hart Benton. At the beginning of his career, Benton, like many young American art students, had gone to Paris. There he mimicked and absorbed avant-garde styles which today seem remote from his mature work. It seems to have been the influence of a nineteenth-century French thinker, Hippolyte Taine, that caused Benton to look back to America. Taine believed that art should be grounded in the artist's environment; to Benton, an American in Paris, that indicated the need for a return ticket. In 1911 Benton arrived in New York and moved into a studio, but he continued to paint in the European styles he had learned until after the First World War. At that time (approximately 1919), he decided he had had enough of purely theoretical abstract art, and wanted to make art accessible to people not versed in the principles of modern art.

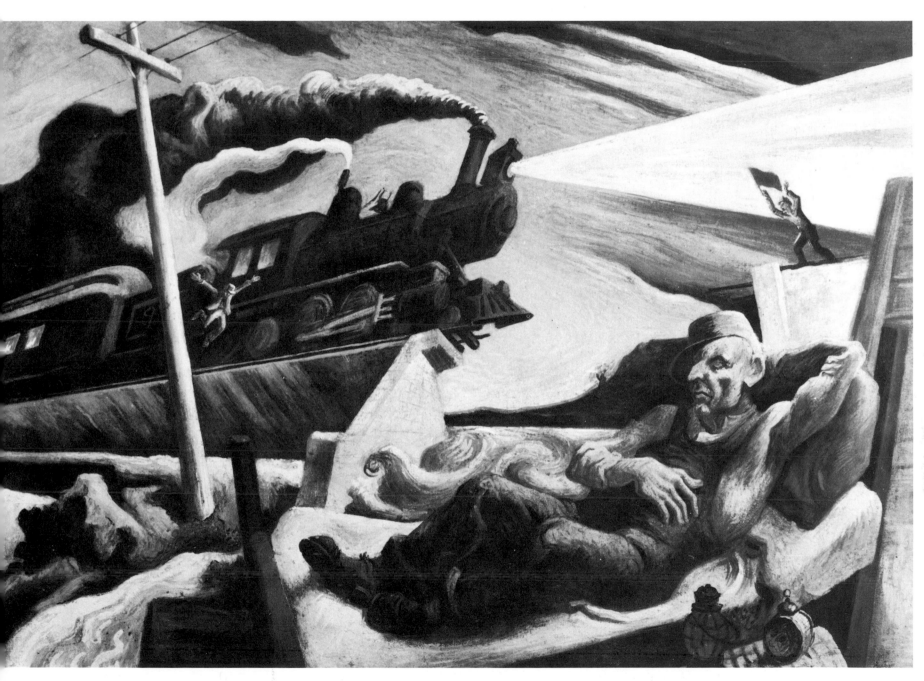

65. *Thomas Hart Benton,* Engineer's Dream, *1930, oil and tempera on canvas, 30″ x 42″. Courtesy Thomas Hart Benton.*

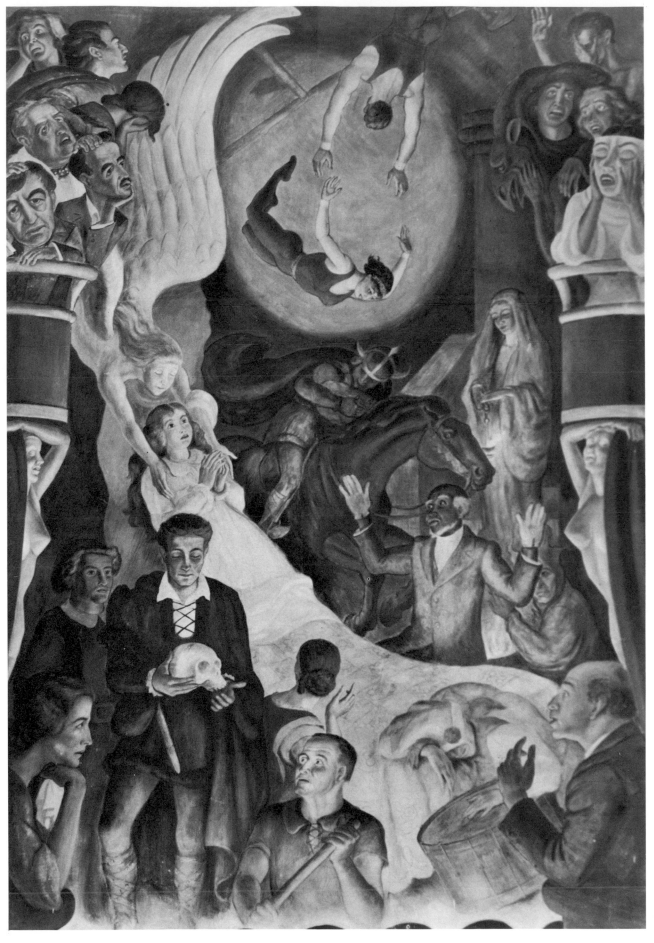

66. John Steuart Curry, Tragedy, *1934, fresco, 12' x 8'. The King's Highway Elementary School, Westport, Connecticut.*

It was at this time that Benton also changed his subject matter. First, he turned his attention to the human figure, painting people at the beach, on picnics, or at the circus. Then, in 1919, he decided to paint a series portraying the pageant of American history. His intention was not to show the heroics of battlefields, the signing of treaties, or the images of the presidents. Rather, he imagined telling the history of America through the exploits of the common person.

Benton conceived the series to consist of some sixty paintings, although he completed only a dozen over a six-year period. These were large panels, each over five feet in height. Their size and number were deliberate. In this series, Benton was not making paintings to be hung in the homes of wealthy patrons; he was making public art. These paintings, he hoped, would be hung together and would be seen by great numbers of people. In this, Benton's ideas paralleled those of the Mexican muralists such as Orozco, Rivera, and Siqueiros.

One painting from the series, *The Pathfinder* of 1924-26 (Plate 67), sums up Benton's intentions. Here Benton shows his emphasis on the common person by carefully avoiding suggestion of any specific individual. He shows a man exploring the wilderness and facing great danger alone. While elements from his Parisian modernist training still exist here, especially obvious in the Cubist-inspired rocks in the right foreground, for the most part, Benton shows his concern for clear and dynamic depiction of the human form. His models are no longer Matisse or Picasso, but Michelangelo and Tintoretto.

John Steuart Curry shared Benton's ideas about painting history. While Curry never planned a series as grandiose as Benton's American Historical Epic, he, too, painted historical subjects, including some murals. His *Oklahoma Land Rush* (Color Plate 41) repeated Benton's approach: history told through the actions of common people. By emphasizing the rush of figures across the land, Curry shared Benton's concern with capturing the energy and vigor of America's pioneers.

Curry also painted some historical scenes that were more specific in their

content. For example, his *Return of Private Davis from the Argonne* (Plate 70) shows a particular event from the First World War: the burial of a soldier in his hometown. But again, although the event is a specific one, Curry's emphasis remains unchanged. This painting does not show a general planning a battle or a president signing a declaration. Instead, Curry chose to focus on everyday Americans, showing how the war was felt at home, far from the front. Because of its focus on the common person, its appeal is universal.

Just as American history provided subject matter for painting, so did traditional American art forms such as folk music and legends. Following the resurgence of interest in the indigeneous folk tradition, artists painted works based on Negro spirituals, Appalachian folk tunes, and legends of folk heroes. For example, John McCrady's *Swing Low, Sweet Chariot* (Color Plate 42) takes its title directly from a spiritual. In this work the artist attempted to capture, in an extremely literal way, the images and emotions evoked by a group singing the song together.

Thomas Hart Benton utilized folk imagery in his art throughout his mature career. He included scenes from the "Ballad of Frankie and Johnny" in his 1936 murals for the Missouri State Capitol. The *Engineer's Dream* of 1930 (Plate 65) also has precedents in railroad ballads, such as "Casey Jones," that recount train wrecks.

Benton added a new twist to the use of legends as subjects for art. In some of his paintings he took Old Testament or classical stories and made them American. By transforming the old story into contemporary American terms, Benton infused it with life and encouraged his audience to view it in a new way. A clear example of this is *Susannah and the Elders* of 1938 (Plate 64). Here, before bathing in a country stream, Susannah has removed her 1930s-style clothing (emphatically placed in the right corner of the picture). Her hairstyle is fashionable, as is the polish on her nails. The elders have crept up, having left their automobile beside the white Midwestern church.

Perhaps most elusive in this chapter is the notion of social commentary. This is because American art in the 1930s is most often divided into two sub-

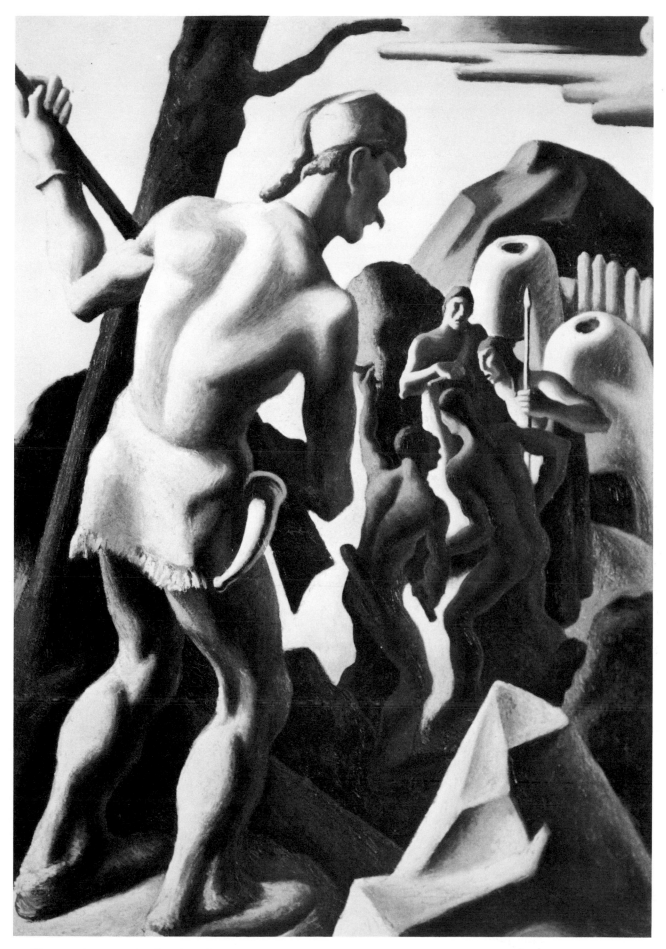

67. Thomas Hart Benton, The Pathfinder (American Historical Epic), *1919–21, oil on canvas, 72″ x 65″.*
Courtesy Thomas Hart Benton.

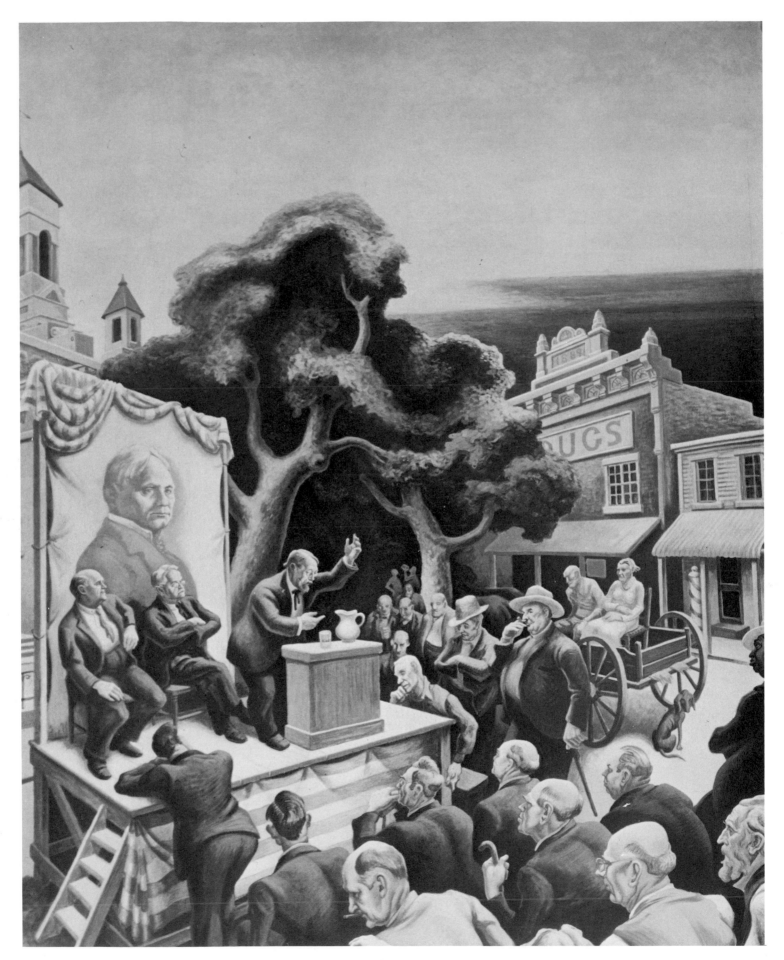

68. Thomas Hart Benton, The Curator (*detail of* Politics and Rural Agriculture)*, 1936, oil and egg tempera on linen mounted on plywood, 14' x 23' (whole). Missouri State Capitol, Jefferson City, Missouri. Courtesy Missouri Tourist Commission.*

69. Jon Corbino, Flood Refugees, *1938, oil on canvas, 40" x 64". The Metropolitan Museum of Art, New York, New York, Arthur H. Hearn Fund, 1950.*

categories, Regionalism and Social Realism, under the broad heading of American Scene painting. Many critics have maintained that the main difference between the two groups is that the Social Realists, unlike the Regionalists, were "message painters." That is, the Social Realists had a specific analysis of America—a left-wing critique of American history and society—and they used their art to convey this analysis to others. As examples of this kind of painting, one can cite Joseph Hirsch's *Amalgamated Mural* (Plate 74) or Fletcher Martin's *Trouble in Frisco* (Plate 71), both of which show the problems and struggles of working people from a leftist perspective.

Yet it is important to remember that every painting has a message of some kind. By studying the way an artist presents his subject, we can determine much about an artist's attitude toward his society. This is as true of Regionalist painters as it is of Social Realists—as well as artists of any other time or place.

From this point of view, even a painting such as Grant Wood's *Spring in Town* (Color Plate 47) can be viewed as social commentary, in that it not only presents a view of a small town, but makes a statement about the quality of life there as well. With its crisp lines and unruffled atmosphere certainly no one would suggest that this is a realistic depiction. The yards and homes are orderly and tidy, and the reason for this order is obvious. Nearly everyone in this picture is involved in keeping it that way—a woman hangs her wash, a man tends his garden, another mows the lawn, and in the distance two people beat a rug. The order is further emphasized by the precision of the lines and the careful repetition of geometric forms. Even the vegetation in this town conforms to the order: the flowers march in perfect rank down the edge of the garden. Wood has altered reality in these ways to convey his image of the town. It is a place that embodies American virtues of hard work and order. In a painting such as this one, the American scene is portrayed as so ideal that it takes on mythic proportions.

In the same vein, a painting such as Curry's *Kansas Cornfield* (Color Plate 46) is more than a botanical illustration. By painting the corn as he did, tow-

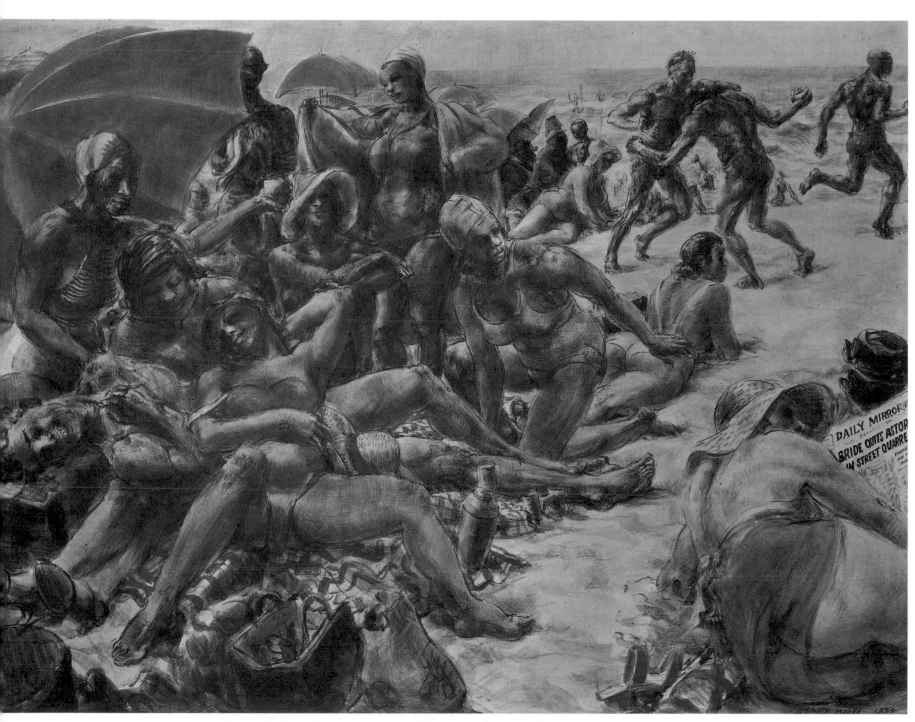

33. *Reginald Marsh,* Negroes on Rockaway Beach, *1934, egg tempera on composition board, 30" x 40".*
Whitney Museum of American Art, New York, New York; gift of Mr. and Mrs. Albert Hackett.

34. *Reginald Marsh*, Hat Display, *1939, watercolor, 40" x 26-1/2". Dr. and Mrs. John J. McDonough, Youngstown, Ohio.*

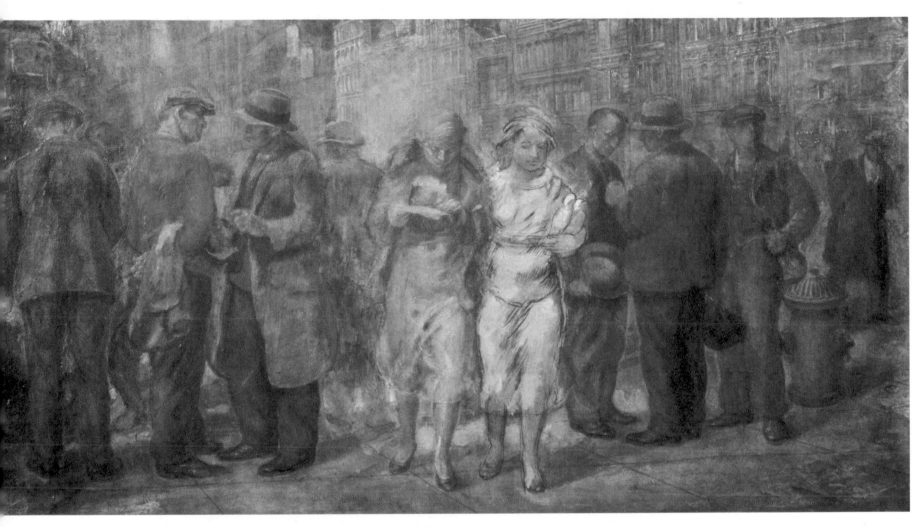

35. *Isabel Bishop,* On the Street, *ca. 1932, oil, 14-1/2″ x 26″. Courtesy Midtown Galleries.*

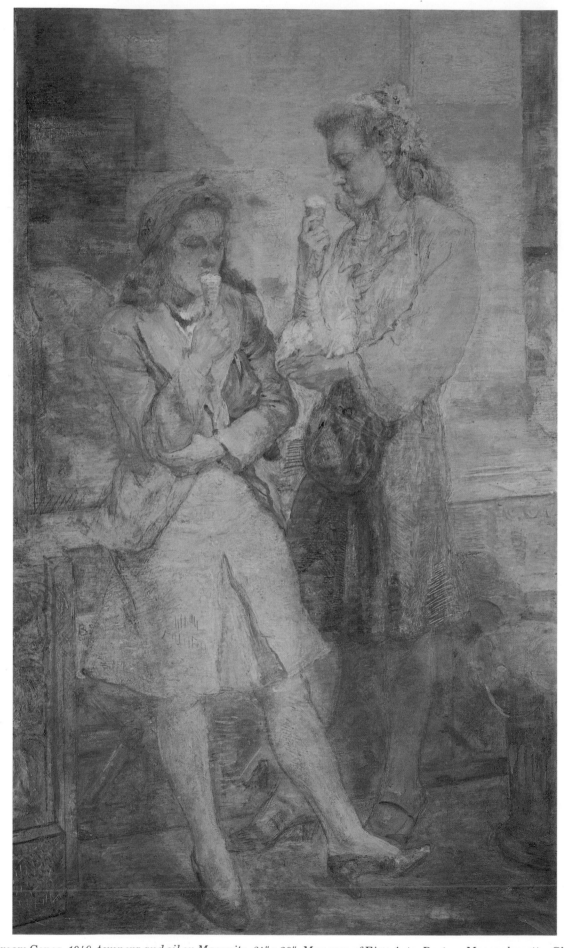

36. Isabel Bishop, Ice Cream Cones, 1940, tempera and oil on Masonite, 34" x 20". Museum of Fine Arts, Boston, Massachusetts; Charles Henry Hayden Fund.

37. *Edward Laning,* Street Orator, *1931, oil on canvas, 31" x 24". Courtesy Bernard Danenberg Galleries.*

38. Kenneth Hayes Miller, Box Party, *1936, oil and tempera on canvas, 60" x 46". Whitney Museum of American Art, New York, New York.*

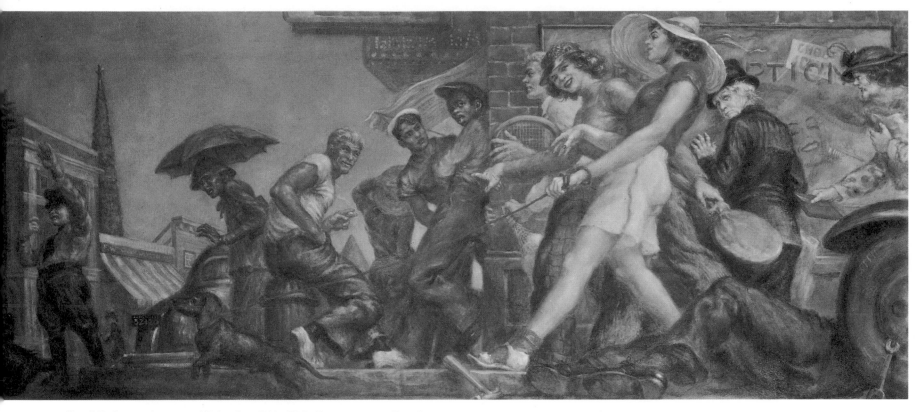

39. *Paul Cadmus*, Aspects of Suburban Life: Main Street, *1937, oil and tempera on canvas, 31-3/4" x 73-3/8". Courtesy Midtown Galleries.*

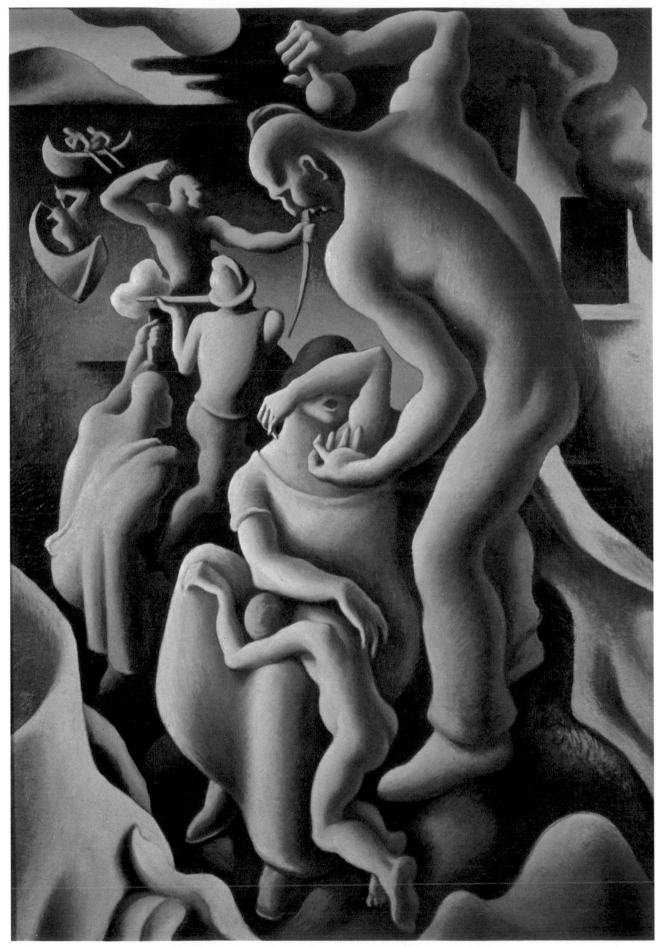

40. *Thomas Hart Benton,* Retribution, *oil on canvas, 60″ x 24″. Courtesy Thomas Hart Benton.*

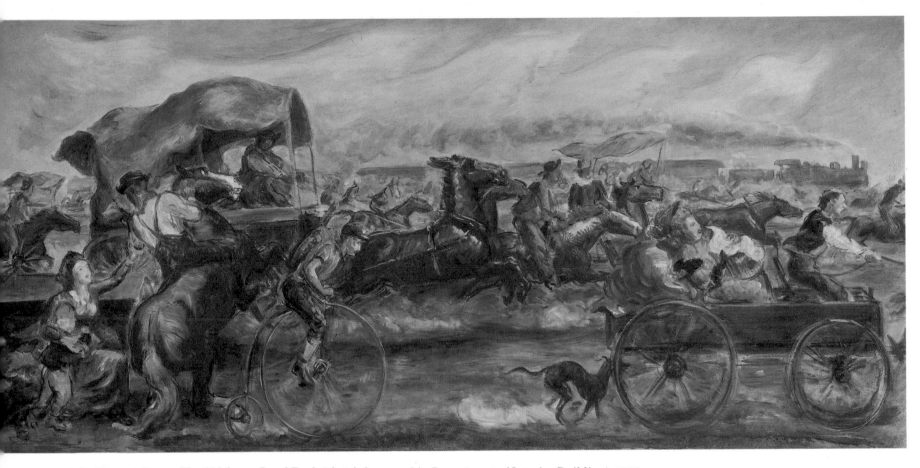

41. John Steuart Curry, The Oklahoma Land Rush *(sketch for mural in Department of Interior Building), 1938,
oil on canvas, 28-3/8" x 59-1/4". National Gallery of Art, Washington, D.C.*

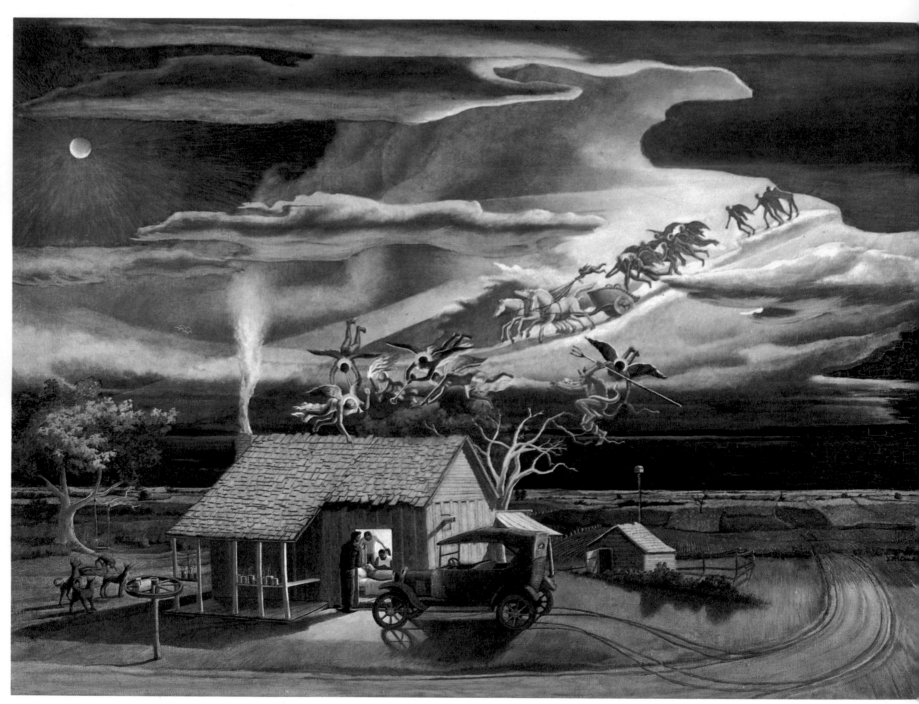

42. *John McGrady*, Swing Low, Sweet Chariot, *1937, oil on canvas, 50-1/4" x 37". The St. Louis Art Museum, St. Louis, Missouri; Eliza McMillan Fund.*

43. Joe Jones, American Farm, *1936, oil and tempera on canvas, 30" x 40". Whitney Museum of American Art, New York, New York.*

44. *William C. Palmer*, Dust, Draught, and Destruction, *1934, egg tempera on composition board, 24" x 30". Whitney Museum of American Art, New York, New York.*

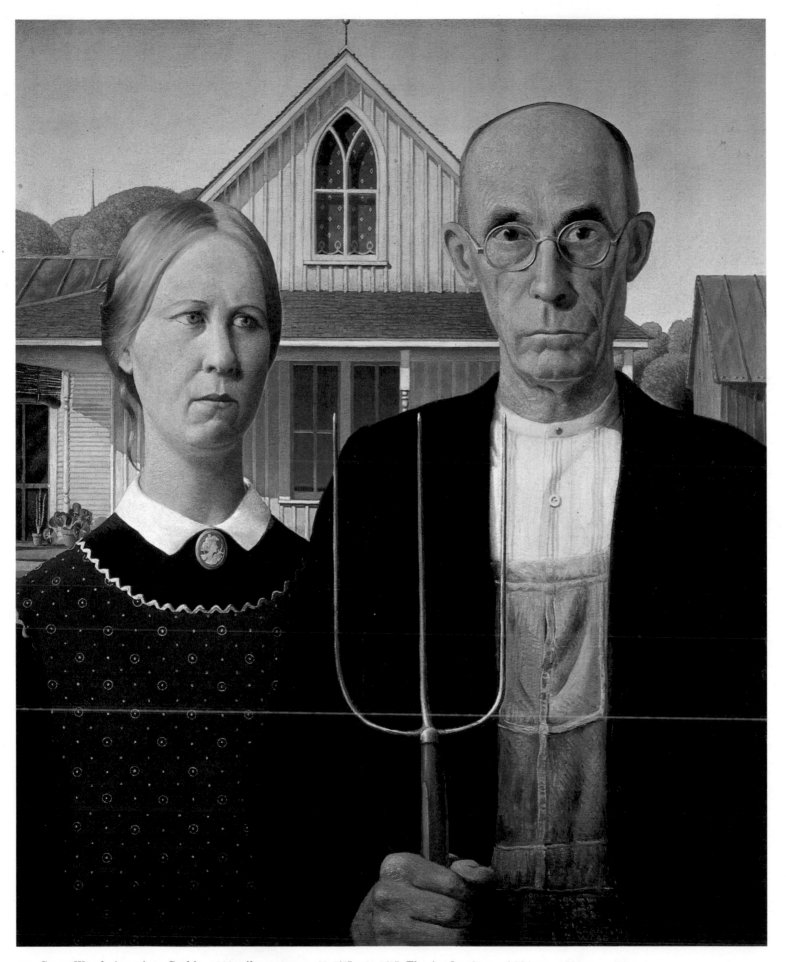

45. *Grant Wood,* American Gothic, *1930, oil on canvas, 29-7/8" x 24-7/8". The Art Institute of Chicago, Chicago, Illinois.*

46. *John Steuart Curry*, Kansas Cornfield, *1933, oil on canvas, 60" x 38-1/4". Wichita Art Museum, Wichita, Kansas; The Roland P. Murdock Collection.*

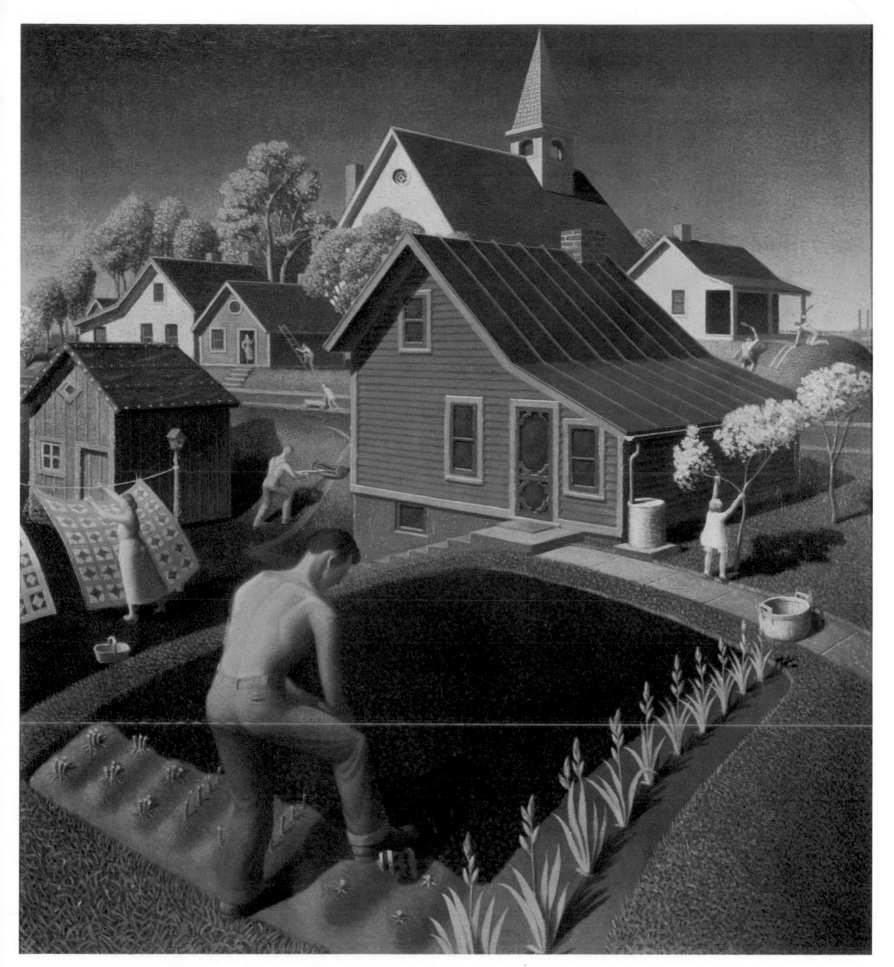

47. *Grant Wood,* Spring in Town, *1941, oil on canvas, 26" x 24-1/2". The Sheldon Swope Art Gallery, Terre Haute, Indiana.*

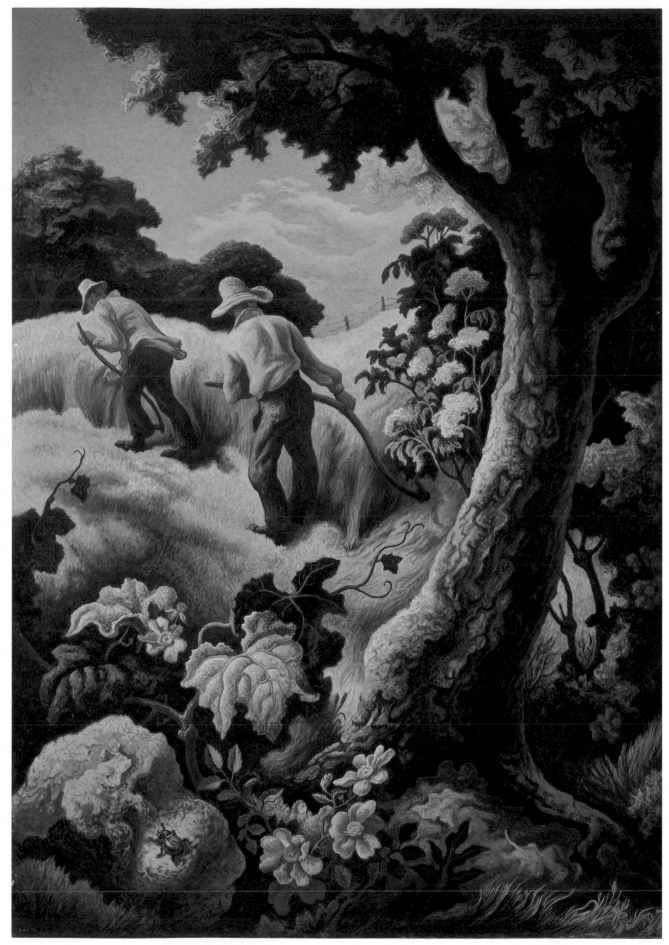

48. *Thomas Hart Benton,* July Hay, *1942–43, oil and egg tempera on composition board, 38" x 26-3/4".*
The Metropolitan Museum of Art, New York, New York; George A. Hearn Fund, 1943.

70. John Steuart Curry, The Return of Private Davis from the Argonne, *1928–40, oil on canvas, 37-1/2" x 51-1/2".*
Alonzo C. Cudworth Post No. 23, The American Legion, Milwaukee, Wisconsin.

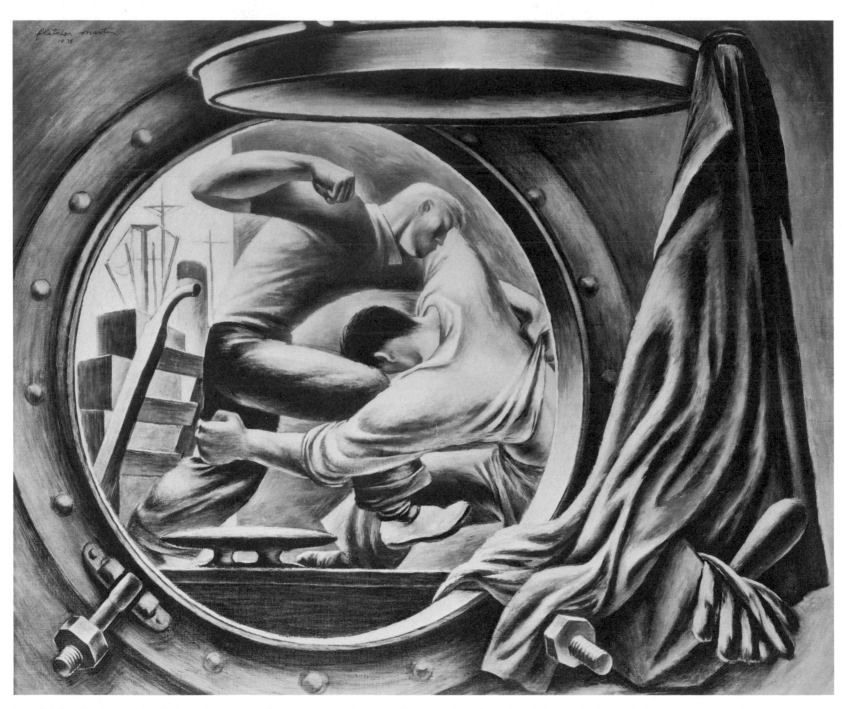

71. Fletcher Martin, Trouble in Frisco, *1938, oil on canvas, 30″ x 36″. Museum of Modern Art, New York, New York; Abby Aldrich Rockefeller Fund.*

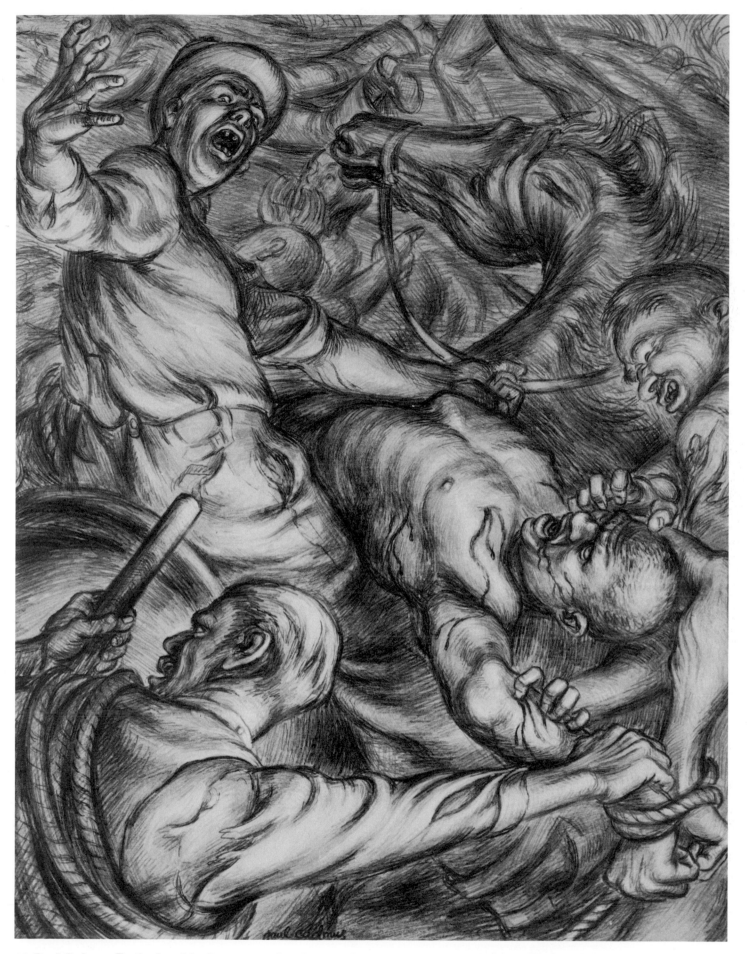

72. Paul Cadmus, To the Lynching!, *1935, pencil and watercolor on paper, 20-1/2" x 15-3/4". Whitney Museum of American Art, New York, New York.*

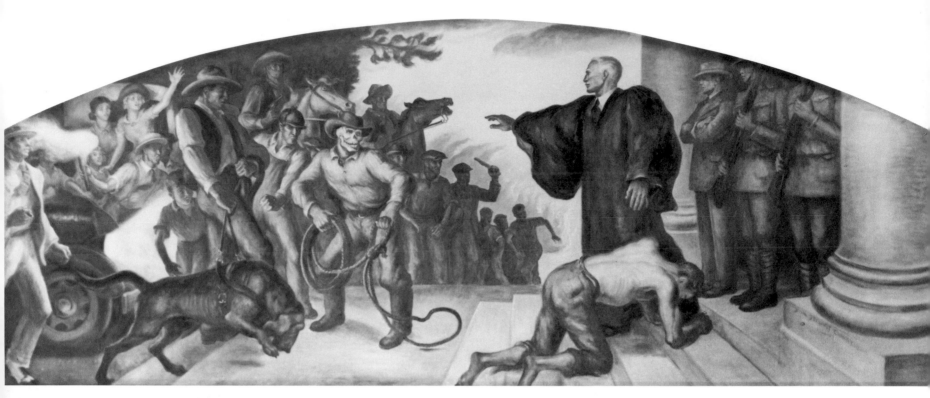

73. John Steuart Curry, Law versus Mob Rule, *1936, oil and tempera on canvas, size unavailable.*
Department of Justice, Public Buildings Service, Washington, D.C.

ering over the viewer and reaching to each edge of the canvas, Curry gave the plants heroic qualities usually reserved for portraits of kings, emperors, or generals. In this painting, corn, a plant closely linked with the American Midwest, becomes a symbol for that region and its richness, fecundity, and strength.

Of course, artists also made more direct or literal statements about American society in their paintings. While the proper realm for art is usually considered to be outside the political arena (save for isolated periods such as the French Revolution), during the 1930s artists, and not just the Social Realists, felt it necessary to speak out on social and political matters.

For example, many Regionalist artists painted works that dealt with the American legal and political systems. Curry painted a mural for the United States Justice Department in 1936 entitled *Law versus Mob Rule* (Plate 73). Here a robed justice is backed, not only by legal power (symbolized by the massive columns of the courthouse), but also by physical power (in the form of the armed men on the steps). The justice gestures protectively toward the mob's intended victim, who seems on the verge of collapse. With his other hand the judge holds back the mob, a collection of malevolent figures representing different kinds of mob violence—including the vigilantes of the West and a group of angry industrial workers. Curry does not deny the strain of violence in America; but he concludes that the greater strength of the American legal system will prevail.

Benton also celebrated American institutions. In *The Orator* (Plate 68), which is a detail of a mural cycle in the Missouri State House, he showed the workings of American politics. Everyone listens to the man on the podium; the crowd includes people from different parts of society, both townspeople and farmers. Benton emphasized the decision-making power of the people; they take their responsibilities seriously and listen carefully to the words of the speaker. It is a nostalgic look backwards, especially when one considers the increased use of mass communications in political campaigns during the presidency of Franklin Roosevelt. Laning's *Street Orator* (Color Plate 37) is

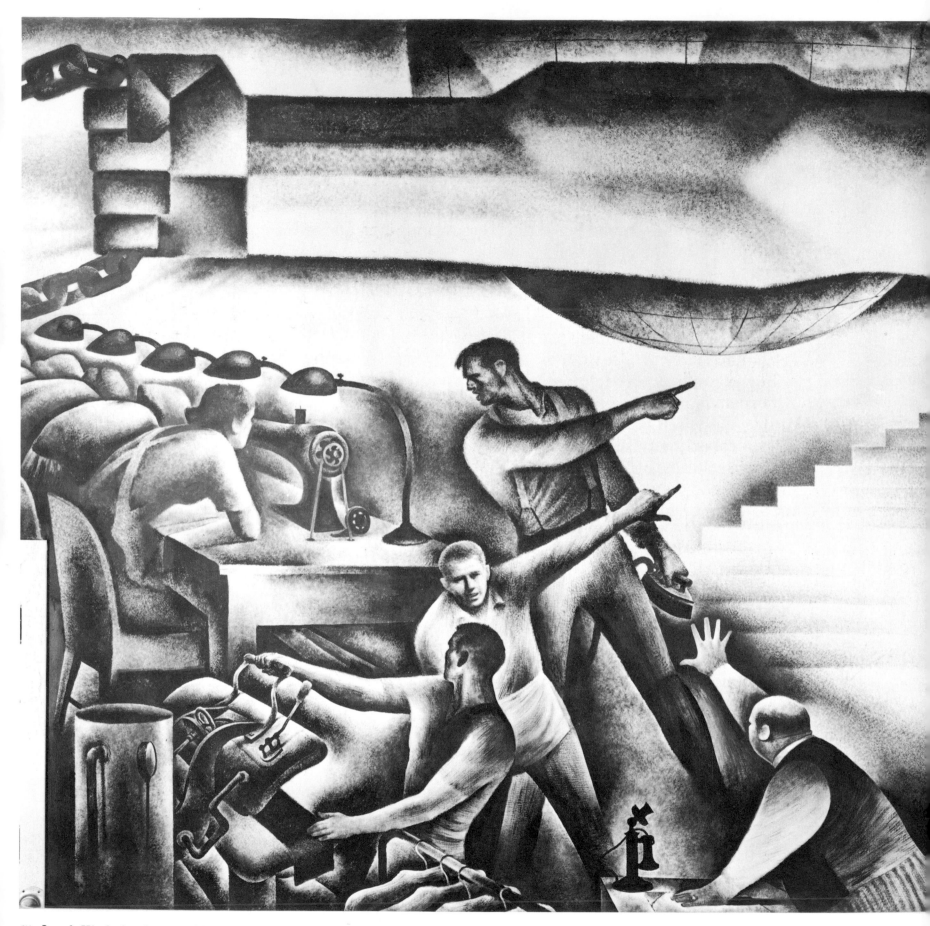

74. Joseph Hirsh, Amalgamated Mural *(detail), 1936, fresco, 11' x 66'. Philadelphia Joint Board,*
Amalgamated Clothing Workers of America, Philadelphia, Pennsylvania.

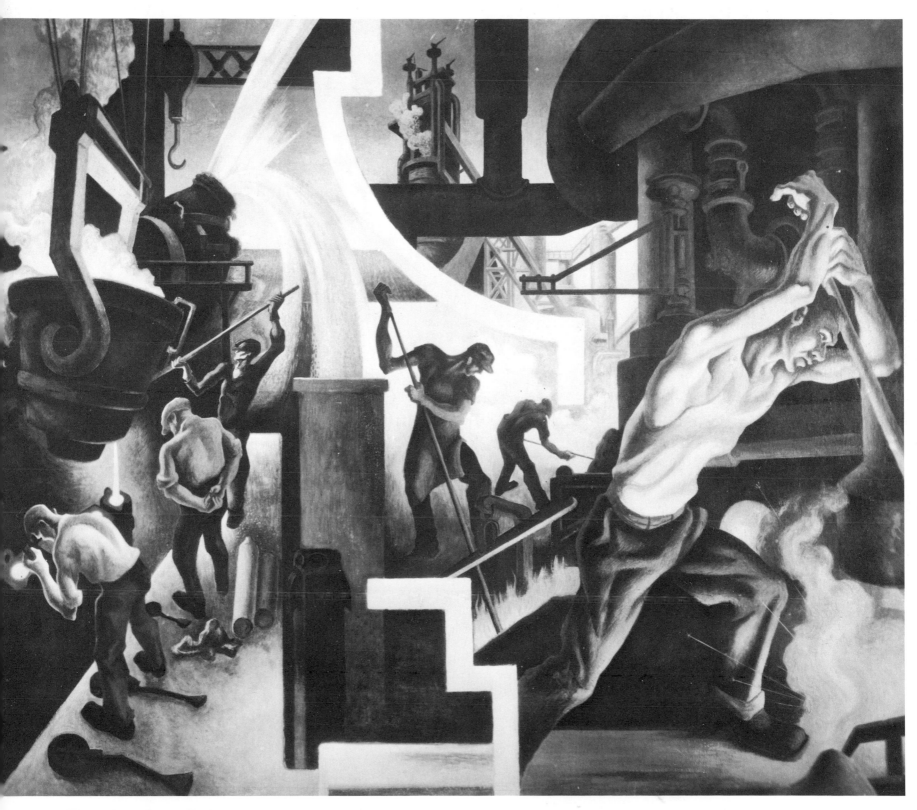

75. *Thomas Hart Benton,* Steel *(detail from* Modern America, *murals for the New School),* 1931, *egg tempera and distemper on linen mounted on panel, 7-1/2″ x 8-11/12″. The New School for Social Research, New York, New York.*

76. Reginald Marsh, Alma Mater, *1933, tempera on composition board, 36″ x 24″.*
The Newark Museum, Newark, New Jersey.

in a similar vein; it, too, depicts the political process and rights of free speech enjoyed by Americans.

Social commentary by Regionalist artists was not restricted to glorifying American institutions. Occasionally, they made criticisms of America that were as severe as those of the Social Realists. For example, in 1935 there was an exhibition entitled "Art Commentary on Lynching." One would expect many Social Realists to have contributed paintings to the exhibition that condemned the brutal treatment to which Blacks were subjected in America—indeed, this was the case. But Regionalists also participated. Both Benton and Curry submitted works, as did Paul Cadmus, whose *To the Lynching!* (Plate 72) is illustrated here. Again, it is obvious that the standard distinctions between the two groups of artists do not always hold.

The Regionalists, however, most often confined their social criticism to mild satire. This can be seen clearly in paintings such as Grant Wood's *Honorary Degree* (Plate 77) of 1936 and Reginald Marsh's *Grand Tier at the Opera* (Plate 78) of 1939, which deal with two aspects of American society with which the Regionalists are not usually associated: academia and high culture. Wood depicts a lifeless ceremony enacted by equally lifeless men. There is no excitement in either their postures or their faces. By relating the human forms to the architecture via the similarity of shape in the pointed Gothic window, the upraised hood, and the two flanking tall men, Wood suggests that the professors are as dated as their setting. Marsh's *Grand Tier at the Opera* is more biting. He caricatures this segment of society by bloating their faces and distorting their bodies. Marsh suggests that many members of the audience are more concerned with each other than with the performance. They are pictured with considerably less vitality and sympathy than Marsh's subway riders (Plates 53, 54).

Yet despite these forays into satire and pointed socio-political criticism, a painting such as Curry's *Our Good Earth* (Plate 81) remains closer to the typical work of the Regionalists, which stresses the image of America as a fertile land inhabited by heroic and hardworking people.

77. Grant Wood, Honorary Degree, *1936, crayon and pencil on paper, 11-1/2″ x 7-1/2″. Albert L. Hydeman, Hong Kong. Courtesy Associated American Artists.*

78. Reginald Marsh, Grand Tier at the Metropolitan Opera, *1939, etching with drypoint, 6-7/8" x 9-7/8". Library of Congress, Washington, D.C.*

79. *Thomas Hart Benton,* The Lord is My Shepherd, *1920–22, tempera on canvas, 33-1/4″ x 27-3/8″. Whitney Museum of American Art, New York, New York.*

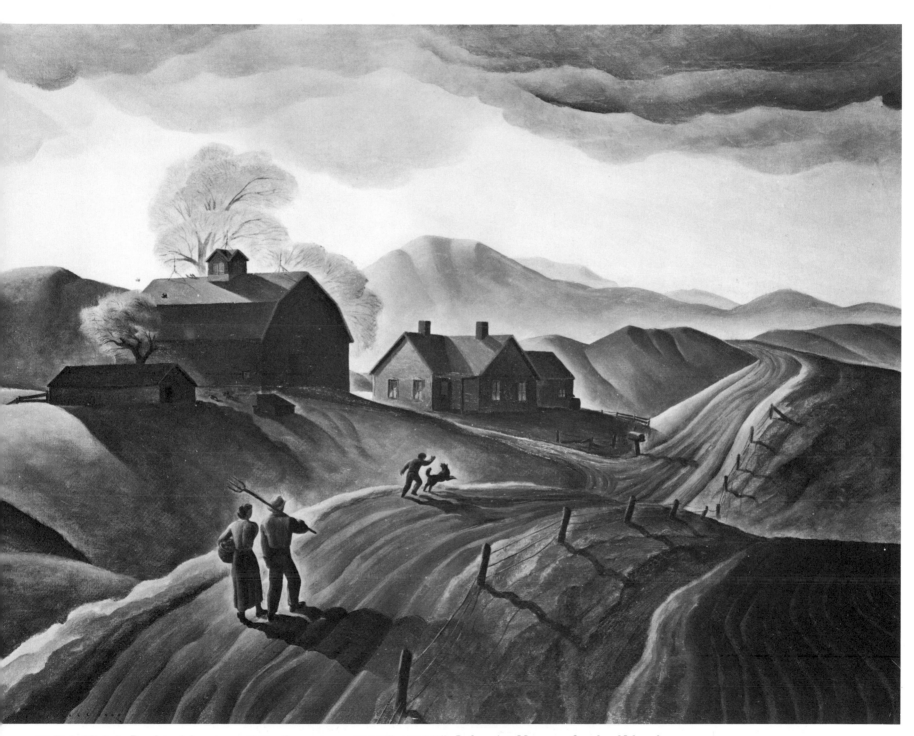

80. Dale Nichols, Road to Adventure, *1940, oil on canvas, 29-1/2″ x 39-1/2″. Joslyn Art Museum, Omaha, Nebraska.*

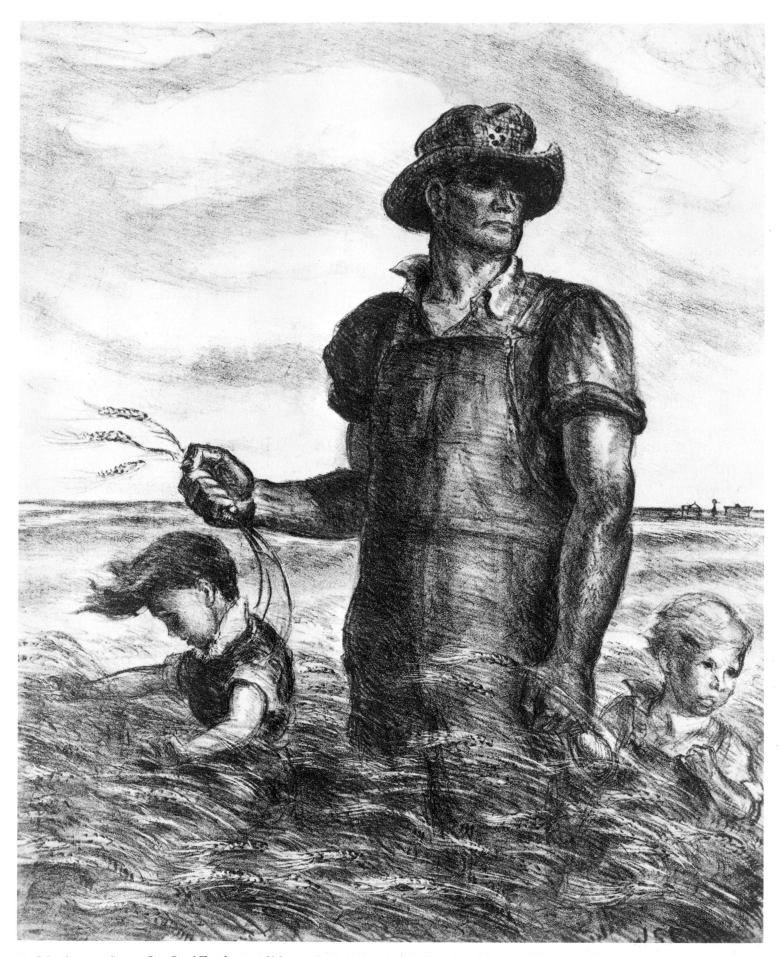

81. John Steuart Curry, Our Good Earth, *1938, lithograph, 14-3/8″ x 10-1/8″. Courtesy Library of Congress, Washington, D.C.*

VI

LOOKING BACKWARD

One quality that the Regionalist movement consistently lacked was a sense of development; during the decade of the 1930s, no important stylistic changes occurred within Regionalist art. Many Regionalist painters retained both their thematic interests and their personal styles as long as they lived, without altering them significantly.

Certain themes remained popular with Regionalist painters well beyond the 1930s. Rural fields and small-town backyards continued to be popular Regionalist subjects (Plates 86, 87, 88). Circus scenes were another common subject painted, for example, by John Steuart Curry in 1932 (Plate 90) and by Paul Cadmus seventeen years later (Plate 91).

In addition to the continued popularity of particular themes, many of the older painters, notably Thomas Hart Benton, Grant Wood, and John Steuart Curry, retained their Regionalist styles throughout their careers. The clearest example of this consistency is Benton, who painted in the same manner for well over forty years. A visual comparison of three Benton paintings (Plates 92, 93, 94), produced in 1939, 1942, and 1965, respectively, demonstrates that once he developed his style, Benton did not vary it. Other Regionalist painters also continued to work in the style they used during the thirties. For example, it is virtually impossible to determine the chronology of Grant Wood's works on the basis of style, as can be seen by comparing a picture of 1932 (Plate 21) with one painted nearly a decade later (Plate 86)

Although major Regionalist artists continued producing works with similar subjects in similar styles for several decades, Regionalism as a movement essentially expired with the 1930s. By the end of the thirties, Regionalist art had begun to lose its widespread popularity. While the older painters retained their Regionalist styles, many of the younger artists made drastic changes in their painting.

One factor that contributed to the demise of Regionalism was the arrival in New York of important European artists. During the late thirties and

early forties, a number of influential modernist painters—including André Masson, Marc Chagall, and Fernand Léger—came to New York. The presence of these members of the school of Paris rekindled interest in European modernism, particularly in abstract art.

With the second United States involvement in a European war, Americans no longer believed that foreign influence was necessarily destructive. On the contrary, people began to be dissatisfied with Regionalism's provincial quality and turned with renewed interest toward the European avant-garde.

However, the importance of Regionalism did not end with the thirties. The Regionalist painters produced large numbers of paintings, many of which are still popular today. In fact, after suffering years of critical neglect and general ridicule, Regionalist art has recently regained considerable popularity. This is due in part to the "new nostalgia" of the 1970s, which can be seen in the other arts—for example, in the Broadway revival of 1930s musicals and in the high prices paid for Art Deco objects.

More important than its popularity, though, is the significance of Regionalism in the context of American art history. Although Regionalist art had no direct stylistic offshoots, it served an extremely important function in the history of American culture. Through its success as a movement, Regionalism helped to establish a new and confident American self-image expressed in the arts in general and painting in particular. Perhaps it was this new confidence that allowed American artists to explore abstract art in a different way. No longer did American painters mimic European modernist styles; rather, they developed approaches of their own, leading to such styles as Abstract Expressionism and Color-Field Painting. Instead of their traditional cultural inferiority complex, American artists had come to believe that they could produce paintings that were the equal of European art. In his book *Modern American Painting*, Peyton Boswell, Jr., looks back on the art of the 1930s, summarizing the significance of Regionalism:

> . . . the native painter had succeeded in dropping his last chains of French serfdom. The decks were swept clear, as the American discovered in some Midwestern tank town or New England textile mill the same powerful urge to create that Gauguin sought in exotic Tahiti and poor, mad Van Gogh found in windswept Arles. The American artist had come home.

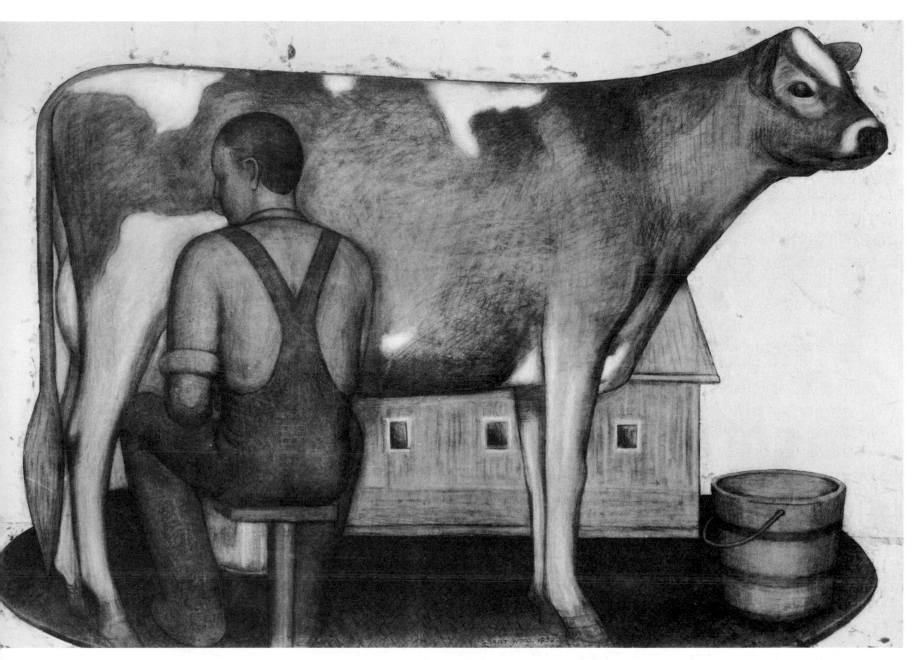

82. *Grant Wood, Hired Hand Milking Cow, 1932, charcoal, pencil, and chalk on brown paper, 38″ x 54″.*
John Deere, Deere Company, Moline, Illinois. Courtesy Associated American Artists.

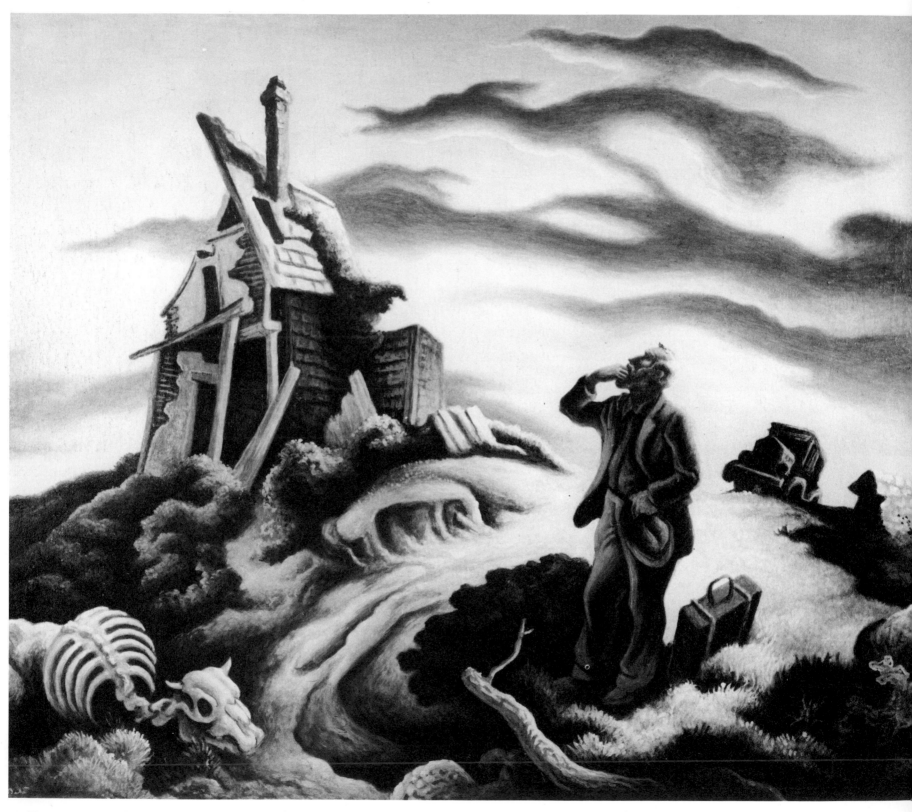

83. Thomas Hart Benton, Prodigal Son, *1943, oil and tempera on composition board, 26-1/8″ x 30-1/2″. Dallas Museum of Fine Arts, Dallas, Texas; Dallas Art Association Purchase.*

84. Grant Wood, Sentimental Ballad, *1940, oil on canvas, 24″ x 50″. New Britain Museum of American Art, New Britain, Connecticut; Charles F. Smith Fund.*

85. *John Steuart Curry,* The Line Storm, *1935, lithograph, 9-7/8″ x 14″. Philadelphia Museum of Art, Philadelphia, Pennsylvania; Harrison Fund.*

86. Grant Wood, Iowa Cornfield, *1941, oil on Masonite, 12-1/2″ x 14-1/2″. Davenport Municipal Art Gallery, Davenport, Iowa. Courtesy Associated American Artists.*

87. Charles Burchfield, The Great Elm, *1939-41, watercolor, 34″ x 54″. Museum of Art, Carnegie Institute, Pittsburgh, Pennsylvania; gift of Mr. and Mrs. James H. Beal, Jr.*

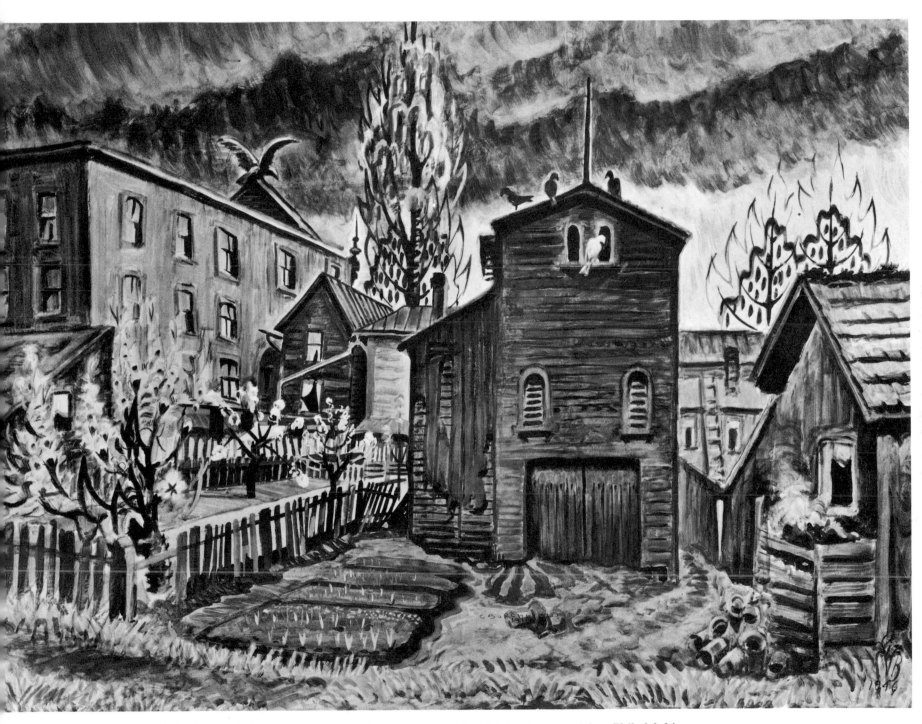

88. Charles Burchfield, Backyards in Spring, *1946, watercolor, 33″ x 34″. Philadelphia Museum of Art, Philadelphia, Pennsylvania; gift of Mrs. Herbert C. Morris.*

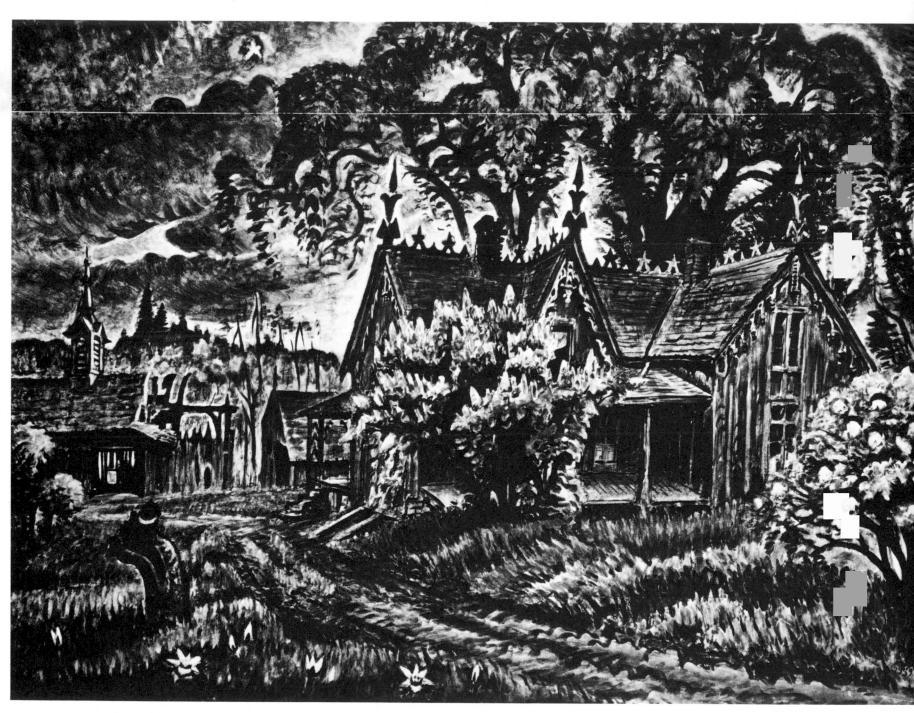

89. *Charles Burchfield,* Lavender and Old Lace, *1939-47, watercolor, 37″ x 50″. New Britain Museum of American Art, New Britain, Connecticut, Charles F. Smith Fund.*

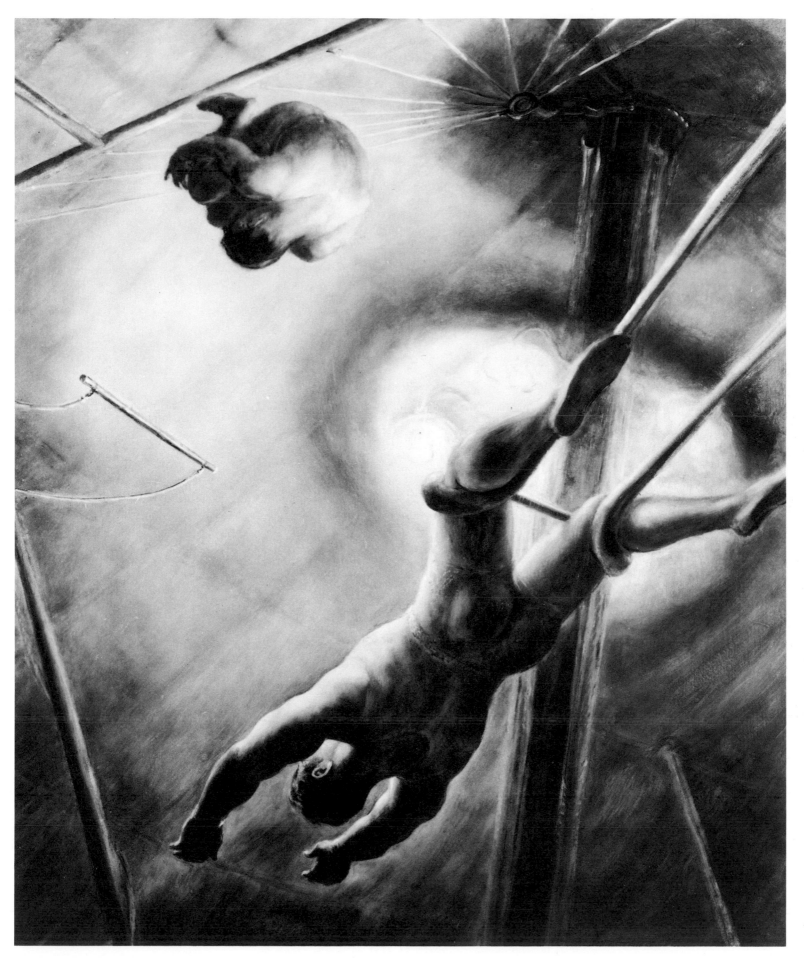

90. *John Steuart Curry,* The Flying Codonas, *1932, tempera and oil on composition board, 36″ x 30″. Whitney Museum of American Art, New York, New York.*

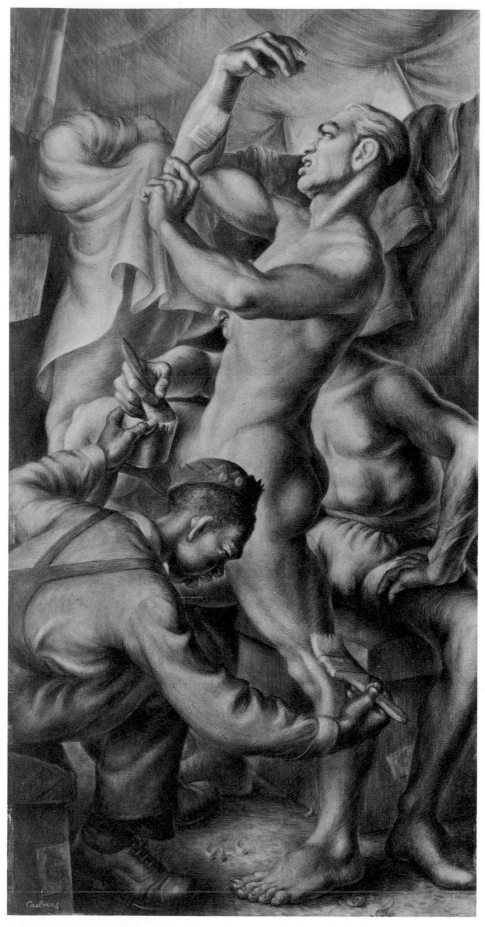

91. *Paul Cadmus,* Gilding the Acrobats, *ca. 1949, tempera and oil on composition board, 36-3/4" x 18-1/2". The Metropolitan Museum of Art, New York, New York; Arthur H. Hearn Fund, 1950.*

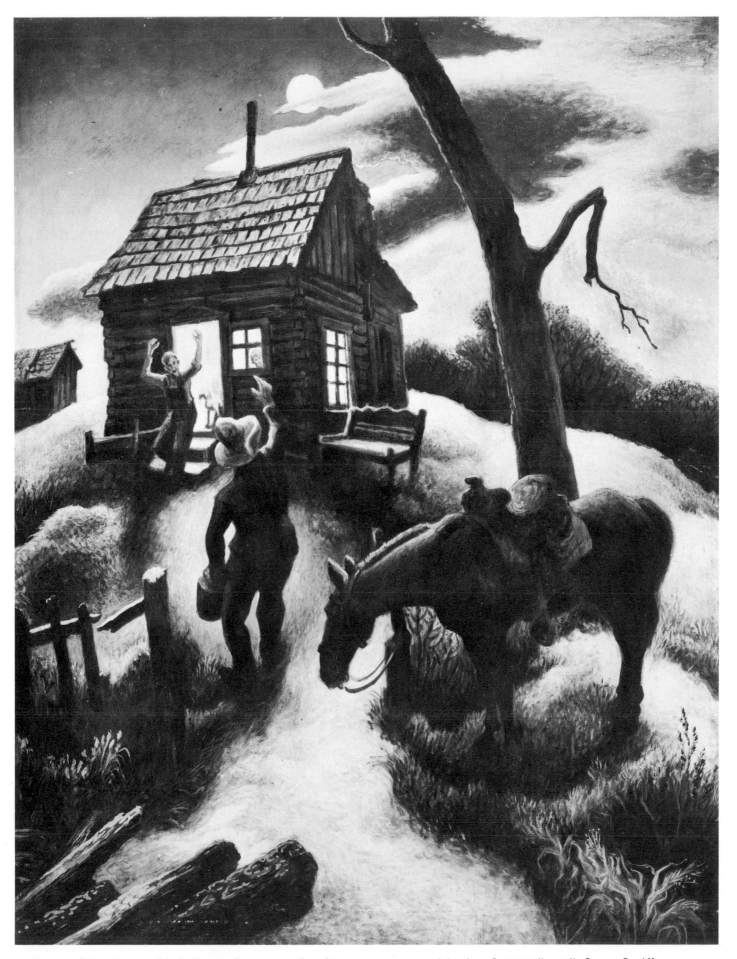

92. *Thomas Hart Benton,* Little Brown Jug, *1939, oil and tempera on composition board, 22-1/2″ x 30″. James L. Allen, Delray Beach, Florida.*

93. *Thomas Hart Benton,* Negro Soldier, *1942, oil and tempera on composition board, 48″ x 60″. The State Historical Society of Missouri, Columbia, Missouri.*

94. Thomas Hart Benton, Ten Pound Hammer, *1965, oil and tempera on canvas, 30-1/2" x 23-3/4".*
Mr. and Mrs. Robert E. Stroud, Kansas City, Missouri. Courtesy Thomas Hart Benton.

BIOGRAPHIES

BENTON, Thomas Hart. Born 1889, Neosho, Missouri. Died 1975, Kansas City, Missouri.

Studied: Art Institute of Chicago School, 1907; Académie Julian, Paris, 1908-11.

Taught: Chelsea Neighborhood Association, New York, 1917; Art Students League of New York, 1926-36; Kansas City Art Institute and School of Design, 1935-40.

Shows: One-man exhibitions included Lakeside Press Gallery, Chicago, 1927; Ferargil Galleries, New York, 1934, 1935; Associated American Artists, New York, 1939; Kansas City Art Gallery, 1939; Whitney Museum of American Art, New York, 1939, 1941, 1969; Joslyn Art Museum, Omaha, 1951; University of Kansas, Lawrence, 1958; Rutgers University, New Brunswick, New Jersey, 1972. Group shows at Forum Exhibition, Anderson Galleries, New York, 1916; Daniel Gallery, New York, 1919; Philadelphia Museum of Art, 1922; Whitney Museum of American Art, New York, 1939, 1940, 1942; Associated American Artists, New York, 1939, 1940, 1942.

Work: Mural commissions for The New School of Social Research, New York, 1928; Whitney Museum of American Art, 1932; State of Indiana, Indianapolis, 1933; Missouri State Capitol, Jefferson City, 1935-36; Harzfeld Department Store, Kansas City, 1947; Lincoln University, Jefferson City, 1952-53; Kansas City River Club, 1947; New York State Power Authority, Massena, 1957-61; Truman Library, Independence, 1958-61.

Awards: Include Gold Medal, Architectural League of New York, 1933; Hon. D. Litt., Lincoln University, 1957; Hon. D. Fine Arts, University of Missouri, 1948; Hon. D. Fine Arts, The New School for Social Research, 1968.

BISHOP, Isabel. Born 1902, Cincinnati, Ohio.

Studied: Wicker Art School, Detroit; New York School of Applied Design; Art Students League of New York with Kenneth Hayes Miller.

Taught: Art Students League, 1935-37; Skowhegan School of Painting and Sculpture, 1956, 1958.

Shows: One-woman shows at Berkshire Museum, Pittsfield, Massachusetts, 1957; Midtown Galleries, New York, 1932, 1935, 1936, 1939, 1949, 1955, 1960, 1967; Whitney Museum of American Art, New York, 1975. Group exhibitions at New York World's Fair, 1939; Museum of Modern Art, New York, Whitney Museum of American Art, 1937, 1950, 1969; Art Institute of Chicago, 1943.

Work: Federal Art Project mural in United States post office, New Lexington, Ohio.

Member: Society of American Graphic Artists, Vice President, 1969-72; National Academy of Design; National Institute of Arts and Letters; Royal Society of Arts, London.

Awards: National Academy of Design Prizes 1942, 1945, 1955; Corcoran Gallery of Art, Second William A. Clark Prize, 1945; National Institute of Arts and Letters Grant, 1943; Pennsylvania Academy of the Fine Arts, Walter Lippincott Prize, 1953; Joseph S. Isidore Medal, National Academy of Design, 1957.

BLANCHE, Arnold Alder. Born 1896, Mantorville, Minnesota. Died 1968, Kingston, New York.

Studied: Minneapolis Institute of Art; Art Students League of New York, 1916-17, with Boardman Robinson, John Sloan, Kenneth Hayes Miller, others.

Taught: Art Students League of New York, 1915-21, 1935-39, 1947-68; California School of Fine Arts, San Francisco, 1930-31; University of Minnesota, Minneapolis, 1949, 1952; Rollins College, Winter Park, Florida, 1950; Woodstock, New York, 1950-61; Minneapolis Institute School, 1954; Norton Gallery and School of Art, West Palm Beach, Florida, 1961-62; Michigan State University, East Lansing, 1964.

Shows: One-man exhibitions included Frank Rehn Gallery, New York, 1923, 1925; Philadelphia Art Alliance; Dudensing Gallery, New York, 1928, 1930; Walter-Dudensing Gallery, Chicago, 1930; Ulrich Gallery, Minneapolis, 1930; Beaux Arts Gallery, San Francisco, 1930; Associated American Artists, New York, 1943, 1955, 1963; University of Minnesota, Minneapolis, 1949; Krasner Gallery, New York, 1954, 1958, 1959, 1961, 1962. Group shows include Art Institute of Chicago, 1930-43; Corcoran Gallery of Art, Washington, D.C., 1931-45; Whitney Museum of American Art, New York, 1931-46, 1948-52; Pennsylvania Academy of the Fine Arts, Philadelphia, 1931-45, 1948-51; Museum of Modern Art, New York; New York World's Fair, 1939; Metropolitan Museum of Art, New York.

Work: Mural commissions for United States post offices in Fredonia, New York; Columbus, Wisconsin; Norwalk, Connecticut.

Awards: Norman Wait Harris Prize, Art Institute of Chicago, 1929; Guggenheim Foundation Fellowship, 1933; Medal, Pennsylvania Academy of the Fine Arts, 1938; Medal, Carnegie Institute International, 1938.

BOHROD, Aaron. Born 1907, Chicago, Illinois.

Studied: Crane Junior College, 1925-26; Art Institute of Chicago School, 1927-29; Art Students League of New York, with John Sloan, 1930-32.

Taught: Illinois State Normal University, Normal, 1941-42; Ohio University, Summers 1949, 1954.

Shows: First one-man show, Frank Rehn Gallery, New York, 1935; most recent, Hammer Galleries, New York, 1969.

Work: Artist-war correspondent in Europe and South Pacific, for *Life* magazine, 1942-45. Since 1948, Artist-in-Residence at University of Wisconsin. Author of *A Pottery Sketchbook*, 1959; *A Decade of Still Life*, 1966.

Awards and Honors: Include Silver Medal, Corcoran Gallery of Art; Guggenheim Foundation Fellowship, 1936, 1937; Art Institute of Chicago, The Mr. and Mrs. Frank G. Logan Prize, 1937, 1945; Childe Hassam Award, American Academy of Arts and Letters, 1962; Honorary D.F.A., Ripon College, 1960. Elected Academician, National Academy of Design, 1952.

BOUCHE, Louis. Born 1896, New York. Died 1969, Pittsfield, Massachusetts.

Studied: Académie Colarossi, Paris; Académie de la Grande Chaumière, Paris; Académie des Beaux-Arts, Paris; Art Students League of New York, 1915-16.

Taught: Art Students League; National Academy of Design, 1951-69.

Shows: One-man shows included Kraushaar Galleries, New York, 1936, 1938, 1940, 1942, 1944, 1946, 1949, 1951, 1954, 1958, 1962, 1964; St. Gaudens Museum, Des Moines, 1966; Temple University, Philadelphia. Group exhibitions included Independents, New York, 1917; Daniel Gallery, New York, 1918-31; Carnegie Institute, Pittsburgh, 1937, 1939; National Academy of Design, New York; Pennsylvania Academy of the Fine Arts, Philadelphia, 1941, 1942, 1945; Cincinnati Art Museum, 1948; Metropolitan Museum of Art, New York, 1965; Whitney Museum of American Art, New York, 1965, 1966.

Awards: Saltus Gold Medal for Merit, National Academy of Design, 1915; Guggenheim Foundation Fellowship, 1933; Carol Beck Gold Medal, Pennsylvania Academy of the Fine Arts, 1944; Third Prize, Artists for Victory, Metropolitan Museum of Art, 1944; Obrig Prize, National Academy of Design, 1955.

BROOK, Alexander. Born 1919, Brooklyn, New York.

Studied: Art Students League of New York with Kenneth Hayes Miller and Frank Vincent DuMond, 1913-17.

Shows: One-man exhibitions included ACA Galleries, New York; Art Institute of Chicago, 1929; Curt Valentine Gallery, New York, 1930; Downtown Gallery, New York, 1934, 1937; Dayton Art Institute, Dayton, 1942; Frank Rehn Gallery, New York, 1947, 1960; Knoedler & Company, New York, 1952; Richard Larcada Gallery, New York, 1969. Group shows included University of Rochester, Rochester, New York, 1937; Carnegie Institute, Pittsburgh, 1939.

Awards: Logan Medal, Art Institute of Chicago, 1929; Second Prize, Carnegie Institute, 1930; Joseph Temple Gold Medal, Pennsylvania Academy of the Fine Arts, 1931; Guggenheim Foundation Fellowship, 1931; First Prize, Carnegie Institute, 1939; First Prize, Los Angeles County Museum of Art, 1934; Medal of Award, San Francisco Museum of Art, 1938; Gold Medal, Paris World's Fair, 1937.

BURCHFIELD, Charles. Born 1893, Ashtabula Harbor, Ohio. Died 1967, West Seneca, New York.

Studied: Cleveland Institute of Art, 1912-16, with H. G. Keller, F. N. Wilcox, W. J. Eastman.

Taught: University of Minnesota at Duluth, 1949; Art Institute of Buffalo, 1949-52; Buffalo Fine Arts School, 1951-52.

Shows: One-man exhibitions included Sunwise Turn Bookshop, New York, 1916; Cleveland Institute of Art, 1916, 1917, 1921, 1944; Art Institute of Chicago, 1921; Grosvenor Gallery, London, 1923; Montross Gallery, New York, 1924, 1926, 1928; Frank Rehn Gallery, New York, 1930, 1931, 1934, 1935, 1936, 1939, 1941, 1943, 1946, 1947, 1950, 1952, 1954-64, 1966; Philadelphia Art Alliance, 1937; Carnegie Institute, Pittsburgh, 1938; Museum of Modern Art, New York, 1954; Whitney Museum of American Art, New York, 1956; State University of New York at Buffalo, 1963; Cleveland Museum of Art, 1953, 1966. Group shows

included Whitney Museum of American Art, 1933, 1936; Art Institute of Chicago, 1921, 1931, 1932, 1933, 1936; Museum of Modern Art, New York 1929, 1932, 1934; Carnegie Institute, 1934, 1935.

Awards and Honors: Include First Prize, Cleveland Museum of Art, 1921; Sesnan Gold Medal, Pennsylvania Academy of the Fine Arts, 1929; Second Prize, Carnegie Institute, 1935; First Prize, 1936 International Arts Festival, Newport, Rhode Island; Dana Medal for Watercolor, Pennsylvania Academy of the Fine Arts, 1940; Blair Prize, Art Institute of Chicago, 1941; Award of Merit, National Institute of Arts and Letters, 1942; Honorable Mention, Carnegie Institute, 1946; Dawson Medal, Pennsylvania Academy of the Fine Arts, 1947; Evans Memorial Prize, Albright-Knox Art Gallery, Buffalo, 1952; Hon. LHD, Kenyon College, 1944; Hon. DFA, Harvard University, 1948; Hon. DFA, Hamilton College, 1948.

CADMUS, Paul. Born 1904, New York.

Studied: National Academy of Design, 1919-26; Art Students League of New York, 1929-31, with J. Pennell and C. Locke.

Shows: One-man exhibitions included Midtown Galleries, New York, 1937, 1949, 1968; Baltimore Museum of Art, 1942. Group shows at Whitney Museum of American Art, New York, 1934, 1936, 1937, 1938, 1940, 1941, 1945; Art Institute of Chicago, 1935; San Francisco Golden Gate International Exposition, 1939; Pennsylvania Academy of the Fine Arts, Philadelphia, 1941; Carnegie Institute, Pittsburgh, 1944, 1945.

Awards: Witkowsky Prize, Art Instititue of Chicago, 1945; National Institute of Arts and Letters grant, 1961.

CARTER, Clarence Holbrook. Born 1904, Portsmouth, Ohio.

Studied: Cleveland School of Art, 1923-27; with Hans Hofmann, 1927.

Taught: Carnegie Institute, Pittsburgh, 1938-44; Minneapolis School of Art, 1949; Lehigh University, Bethlehem, 1954; Ohio University, Athens, 1955; Atlanta Art Institute, 1957; Lafayette College, Easton, Pennsylvania, 1961-71.

Shows: One-man shows at Suffolk Museum, Stony Brook, L.I.; Butler Institute of American Art, Youngstown, Ohio; Allentown Art Museum, Allentown, Pennsylvania. Group shows included Carnegie Institute; Museum of Modern Art, New York.

Awards: Butler Institute of American Art, 1937, 1940, 1943, 1946; Carnegie Institute, 1941, 1943, 1949.

CIKOVSKY, Nicolai. Born 1894, Pinsk, Russia. Came to United States, 1923.

Studied: At Vilna Art School, Russia, 1910-14; Penza Art School, 1914-18; Moscow High Technical Art Institute, 1921-23.

Taught: Art Students League of New York; Art Institute of Chicago, 1937; Corcoran School of Art, Washington, D.C.

Shows: One-man exhibitions included Downtown Gallery, New York, 1933, 1938; Whyte Gallery, Washington, D.C., 1939; Associated American Artists, New York, 1944, 1946, 1949, 1952, 1956. Group shows at Art Institute of Chicago, 1932, 1933, 1960, 1961; Newark Museum; Museum of Modern Art, New York; Carnegie Institute, Pittsburgh; National Academy of Design, New York.

Work: Mural commissions for the U.S. Department of the Interior and United States post offices.

Awards: Logan Medal, Art Institute of Chicago, 1933; First Prize, Worcester Art Museum, 1933; Harris Medal, Art Institute of Chicago, 1932; Maynard Prize, National Academy of Design, 1964.

CORBINO, Jon. Born 1905, Vittoria, Italy. Died 1964, Sarasota, Florida. Came to the United States, 1913.

Studied: Pennsylvania Academy of the Fine Arts, 1923, with Daniel Barber; Art Students League of New York, with George Luks, Frank Vincent DuMond, others.

Taught: National Academy of Design, New York, 1945; Art Students League, 1938-1956.

Shows: One-man exhibition at Oberlin College, 1929, also 1939; others included Contemporary Arts Gallery, New York, 1934; Macbeth Gallery, New York, 1937, 1938, 1940; Corcoran Gallery of Art, Washington, D.C., 1938; Frank Rehn Gallery, New York, 1948, 1951, 1955, 1959; Frank Gehlschlaeger Gallery, Chicago, 1953, 1956, 1960.

Member: National Academy of Design; Lotus Club; Pennsylvania Academy of the Fine Arts.

Awards: Include Guggenheim Foundation Fellowship, 1936, 1937; Art Institute of Chicago prizes, 1937, 1944; Baltimore Museum of Art Award, 1938; National Academy of Design prizes, 1938, 1944, 1945, 1960, 1961; National Institute of Arts and Letters, 1941; Pennsylvania Academy of the Fine Arts, 1938; Audubon Association Medal, 1945; National Arts Club, 1950.

CURRY, John Steuart. Born 1897, Dunavent, Kansas. Died 1946, Madison, Wisconsin.

Studied: Kansas City Art Institute and School of Design, 1916; Art Institute of Chicago, 1916-18, with John W. Norton and E. J. Timmons; Geneva College, Beaver Falls, Pennsylvania, 1918-19; in Paris, 1926, with Basil Schoukhaieff.

Taught: Art Students League of New York, 1932-36; Cooper Union, New York, 1932-34; University of Wisconsin, Madison, 1936.

Shows: One-man exhibitions included Whitney Studio Club, New York, 1930; Ferargil Galleries, New York, 1933, 1935; University of Wisconsin, Madison, 1937; Walker Gallery, New York, 1938; Associated American Artists, New York, 1947; University of Kansas, Lawrence, 1957. Group shows included Whitney Museum of American Art, New York; Art Institute of Chicago; Wichita Art Museum.

Work: Mural commissions for the U.S. Department of Justice, Washington, D.C., 1936-37; Kansas State Capitol, 1938-40; University of Wisconsin, Madison, 1940-42.

Awards: Include Second Prize, Artists for Victory, Metropolitan Museum of Art, 1942; Carnegie Institute, Pittsburgh, 1933; Gold Medal, Pennsylvania Academy of the Fine Arts, 1941.

DASBURG, Andrew. Born 1887, Paris. Came to United States, 1892.

Studied: Art Students League of New York, with Kenyon Cox and Frank Vincent DuMond; Art Students League Summer School, Woodstock, New York, with Birge Harrison; also studied with Robert Henri.

Taught: Art Students League.

Shows: Included Armory Show, New York, 1913; Dallas Museum of Fine Arts, 1957; American Foundation of the Arts (Ford Foundation), 1959; Frank Rehn Gallery, New York, 1958; Whitney Museum of American Art, New York, 1932, 1933, 1934, 1936; Denver Art Museum; Metropolitan Museum of Art, New York; San Francisco Art Museum.

Awards: Pan American Exhibition, Los Angeles, 1925; Carnegie Institute, 1927. Grants from Guggenheim Foundation, 1932; Ford Foundation, 1959; National Foundation for the Arts, 1967.

DEHN, Adolf. Born 1895, Waterville, Minnesota. Died 1968.

Studied: Minneapolis Art School, 1914-17; Art Students League of New York, 1918-21, with Boardman Robinson.

Shows: Included one-man exhibitions at Macbeth Gallery, New York, 1933; Associated American Artists, New York, 1941, 1951; Brooklyn Public Library, New York, 1944; Dayton Art Institute, 1946; Milch Gallery, New York, 1957, 1960, 1968; FAR Gallery, New York, 1964. Group shows included Whitney Museum of American Art, New York, 1933, 1936; Museum of Fine Arts, Boston; Museum of Modern Art, New York; Metropolitan Museum of Art, New York; Art Institute of Chicago, 1932, 1933, 1935.

Member: National Academy of Design; American Academy of Arts and Letters, 1965.

Awards: Art Institute of Chicago, 1943; Philadelphia Art Alliance, 1936; Library of Congress, 1946; Guggenheim Foundation Fellowship, 1939, 1951.

DODD, Lamar. Born 1909, Fairburn, Georgia.

Studied: Georgia Institute of Technology, 1926-27; Art Students League of New York, 1929-33, with John Steuart Curry, Boardman Robinson, George Bridgeman, George Luks.

Taught: University of Georgia, Athens, since 1937.

Shows: One-man exhibitions included Ferargil Galleries, New York, 1933; Grand Central Moderns, New York, 1965, 1967. Group shows at the Carnegie Institute, Pittsburgh, 1936; Whitney Museum of American Art, New York, 1937-57; San Francisco Golden Gate International Exposition, 1939; New York World's Fair, 1939.

Awards: Include purchase prizes at Virginia Museum of Fine Arts, 1948; Pennsylvania Academy of Fine Arts, 1958; Whitney Museum of American Art, 1958. Also prizes from Art Institute of Chicago, 1936; National Institute of Arts and Letters, 1950; National Academy of Design, 1957.

HIRSCH, Joseph. Born 1910, Philadelphia, Pennsylvania.

Studied: Philadelphia Museum School; also with Henry Hensche and George Luks.

Taught: Art Institute of Chicago; Art Students League of New York, 1959-67; University of Utah, Salt Lake City, 1959; Dartmouth College, Hanover, New Hampshire, 1966; Utah State University, Logan; Brigham Young University, Provo, Utah, 1971.

Shows; One-man exhibitions included ACA Galleries, New York; Associated American Artists, New York, 1946, 1948, 1954; Forum Gallery, New York, 1965, 1969. Group shows included Metropolitan Museum of Art, New York; Whitney Museum of American Art, New York; Pennsylvania Academy of the Fine Arts, Philadelphia.

Work: Completed mural commissions for Amalgamated Clothing Workers Building, Philadelphia; Benjamin Franklin High School, Philadelphia; Philadelphia Municipal Court Building.

Awards: Include First Prize, New York World's Fair, 1939; Guggenheim Foundation Fellowship, 1942, 1943; National Institute of Arts and Letters grant, 1947; Second Prize, Carnegie International, 1947; Blair Prize, Art Institute of Chicago; Fulbright Fellowship, 1949; Altman Prize, National Academy of Design, 1959, 1966; Carnegie Prize, National Academy of Design Annual, 1968.

HOGUE, Alexandre. Born 1898, Memphis, Missouri.

Taught: Texas Women's University, Denton; University of Tulsa, Tulsa, Oklahoma.

Shows: Included Jeu de Paume, Paris, 1938; Carnegie Institute International Exhibitions, Pittsburgh, 1938, 1939, 1946; New York World's Fair, 1939; San Francisco Golden Gate International Exposition, 1939; Museum of Modern Art, New York, 1952; Corcoran Gallery of Art, Washington, D. C.

Awards: Purchase prizes at the Dallas Museum of Fine Arts, 1959; Philbrook Art Center, Tulsa, 1961; Springfield Art Museum, Springfield, Missouri, 1965.

HOPPER, Edward. Born 1882, Nyack, New York. Died 1967, New York.

Studied: New York School of Art, 1900-6, with Kenneth Hayes Miller, Robert Henri, and others. Attended commercial art school, New York, 1899-1900. Traveled to Paris, 1906-7, 1909-10; also traveled extensively within the United States.

Shows: First one-man show at Whitney Studio Club, New York, 1919; others at Frank Rehn Gallery, New York, 1924, 1927, 1929, 1946, 1948, 1965. Major retrospective shows at Museum of Modern Art, New York, 1933; Whitney Museum of American Art, New York, 1950, 1964.

Awards and Honors: Include Chicago Society of Etchers, Mr. and Mrs. Frank G. Logan Medal, 1923; Corcoran Gallery of Art, William A. Clark Prize, 1937; Edward MacDowell Medal, 1966; Hallmark International Competition, 1957. Honorary advanced degrees from Art Institute of Chicago, 1950; Rutgers University, New Brunswick, New Jersey, 1953.

HURD, Peter. Born 1904, Roswell, New Mexico.

Studied: New Mexico Military Institute, 1921. Received Senatorial appointment to U.S. Military Academy at West Point, 1921-23. Resigned to study art at Haverford College, Pennsylvania, 1923-24. Studied with N. C. Wyeth, 1924-29; concurrently attended life drawing classes at Pennsylvania Academy of the Fine Arts, Philadelphia.

Shows: Retrospective exhibitions at Amon Carter Museum of Western Art, Fort Worth, Texas, 1964; California Palace of Legion of Honor, San Francisco, 1965.

Work: Commissioned to paint numerous murals and the official portrait of President Lyndon B. Johnson. War correspondent for *Life* magazine, 1942-45. Author and illustrator of several books.

Member: National Academy of Design; American Watercolor Society; Century Association; Wilmington Society of Fine Arts.

Awards: Wilmington Society of Fine Arts, 1941, 1945; Pennsylvania Academy of Fine Arts Medal, 1945; National Academy of Design, Isaac Maynard Prize, 1954.

JONES, Joe (Joseph John). Born 1909, St. Louis, Missouri. Died 1963, Morristown, New Jersey.

Studied: Largely self-taught as an artist.

Taught: St. Bernards School for Boys, Ralston, New Jersey; Peck School, Morristown, New Jersey.

Shows: Whitney Museum of American Art, New York, 1935, 1946; Carnegie Institute, Pittsburgh, 1937, 1947; Corcoran Gallery of Art, Washington, D.C.; Pennsylvania Academy of the Fine Arts, Philadelphia; Golden Gate Exposition, San Francisco, 1939; New York World's Fair, 1939; Colorado Springs Fine Arts Center; Kansas City Art Institute; City Art Museum of St. Louis; Detroit Institute of Art; Dayton Art Institute; Associated American Artists, New York, 1953, 1955.

Work: Artist-war correspondent, Alaskan Theater, for U.S. War Department, 1942.

Member: National Society of Mural Painters.

Awards: Include Pennsylvania Academy of the Fine Arts Medal; Guggenheim Foundation Fellowship, 1937; National Academy of Design Prize, 1946.

LANING, Edward. Born 1906, Petersburg, Illinois.

Studied: University of Chicago; Art Students League of New York, with Boardman Robinson, John Sloan, others; Academy of Fine Arts, Rome. Traveled extensively in United States, Europe, North Africa.

Taught: Cooper Union, New York, 1938-41; Kansas City Art Institute, 1945-50; Pratt Institute, New York, 1952-56; Art Students League of New York, 1952- present.

Shows: First one-man show at Dudensing Gallery, New York, 1932; others included Hewitt Gallery, 1950; Griffin Gallery, New York, 1963; Danenberg Gallery, New York, 1969. Also in several group shows.

Work: Murals for various Sheraton Corporation hotels; U.S. Department of the Interior, Bureau of Reclamation, 1969.

Member: National Academy of Design; National Society of Mural Painters.

Awards: Include Guggenheim Foundation Fellowship, 1945; Fulbright Fellowship, 1950.

LUCIONI, Luigi. Born 1900, Malnate, Italy. Came to United States as a young man.

Studied: Night classes at Cooper Union, New York, 1915-19; National Academy of Design, New York, 1919-23; with William Starkweather, 1918-25.

Shows: Included National Academy of Design, New York, 1926, 1927, 1931; Pennsylvania Academy of the Fine Arts, Philadelphia, 1930, 1933; one-man shows at Ferargil Galleries, New York, 1928, 1930, 1933, 1935; St. Louis City Art Museum, 1932.

Member: Associated American Artists; Society of American Etchers; Tiffany Art Group.

Awards: Include L. C. Tiffany Foundation Medal, 1928; Allied Artists of America, 17th Annual Exhibition, Medal of Honor, 1929.

McCRADY, John. Born 1911, Canton, Mississippi. Died 1968, New Orleans, Louisiana.

Studied: University of Mississippi, University; University of Pennsylvania, Philadelphia, 1930-32; New Orleans Art School, 1933; Art Students League of New York, 1934.

Shows: One-man shows at Downtown Gallery, New Orleans; Mary Buie Museum, Oxford, Mississippi.

Work: Director, John McCrady Art School, New Orleans. Co-author and illustrator of several books. Painted a number of murals.

Awards: Selected by *Time* magazine as outstanding regional painter, 1938. Others include New Orleans Arts and Crafts Club prize, 1938; Louisiana Arts Committee Award, 1939, 1940; Blanche S. Benjamin Prize, 1941; New Orleans Art Association Award, 1946; Southern States Art League Award, 1946; Delgado Museum of Art Award, 1948; National Institute of Arts and Letters Grant, 1949; Art Students League National Scholarship, 1934; Guggenheim Foundation Fellowship, 1939.

MARSH, Reginald. Born 1898, Paris, France. Died 1954, Dorset, Vermont. Came to United States 1900.

Studied: Lawrenceville School, 1915-16; Yale University, 1916-20, art editor and cartoonist for the Yale *Record*; Art Students League of New York, 1919, 1920-24, 1927-28, with John Sloan, Kenneth Hayes Miller, George Luks, others.

Taught: Art Students League; Moore Institute of Art, Science, and Industry, Philadelphia, 1953-54.

Shows: First one-man exhibition, Whitney Studio Club, 1924; others included Frank Rehn Gallery, 1930-1934, 1936, 1938, 1940, 1941, 1943, 1944, 1946, 1948, 1950, 1953, 1962, 1964, 1965; Yale University, 1937; Kennedy Galleries, Inc., New York, 1964. Retrospective exhibition, Gallery of Modern Art, New York, 1964. Also in many group shows.

Work: Painted two murals for government buildings in Washington, D.C. and New York, 1937. Traveled extensively in Europe. Artist-war correspondent for *Life* magazine, 1943.

Awards: Include Wanamaker Prize, 1934; National Academy of Design, The Thomas B. Clark Prize, 1945; National Institute of Arts and Letters, Gold Medal for Graphics, 1954.

MARTIN, Fletcher. Born 1904, Palisade, Colorado.

Studied: Self-taught as an artist.

Taught: Iowa State University, Ames, 1940; Kansas City Art Institute, 1941-42; Art Students League of New York, 1948-67; University of Florida, Gainesville, 1949-52; Mills College, Oakland, California, 1953; University of Minnesota, Minneapolis, 1954; San Antonio Art Institute, 1957; Los Angeles County Art Museum, 1958-59; Washington State University, Pullman, 1960-61.

Shows: One-man shows in San Diego, 1934; Jake Zeitlin Gallery, Los Angeles, 1939; Midtown Galleries, New York, 1940, 1943; John Heller Gallery, New York, 1955, 1957. Retrospective exhibitions at the University of Minnesota, Minneapolis, 1954; Roberson Center for the Arts and Sciences, Binghamton, New York, 1968.

Work: Artist-war correspondent for *Life* magazine, 1943. Traveled extensively in the United States, Mexico, Europe, North Africa, Australia.

Awards: Include National Academy of Design, Benjamin Altman Prize, 1949; Ford Foundation/American Federation of Arts, Artist-in-Residence Grant, 1964.

MILLER, Kenneth Hayes. Born 1878, Oneida, New York. Died 1952, New York.

Studied: Art Students League of New York, with Kenyon Cox and Frank Vincent DuMond; also with William Merritt Chase at the New York School of Art. Traveled in Europe.

Taught: New York School of Art, 1899-1911; Art Students League, 1911-35, 1937-43, 1945-52. Students included George Bellows, Edward Hopper, Reginald Marsh, Isabel Bishop.

Shows: One-man exhibitions at Montross Gallery, New York, 1922, 1923, 1925, 1928; Frank Rehn Gallery, New York, 1929, 1935; Art Students League, 1953. Contributed to numerous group shows.

Member: National Academy of Design; National Institute of Arts and Letters.

Awards: Include the National Academy of Design Gold Medal, 1943; National Institute of Arts and Letters Prize, 1947.

NICHOLS, Dale William. Born 1904, David City, Nebraska.

Studied: Chicago Academy of Fine Arts; Art Institue of Chicago; with Joseph Binder.

Taught: Carnegie Visiting Professor and Artist-in-Residence, University of Illinois, Urbana, 1939-40.

Shows: First one-man show at Macbeth Galleries, New York, 1938. Group shows included Art Institute of Chicago, 1936, 1938, 1939; Carnegie Institute, Pittsburgh, 1937, 1946; Denver Art Museum, 1943; Century of Progress, Chicago, 1934; New York World's Fair, 1939; Golden Gate Exposition, San Francisco, 1939; Dallas Museum of Fine Arts, 1936.

Work: Art Editor, *Encyclopaedia Britannica;* Art Chairman, Tucson Regional Plan, 1943-45. Author of several books and magazine articles.

Member: Society of Typographic Artists; Tucson Archaeological Society.

Awards: Art Institute of Chicago, 1935, 1939.

O'KEEFFE, Georgia. Born 1887, Sun Prairie, Wisconsin.

Studied: Chatham Episcopal Institute, Virginia, 1901; Art Institute of Chicago, 1904-5, with John Vanderpoel; Art Students League of New York, 1907-8, with William Merritt Chase; Columbia University, New York, 1916, with Arthur Dow, Alon Bement. Traveled in the United States, Europe, Mexico, Peru, Japan.

Taught: University of Virginia; Supervisor of Art in public schools, Amarillo, Texas, 1912-16; taught elsewhere in Texas and South Carolina.

Shows: First one-woman exhibition at "291," New York, 1917; others included An American Place (Gallery), New York, 1931, 1932, 1935-42, 1944-46, 1950; University of Minnesota, Minneapolis, 1937; Downtown Gallery, New York, 1937, 1952, 1955, 1958, 1961; University of New Mexico, Albuquerque, 1966. Retrospectives included: Art Institute of Chicago, 1943; Museum of Modern Art, New York, 1946; Amon Carter Museum of Western Art, Fort Worth, Texas, 1966; Whitney Museum of American Art, New York, 1970.

Awards and Honors: Honorary advanced degrees from the College of William and Mary, Williamsburg, Virginia, 1939; University of Wisconsin, Madison, 1942. Elected to National Institute of Arts and Letters, 1947. Brandeis University, Creative Arts Award, 1963.

PALMER, William C. Born 1906, Des Moines, Iowa.

Studied: Art Students League of New York, 1924-26, with Boardman Robinson, Thomas Hart Benton, Kenneth Hayes Miller, others; private study with Miller, 1928-29; Ecole des Beaux-Arts, Fontainebleau.

Taught: Art Students League, 1936-40; Hamilton College, Clinton, New York, 1941-47; Munson-Williams-Proctor Institute, Utica, New York, 1941- present.

Shows: First one-man show at Midtown Galleries, New York, 1932; also in 1937, 1940, 1944, 1950, 1952, 1954, 1957, 1959, 1962, 1967; others at Syracuse University, Syracuse, New York; Skidmore College, Saratoga Springs, New York; Colgate University, Hamilton, New York; St. Lawrence University, Canton, New York.

Work: Painted several murals for government and other buildings, 1933-39.

Awards: Include Paris Salon Medal, 1937; National Academy of Design, 1946; Audubon Artists, 1947; National Institute of Arts and Letters grant, 1953.

PEIRCE, Waldo. Born 1884, Bangor, Maine. Died 1970, Newburyport, Massachusetts.

Studied: Phillips Academy, Andover, Massachusetts; Harvard University, Cambridge, Massachusetts, B.A., 1908; Académie Julian, Paris, 1911. Traveled in Europe, North Africa.

Shows: First one-man exhibition, Wildenstein Galleries, New York, 1926; others at Midtown Galleries, New York, 1939, 1941, 1944, 1945, 1949, 1960, 1968. Retrospective, William A. Farnsworth Library and Art Museum, Rockland, Maine, 1950.

Work: Federal Art Project, U.S. post office murals in Westbrooke, Maine; Troy, New York; Peabody, Massachusetts.

Awards: Pomona College, 1939; Pepsi-Cola Company, 1944; First Honorable Mention, Carnegie Institute of Technology, 1944.

SAMPLE, Paul Starrett. Born 1896, Louisville, Kentucky. Died 1974.

Studied: With Jonas Lie, 1925–38; with F. Tolles Chamberlain; with Stanton MacDonald-Wright; Dartmouth College, Hanover, New Hampshire.

Taught: University of Southern California, Los Angeles; Artist-in-Residence, Dartmouth College, 1938-62. Painted several murals.

Shows: Carnegie Institute, Pittsburgh; National Academy of Design, New York; Pennsylvania Academy of the Fine Arts, Philadelphia; Corcoran Gallery of Art Biennial, Washington, D.C. One-man retrospective at the Currier Gallery of Art, Manchester, New Hampshire, 1948.

Member: National Academy of Design; American Watercolor Society.

Awards: Include Pennsylvania Academy of the Fine Arts, Temple Medal, 1936; National Academy of Design, First Benjamin Altman Prize, 1962.

SIPORIN, Mitchell. Born 1910, New York.

Studied: Crane Junior College; Art Institute of Chicago School; American Academy, Rome, 1949-50; studied privately with Todros Geller. Traveled in Mexico, Latin America, Europe, Africa.

Taught: Boston Museum School, 1949; Columbia University, New York, 1951; Brandeis University, Waltham, Massachusetts, 1951–present; Artist-in-Residence, American Academy, Rome, 1966-67.

Shows: First one-man show, Downtown Gallery, New York, 1940; most recent, Lee Nordness Galleries, New York, 1960. Retrospective show at De Cordova and Dana Museum, Lincoln, Massachusetts, 1954.

Work: Murals in Bloom Township High School, Chicago, 1938; Lane Technical High School, Chicago, 1940; U.S. post offices, Decatur, Illinois, 1940; St. Louis, Missouri, 1940-42.

Awards: Include Guggenheim Foundation Fellowships, 1945, 1946; Prix de Rome, 1949; Fulbright Fellowship, 1966-67.

SLOAN, John. Born 1871, Lock Haven, Pennsylvania. Died 1951, Hanover, New Hampshire.

Studied: Spring Garden Institute, Philadelphia; Pennsylvania Academy of Fine Arts, Philadelphia, 1892, with Thomas Anshutz.

Taught: Art Students League of New York, 1914-26, 1935-37; Archipenko School of Art, 1932-33; George Luks School, 1934.

Shows: First one-man show, Whitney Studio Club, New York, 1916; others at Kraushaar Galleries, New York, 1917, 1926, 1927, 1930, 1937, 1939, 1943, 1948, 1952, 1960, 1966; Corcoran Gallery of Art, Washington, D.C., 1933; Whitney Museum of American Art, New York, 1936, 1952. Retrospectives at Wanamaker Gallery, Philadelphia, 1940; Dartmouth College, Hanover, New Hampshire, 1946; Phillips Academy, Andover, Massachusetts, 1946.

Work: Art Editor of *The Masses*, 1912-16.

Member: Society of Independent Artists, New York (President, 1918-42); National Institute of Arts and Letters.

Awards: Include Philadelphia Sesquicentennial Medal, 1926; Pennsylvania Academy of the Fine Arts, Carol H. Beck Gold Medal, 1931; Metropolitan Museum of Art Award, 1942; National Institute of Arts and Letters Gold Medal, 1950.

SOYER, Isaac. Born 1902, Tombov, Russia. Came to United States, 1914, two years after his older brothers, Moses and Raphael.

Studied: Cooper Union, New York, 1920-24; National Academy of Design, New York, 1924-25; Educational Alliance Art School, New York, 1925-28. Spent a year in Paris and Madrid.

Taught: Educational Alliance Art School, 1950- present; The New School for Social Research, New York; Art Students League of New York, 1971- present.

Shows: Museum of Modern Art, New York; Art Institute of Chicago; Pennsylvania Academy of the Fine Arts, Philadelphia; Corcoran Gallery of Art, Washington, D.C.; New York World's Fair, 1939.

Awards: Include Western New York Exhibition, First Prize, 1944; Audubon Artists Exhibition, First Prize for Landscape, 1945.

SOYER, Raphael. Born Tombov, Russia, 1899. Came to United States, 1912.

Studied: Cooper Union, New York; National Academy of Design, New York, 1919-21; Art Students League of New York, briefly with Guy Pène du Bois.

Taught: Art Students League; American Art School, New York; The New School for Social Research, New York; National Academy of Design, 1965-67.

Shows: One-man exhibitions at the Daniel Gallery, New York, 1929; Curt Valentine Gallery, New York, 1933-1935, 1937, 1938; Associated American Artists, New York, 1940, 1941, 1948, 1953, 1955; Philadelphia Art Alliance, 1949; Forum Gallery, New York, 1964, 1966. Retrospective show, Whitney Museum of American Art, New York, 1967. Also many group shows.

Awards: Include M.V. Kohnstamm Prize, Art Institute of Chicago, 1932; Gold Medal, Corcoran Gallery of Art, 1951.

WOOD, Grant. Born 1891, Anamosa, Iowa. Died 1941, Iowa City, Iowa.

Studied: Iowa State University, Ames; Minneapolis School of Design; Académie Julian, Paris. Traveled in Germany, France.

Taught: In Rosedale, Iowa, 1911-12; in Jackson, Iowa, 1919-23; Art Institute of Chicago School, 1916; Iowa State University, 1934-42.

Shows: One-man shows at Ferargil Galleries, New York, 1935; Lakeside Press Gallery, Chicago, 1935; Hudson D. Walker Gallery, New York, 1936. Retrospectives at University of Kansas, Lawrence, 1959; Davenport Municipal Art Gallery, Davenport, Iowa, 1966; Cedar Rapids Art Association, 1969. Also in numerous group exhibitions.

Member: National Academy of Design; National Society of Mural Painters.

Awards and Honors: First Prize, Iowa State Fair, 1929-32. Honorary advanced degrees from University of Wisconsin, Madison; Wesleyan University, Middletown, Connecticut; Lawrence College; Northwestern University, Evanston, Illinois.

BIBLIOGRAPHY

Agee, William C.
 The 1930's: Painting and Sculpture in America. New York: Whitney Museum of American Art, 1968.

Baigell, Matthew.
 The American Scene: American Painting of the 1930's. New York: Praeger, 1974.

Baigell, Matthew.
 Thomas Hart Benton. New York: Abrams, 1974.

Benton, Thomas Hart.
 An Artist in America. Columbia, Missouri: University of Missouri Press, 1968.

Boswell, Peyton, Jr.
 Modern American Painting. New York: Dodd and Mead, 1939.

Brown, Hazel E.
 Grant Wood and Marvin Cone: Artists of an Era. Ames, Iowa: Iowa State University Press, 1972.

Cahill, Holger.
 New Horizons in American Art. New York: Museum of Modern Art, 1936.

Cheney, Martha Candler.
 Modern Art in America. New York: McGraw-Hill, 1939.

Crane, Aimee, ed.
 Portrait of America. New York: Hyperion Press, 1945.

Craven, Thomas.
 Men of Art. New York: Simon and Schuster, 1934.

Garwood, Darrell.
 Artist in Iowa: A Life of Grant Wood. New York: Greenwood, 1971 (reprint of 1944 edition).

Goodrich, Lloyd.
 Edward Hopper. New York: Abrams, 1971.

Goodrich, Lloyd.
 Reginald Marsh. New York: Abrams, 1972.

McKinzie, Richard D.
 The New Deal for Artists. Princeton, New Jersey: Princeton University Press, 1973.

Mumford, Lewis.
 "The Theory and Practice of Regionalism," *The Sociological Review*, January and April, 1928.

O'Connor, Francis V.
 Federal Support for the Visual Arts: The New Deal and Now. Greenwich, Connecticut: New York Graphic Society, 1969.

Rourke, Constance.
 "The Roots of American Culture," in *The Roots of American Culture and Other Essays*, Van W. Brooks, ed. New York: Harcourt, Brace, Jovanovich, 1966 (paper).

Schmeckebier, Laurence E.
 John Steuart Curry's Pageant of America. New York: American Artists Group, 1945.

Shapiro, David, ed.
 Social Realism: Art as a Weapon. New York: Ungar, 1973.

Susman, Warren, ed.
 Culture and Commitment, 1929–1945. New York: Braziller, 1973.

Swados, Harvey, ed.
 The American Writer and the Great Depression. Cleveland: Bobbs-Merrill, 1966.

INDEX

(Note: Paintings appear on pages numbered in *italics*.)

Edited by Bonnie Silverstein
Designed by Bob Fillie